THE BRICK BIBLE
THE NEW TESTAMENT

THE BRICK BIBLE
THE NEW TESTAMENT

A NEW SPIN ON THE STORY OF JESUS
As Told and Illustrated by Brendan Powell Smith

Skyhorse Publishing

This is an original, modern interpretation of the Bible, based on older public domain translations such as the *King James Bible, Darby 's Bible*, and *Young 's Literal Bible*. In addition, modern English Bible translations were used as references, and the author consulted the original Hebrew for certain passages.

Skyhorse Publishing books may be purchased in bulk at special discounts for sales promotion, corporate gifts, fund-raising, or educational purposes. Special editions can also be created to specifications. For details, contact the Special Sales Department, Skyhorse Publishing, 307 West 36th Street, 11th Floor, New York, NY 10018 or info@skyhorsepublishing.com.

Skyhorse and Skyhorse Publishing are registered trademarks of Skyhorse Publishing, Inc.®, a Delaware corporation.

www.skyhorsepublishing.com

10 9 8 7 6 5 4 3 2

Library of Congress Cataloging-in-Publication Data

Smith, Brendan Powell.
The brick Bible : the New Testament : a new spin on the story of Jesus / Brendan Powell Smith.
 p. cm.
ISBN 978-1-62087-172-0 (pbk. : alk. paper)
1. Bible stories, English.–N.T. 2. Lego toys–Juvenile literature. I. Title.
BS2401.S56 2012
225.9′505–dc23

 2012017336

Printed in the United States of America

Editor: Julie Matysik
Designer: Brian Peterson
Production manager: Abigail Gehring

CONTENTS

Foreword

Brendan Powell Smith creates a spectacular twenty-first-century Biblical art masterpiece by illustrating an old familiar book, the New Testament, with an old familiar toy, LEGO® bricks. Smith uses direct quotes from the Bible to maintain the intent of the text, which he combines with modern language to make the stories easier for the reader to understand. Each story is told as close to the original as possible.

Many people have the desire to read the Bible, but find it difficult for a number of reasons. Many feel intimidated because they don't think they will be able to understand it. Smith has created a Bible for adults that has simple, relatable pictures. This bold attempt to introduce the stories of the New Testament to readers who may not be as likely to attend church services or pick up and the read the Bible is long overdue.

For those who have read the Bible, often the interpretation of its stories comes not from one's own experiences, but rather from the understanding of others that has been passed down from generation to generation. With this unconventional method of using toys to illustrate the New Testament, Smith courageously challenges us to read and re-read scriptural text through a new lens. This book challenges the conventional interpretations of Biblical text and pushes the reader to think beyond what he or she may have been taught in the past—whether at home, at school, at church, or elsewhere. Seeing the Bible in a new light provides the opportunity for the reader to consider a different interpretation and to even question his or her preconceived notions and beliefs.

This version of the New Testament is structured around the story of Jesus—his birth, teachings, and death—and also includes the story of Paul. It ends, of course, with Revelation. Additionally, Jesus's teachings are set in a modern-day context to bring his words greater meaning.

This book is for people who feel that the Bible is not relevant today. It is for those who feel the Bible is outdated and the stories only relate to people of long ago. With the use of a familiar toy, Smith

demonstrates that the Bible is not a sterile book and it does not shy away from painful human issues, such as violence and death. In turn, the reader will begin to see how the Biblical stories of old also relate directly to the present. The Bible then comes alive once readers begin to understand the stories and find them relevant to their own lives, and Smith's rendition of the New Testament allows for just this to happen.

You may wonder, can God's word be understood in today's world through the use of pictures? Picture books are usually reserved for children, with the assumption that children can better understand a picture and then connect it to words. Art has been used for centuries, however, to demonstrate various interpretations of scriptural text. With the use of a familiar toy and modern language, this Bible recognizes the importance of illustrations for all ages and certainly proves that a picture really is worth a thousand words.

You are invited to read the stories of the New Testament for the first time or to re-read sections with a more open mind. Whether you are a Biblical scholar or a first-time reader, you will be intrigued by how Smith has used the simplicity of a toy to tell of the mighty acts of God in the world. Some stories within will confirm what the reader already believes. Many of the stories may seem to contradict what the reader has experienced as his or her truth. Either way, Smith has created a new conversation around these timeless stories of the New Testament.

Above all, *The Brick Bible: The New Testament* encourages you to read the Bible.

Wanda M. Lundy
Professor of Ministry Studies
New York Theological Seminary

PART I.
THE GOSPELS

THIS IS HOW JESUS CHRIST CAME TO BE BORN. GOD SENT THE ANGEL GABRIEL TO A TOWN IN GALILEE CALLED NAZARETH...

...TO A VIRGIN ENGAGED TO A MAN NAMED JOSEPH, WHO WAS DESCENDED FROM KING DAVID. THE VIRGIN'S NAME WAS MARY.

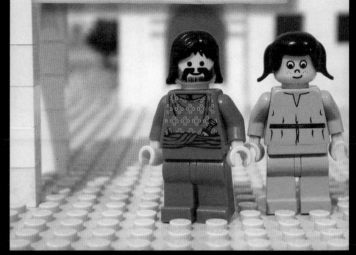

MARY WAS GREATLY TROUBLED BY HIS WORDS AND WONDERED WHAT THIS SORT OF GREETING MIGHT MEAN.

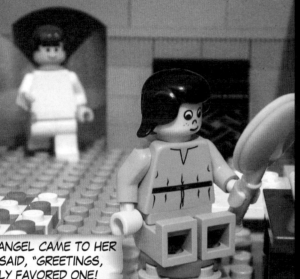

THE ANGEL CAME TO HER AND SAID, "GREETINGS, HIGHLY FAVORED ONE! THE LORD IS WITH YOU."

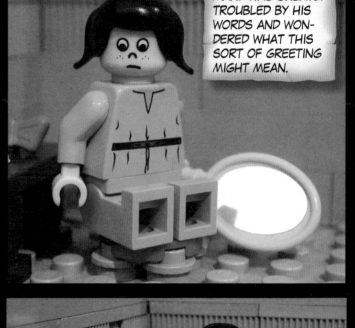

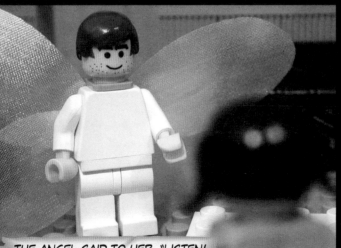

THE ANGEL SAID TO HER, "LISTEN! YOU WILL BECOME PREGNANT AND GIVE BIRTH TO A CHILD. YOU WILL NAME HIM JESUS."

MARY SAID TO THE ANGEL, "HOW CAN THIS HAPPEN IF I HAVE NOT YET LAIN WITH A MAN?"

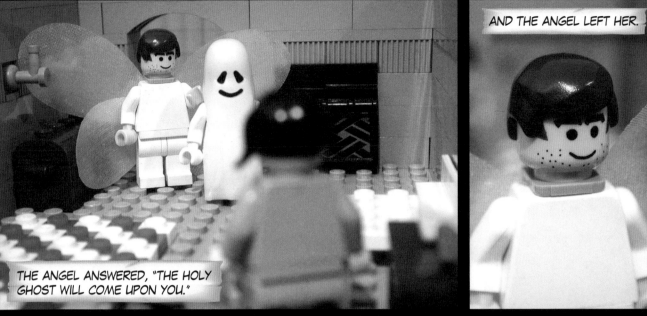

THE ANGEL ANSWERED, "THE HOLY GHOST WILL COME UPON YOU."

AND THE ANGEL LEFT HER.

SHORTLY AFTERWARD, MARY GOT UP AND HURRIED OFF TO THE HILL COUNTRY.

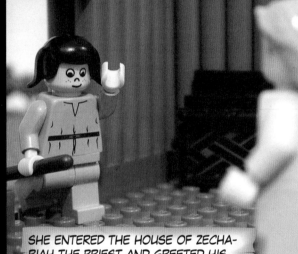

SHE ENTERED THE HOUSE OF ZECHARIAH THE PRIEST AND GREETED HIS WIFE ELIZABETH. MARY SAID, "MY SOUL EXALTS THE LORD IN PRAISE!"

"HE HAS WROUGHT MIGHTY DEEDS WITH HIS ARM. HE HAS SCATTERED THE PROUD AND ARROGANT."

"HE HAS CAST DOWN RULERS FROM THEIR THRONES."

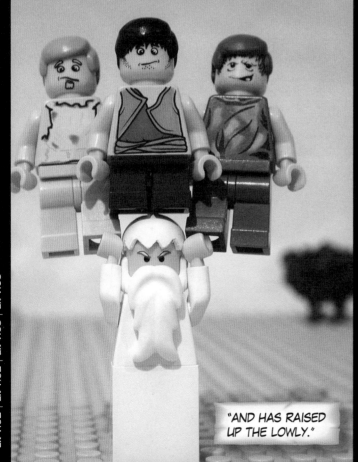

"AND HAS RAISED UP THE LOWLY."

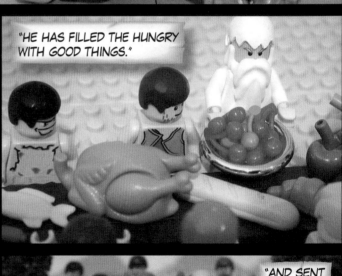

"HE HAS FILLED THE HUNGRY WITH GOOD THINGS."

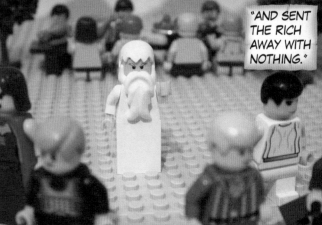

"AND SENT THE RICH AWAY WITH NOTHING."

MARY WAS FOUND TO BE PREGNANT BY THE HOLY GHOST.

MARY REMAINED WITH ELIZABETH FOR ABOUT THREE MONTHS AND THEN RETURNED HOME.

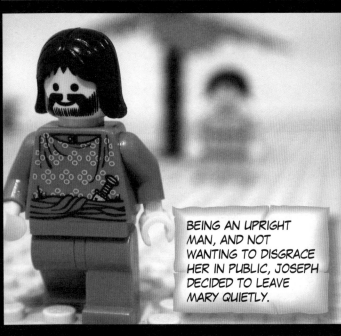

BEING AN UPRIGHT MAN, AND NOT WANTING TO DISGRACE HER IN PUBLIC, JOSEPH DECIDED TO LEAVE MARY QUIETLY.

BUT AN ANGEL APPEARED TO HIM IN A DREAM, SAYING, "DO NOT BE AFRAID TO TAKE MARY AS YOUR WIFE. THE CHILD IN HER IS OF THE HOLY GHOST."

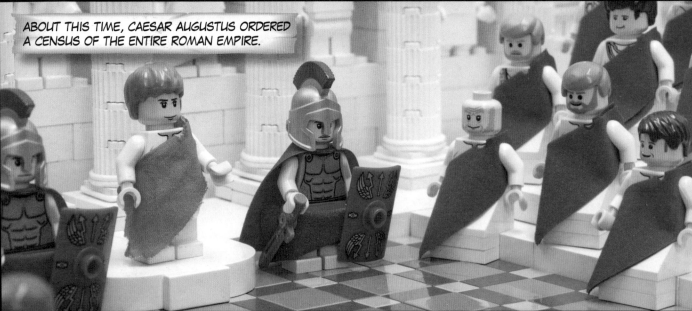

ABOUT THIS TIME, CAESAR AUGUSTUS ORDERED A CENSUS OF THE ENTIRE ROMAN EMPIRE.

SO EVERYONE WENT TO THEIR HOMETOWNS TO BE REGISTERED. BECAUSE HE WAS A DESCENDANT OF KING DAVID, JOSEPH SET OUT FROM NAZARETH TO THE TOWN OF BETHLEHEM, TO REGISTER WITH HIS PREGNANT FIANCÉ, MARY.

IT HAPPENED, WHILE THEY WERE THERE, THAT THE TIME CAME FOR HER TO DELIVER HER CHILD, AND MARY GAVE BIRTH TO HER FIRSTBORN SON.

SHE WRAPPED HIM IN SWADDLING CLOTHES AND LAID HIM IN A MANGER, BECAUSE THERE WAS NO ROOM FOR THEM AT THE INN.

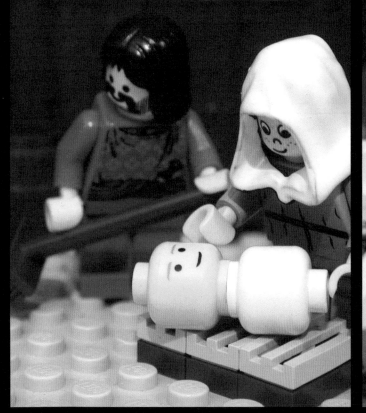

NOW THERE WERE SOME SHEPHERDS OUT IN THE NEARBY FIELDS, KEEPING WATCH OVER THEIR FLOCKS AT NIGHT.

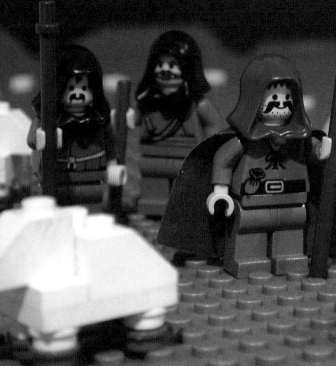

AN ANGEL OF THE LORD APPEARED BEFORE THEM, AND THE GLORY OF THE LORD SHONE AROUND THEM. THE SHEPHERDS WERE TERRIFIED.

Lk 2:7 | Lk 2:8 | Lk 2:9

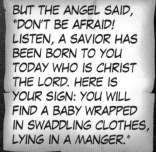

BUT THE ANGEL SAID, "DON'T BE AFRAID! LISTEN, A SAVIOR HAS BEEN BORN TO YOU TODAY WHO IS CHRIST THE LORD. HERE IS YOUR SIGN: YOU WILL FIND A BABY WRAPPED IN SWADDLING CLOTHES, LYING IN A MANGER."

SUDDENLY A MULTITUDE OF THE HEAVENLY HOST WAS THERE WITH THE ANGEL, PRAISING GOD AND SAYING, "GLORY TO GOD IN THE HIGHEST, AND ON EARTH PEACE AMONG MEN HE FAVORS."

Lk 2:10-12 | Lk 2:13-14

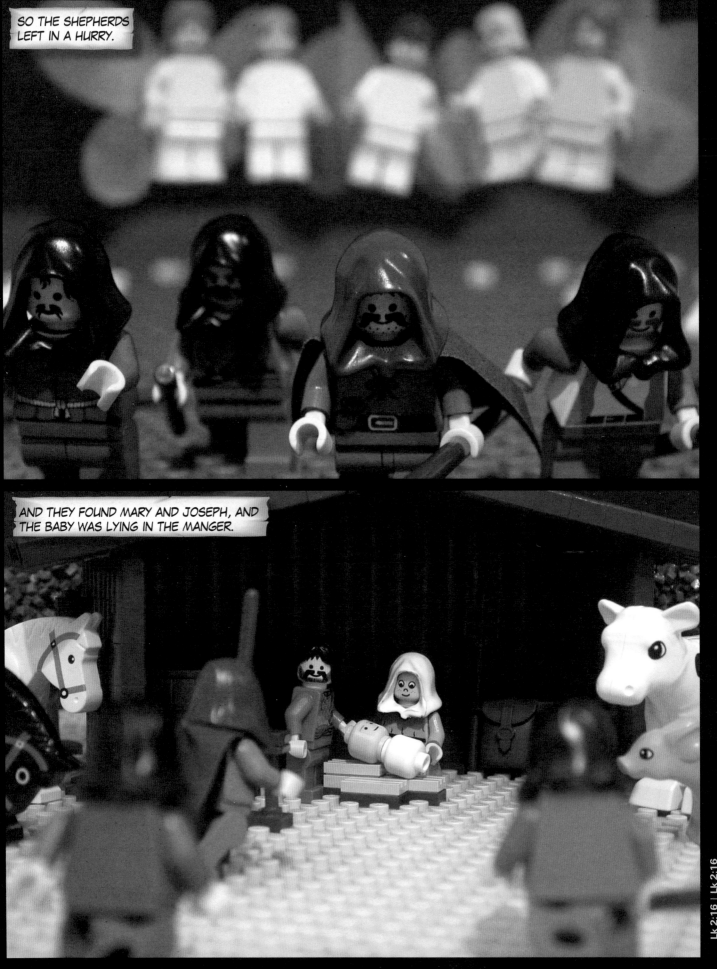

HAVING SEEN THE BABY, THE SHEPHERDS MADE KNOWN WHAT THEY HAD BEEN TOLD ABOUT THIS CHILD, AND ALL WHO HEARD IT MARVELED AT THE THINGS THAT THE SHEPHERDS TOLD THEM.

AFTER EIGHT DAYS PASSED, IT WAS TIME FOR THE CHILD TO BE CIRCUMCISED, AND HE WAS GIVEN THE NAME JESUS.

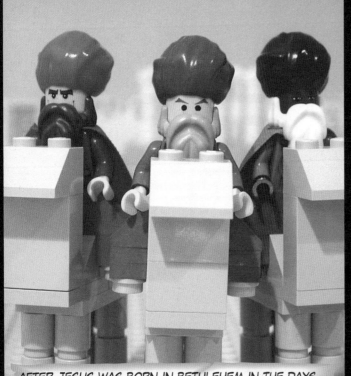

AFTER JESUS WAS BORN IN BETHLEHEM IN THE DAYS OF KING HEROD, SOME MAGI FROM THE EAST CAME TO JERUSALEM, SAYING, "WHERE IS HE WHO IS BORN KING OF THE JEWS? FOR WE SAW HIS STAR WHEN IT ROSE, AND HAVE COME TO DO HIM HOMAGE."

WHEN HEROD THE KING HEARD ABOUT THIS, HE WAS DISTURBED, AS WAS ALL OF JERUSALEM WITH HIM.

GATHERING TO-GETHER ALL THE CHIEF PRIESTS AND EXPERTS ON THE LAW OF MOSES, KING HEROD ASKED THEM WHERE THE MESSIAH WAS TO BE BORN. THEY SAID TO HIM, "AT BETHLEHEM IN JUDEA, JUST AS IT WAS WRITTEN BY THE PROPHET."

THEN KING HEROD SUMMONED THE MAGI. HE SENT THEM OFF TO BETHLEHEM, SAYING, "GO AND SEARCH FOR THE YOUNG CHILD. WHEN YOU HAVE FOUND HIM, LET ME KNOW, SO THAT I MAY ALSO GO AND DO HIM HOMAGE."

HAVING LISTENED TO THE KING, THE MAGI SET OFF. THE STAR THAT THEY HAD SEEN RISING WENT ON BEFORE THEM UNTIL IT CAME TO A STOP OVER THE PLACE WHERE THE CHILD WAS.

THEY CAME INTO THE HOUSE AND SAW THE YOUNG CHILD WITH HIS MOTHER MARY.

THEY BOWED DOWN AND DID HIM HOMAGE. OPENING THEIR TREASURES, THEY OFFERED TO HIM GIFTS OF GOLD, FRANKINCENSE, AND MYRRH.

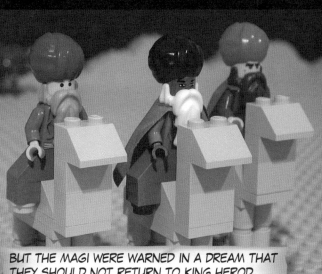

BUT THE MAGI WERE WARNED IN A DREAM THAT THEY SHOULD NOT RETURN TO KING HEROD, AND SO THEY TRAVELED BACK TO THEIR OWN COUNTRY BY A DIFFERENT ROUTE.

WHEN THE MAGI HAD LEFT, SUDDENLY AN ANGEL OF THE LORD APPEARED TO JOSEPH IN A DREAM, SAYING, "GET UP AND TAKE THE CHILD AND HIS MOTHER. FLEE INTO EGYPT, FOR KING HEROD WILL BE SEARCHING FOR THE CHILD TO DESTROY HIM."

SO JOSEPH GOT UP THAT NIGHT AND TOOK THE CHILD AND HIS MOTHER AND WENT TO EGYPT.

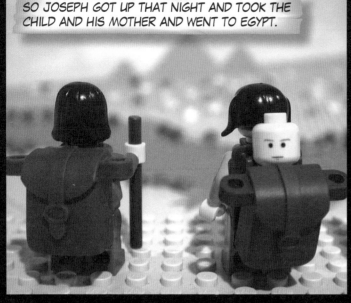

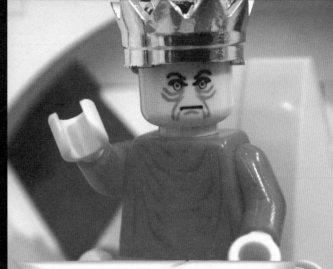

WHEN KING HEROD REALIZED THAT HE HAD BEEN TRICKED BY THE MAGI, HE WAS FURIOUS.

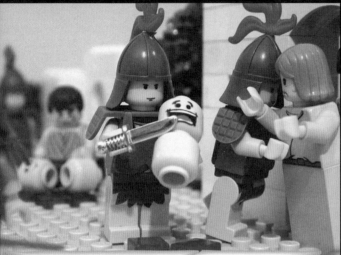

HE SENT OUT SOLDIERS TO KILL ALL THE MALE CHILDREN TWO YEARS OLD OR YOUNGER THROUGHOUT BETHLEHEM AND THE SURROUNDING COUNTRYSIDE.

AFTER KING HEROD DIED, AN ANGEL OF THE LORD APPEARED TO JOSEPH IN EGYPT IN A DREAM, SAYING, "GET UP AND TAKE THE CHILD AND HIS MOTHER. GO TO THE LAND OF ISRAEL, FOR THOSE WHO SOUGHT TO KILL THE CHILD ARE DEAD."

SO JOSEPH GOT UP AND TOOK THE CHILD AND HIS MOTHER AND RETURNED TO THE LAND OF ISRAEL.

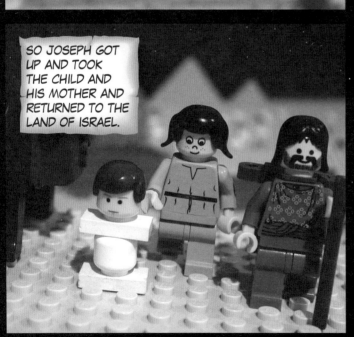

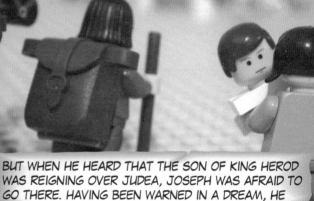

BUT WHEN HE HEARD THAT THE SON OF KING HEROD WAS REIGNING OVER JUDEA, JOSEPH WAS AFRAID TO GO THERE. HAVING BEEN WARNED IN A DREAM, HE WITHDREW TO THE REGION OF GALILEE, AND CAME TO LIVE IN A TOWN CALLED NAZARETH.

THE CHILD GREW AND BECAME STRONG AND FILLED WITH WISDOM.

AND GOD'S FAVOR WAS WITH HIM.

NOW IN THOSE DAYS, JOHN THE BAPTIST CAME INTO THE DESERT OF JUDEA. HE WORE CLOTHING MADE FROM CAMEL'S HAIR WITH A LEATHER BELT AROUND HIS WAIST, AND HIS FOOD WAS LOCUSTS AND WILD HONEY.

HE WENT INTO THE REGION AROUND THE JORDAN RIVER, PREACHING A BAPTISM OF REPENTANCE FOR THE FORGIVENESS OF SINS, SAYING, "REPENT! FOR THE KINGDOM OF HEAVEN DRAWS NEAR!"

THE WHOLE JUDEAN COUNTRYSIDE AND ALL OF JERUSALEM WERE GOING OUT TO HIM, AND JOHN SAID TO THE CROWDS COMING OUT TO BE BAPTIZED BY HIM, "YOU OFFSPRING OF SNAKES! WHO WARNED YOU TO FLEE FROM THE COMING WRATH?"

"I BAPTIZE YOU WITH WATER, BUT THE ONE COMING AFTER ME WILL BAPTIZE YOU WITH THE HOLY SPIRIT AND FIRE! HE WILL GATHER HIS WHEAT INTO THE BARN, BUT THE CHAFF HE WILL BURN UP WITH NEVER-ENDING FIRE!"

IN THOSE DAYS JESUS CAME FROM NAZARETH IN GALILEE.

AND HE WAS BAPTIZED BY JOHN IN THE JORDAN.

AND IMMEDIATELY COMING UP OUT OF THE WATER, JESUS SAW THE HEAVENS SPLITTING APART AND THE SPIRIT DESCENDING ON HIM LIKE A DOVE.

AND A VOICE CAME FROM HEAVEN: "YOU ARE MY SON. TODAY I HAVE FATHERED YOU."

IMMEDIATELY THE SPIRIT DROVE JESUS INTO THE DESERT TO BE TEMPTED BY THE DEVIL.

HE WAS IN THE DESERT FORTY DAYS. HE WAS WITH WILD ANIMALS, AND ANGELS WERE MINISTERING TO HIS NEEDS.

THE TEMPTER CAME AND SAID TO HIM, "IF YOU ARE THE SON OF GOD, COMMAND THESE STONES TO BECOME LOAVES OF BREAD."

JESUS ANSWERED HIM, "IT IS WRITTEN, 'MAN DOES NOT LIVE BY BREAD ALONE.'"

Mk 1:12 | Mt 4:1 | Mk 1:13 | Mt 4:3 | Lk 4:4

THEN THE DEVIL BROUGHT HIM TO THE HIGHEST POINT OF THE TEMPLE IN JERUSALEM, AND SAID, "IF YOU ARE THE SON OF GOD, THROW YOURSELF DOWN FROM HERE. FOR IT IS WRITTEN, 'HE WILL COMMAND HIS ANGELS TO PROTECT YOU. THEY WILL BEAR YOU UP SO THAT YOU WILL NOT STRIKE YOUR FOOT AGAINST A STONE.'"

JESUS ANSWERED HIM, "IT IS SAID, 'YOU ARE NOT TO PUT THE LORD YOUR GOD TO THE TEST.'"

AGAIN, THE DEVIL TOOK HIM TO A VERY HIGH MOUNTAIN AND SHOWED HIM ALL THE KINGDOMS OF THE WORLD AND THEIR SPLENDOR.

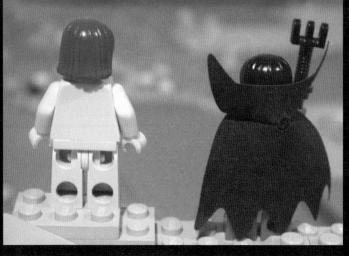

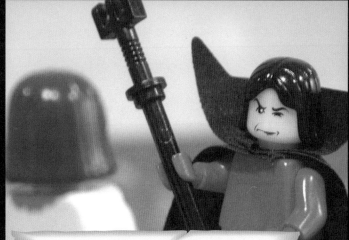

AND THE DEVIL SAID TO HIM, "THIS WHOLE REALM HAS BEEN GRANTED TO ME, AND I CAN GIVE IT TO WHOMEVER I WISH. IF YOU WORSHIP ME, IT SHALL ALL BE YOURS."

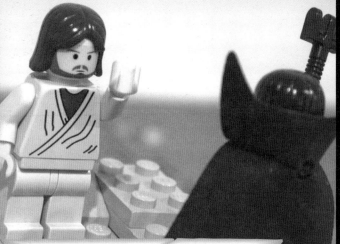

JESUS SAID TO HIM, "GO AWAY, SATAN! FOR IT IS WRITTEN: 'YOU ARE TO WORSHIP THE LORD YOUR GOD AND SERVE ONLY HIM.'"

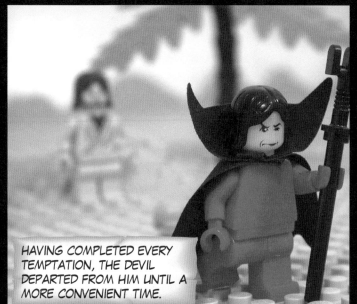

HAVING COMPLETED EVERY TEMPTATION, THE DEVIL DEPARTED FROM HIM UNTIL A MORE CONVENIENT TIME.

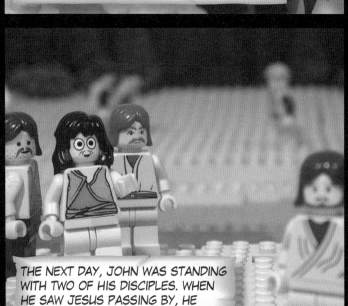

THE NEXT DAY, JOHN WAS STANDING WITH TWO OF HIS DISCIPLES. WHEN HE SAW JESUS PASSING BY, HE SAID, "LOOK, THE LAMB OF GOD!"

WHEN THE TWO DISCIPLES HEARD HIM SAY THIS, THEY FOLLOWED JESUS.

Mt 4:8 | Mt 4:9 | Mt 4:10 | Lk 4:13 | Jn 1:35-36 | Jn 1:37

THEY SAID, "RABBI, WHERE ARE YOU STAYING?" AND HE SAID TO THEM, "COME AND SEE."

SO THEY CAME AND SAW WHERE HE WAS STAYING, AND THEY STAYED WITH HIM THAT DAY, IT BEING FOUR O'CLOCK IN THE AFTERNOON.

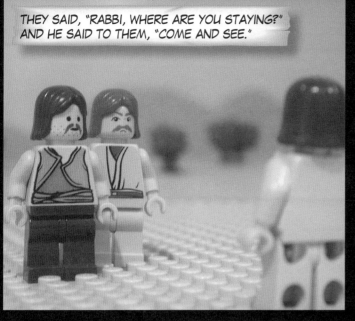

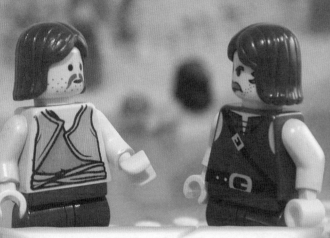

ANDREW, SIMON PETER'S BROTHER, WAS ONE OF THE TWO WHO HAD FOLLOWED JESUS. THE FIRST THING ANDREW DID WAS TO FIND HIS BROTHER SIMON AND TELL HIM, "WE HAVE FOUND THE MESSIAH."

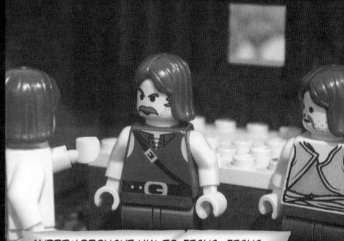

ANDREW BROUGHT HIM TO JESUS. JESUS LOOKED AT HIM AND SAID, "YOU ARE SIMON, SON OF JOHN. YOU WILL BE CALLED CEPHAS"— (WHICH TRANSLATES AS PETER).

THE NEXT DAY JESUS DECIDED TO LEAVE FOR GALILEE. HE FOUND PHILIP, AND HE SAID TO HIM, "FOLLOW ME." PHILIP WAS FROM BETHSAIDA, THE TOWN OF ANDREW AND PETER.

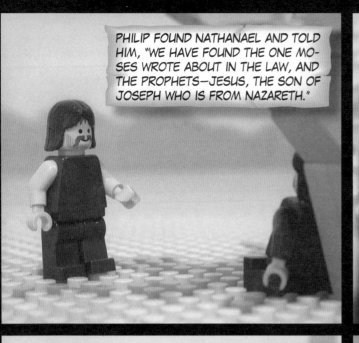

PHILIP FOUND NATHANAEL AND TOLD HIM, "WE HAVE FOUND THE ONE MO-SES WROTE ABOUT IN THE LAW, AND THE PROPHETS—JESUS, THE SON OF JOSEPH WHO IS FROM NAZARETH."

"NAZARETH?" ASKED NATHANAEL. "CAN ANYTHING GOOD COME FROM THERE?" "COME AND SEE!" SAID PHILIP.

JESUS SAW NATHANAEL COMING TOWARD HIM AND EXCLAIMED, "LOOK, A TRUE ISRAELITE IN WHOM THERE IS NO DECEIT!"

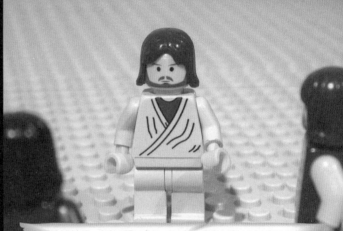

NATHANAEL ASKED HIM, "HOW DO YOU KNOW ME?" JESUS REPLIED, "BEFORE PHILIP CALLED YOU, WHEN YOU WERE UNDER THE FIG TREE, I SAW YOU."

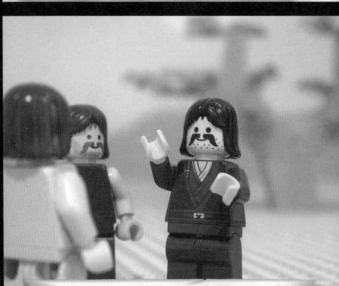

NATHANAEL ANSWERED HIM, "RABBI, YOU ARE THE SON OF GOD. YOU ARE THE KING OF ISRAEL!"

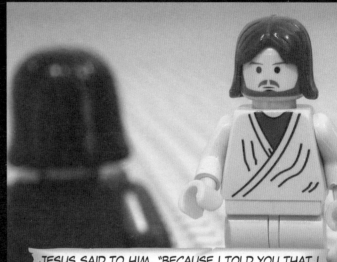

JESUS SAID TO HIM, "BECAUSE I TOLD YOU THAT I SAW YOU UNDER THE FIG TREE, DO YOU BELIEVE? YOU WILL SEE GREATER THINGS THAN THESE."

28

AND JOHN REBUKED HEROD ON ACCOUNT OF HERODIAS, HIS BROTHER PHILIP'S WIFE, BECAUSE HEROD HAD MARRIED HER. JOHN REPEATEDLY TOLD HEROD, "IT IS NOT LAWFUL FOR YOU TO HAVE YOUR BROTHER'S WIFE."

HEROD THE TETRARCH LIKED TO LISTEN TO JOHN, THOUGH WHEN HE HEARD HIM, HE WAS THOROUGHLY BAFFLED.

SO HEROD HAD JOHN LOCKED UP IN PRISON.

WHEN JESUS HEARD THAT JOHN HAD BEEN IMPRISONED, HE WENT TO GALILEE AND BEGAN TO PREACH THIS MESSAGE: "REPENT, FOR THE KINGDOM OF HEAVEN DRAWS NEAR!"

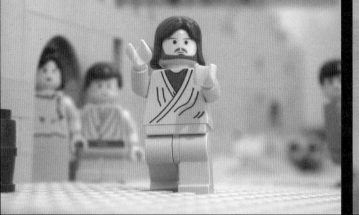

AS HE WAS WALKING BY THE SEA OF GALILEE HE SAW TWO BROTHERS, SIMON CALLED PETER AND HIS BROTHER ANDREW, CASTING A NET INTO THE SEA, FOR THEY WERE FISHERMEN.

HE SAID TO THEM, "FOLLOW ME, AND I WILL TURN YOU INTO FISHERS OF MEN."

IMMEDIATELY THEY LEFT THEIR NETS AND FOLLOWED HIM.

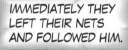

JESUS CALLED THEM.

GOING ON FROM THERE HE SAW TWO OTHER BROTHERS, JAMES THE SON OF ZEBEDEE AND HIS BROTHER JOHN. THEY WERE IN A BOAT WITH THEIR FATHER ZEBEDEE, MENDING THEIR NETS.

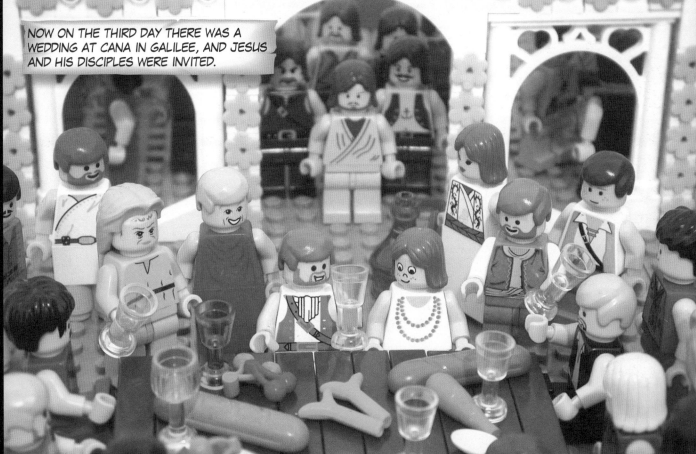

AND IMMEDIATELY THEY LEFT THE BOAT AND THEIR FATHER AND FOLLOWED HIM.

NOW ON THE THIRD DAY THERE WAS A WEDDING AT CANA IN GALILEE, AND JESUS AND HIS DISCIPLES WERE INVITED.

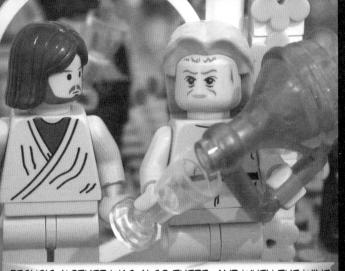

JESUS'S MOTHER WAS ALSO THERE, AND WHEN THE WINE RAN OUT, SHE SAID TO HIM, "THEY HAVE NO MORE WINE."

JESUS REPLIED, "WOMAN, WHAT HAVE I TO DO WITH YOU? MY TIME HAS NOT YET COME."

HIS MOTHER SAID TO THE SERVANTS, "WHATEVER HE TELLS YOU, DO IT."

NOW THERE WERE SIX STONE WATER JARS THERE, EACH HOLDING TWENTY OR THIRTY GALLONS. JESUS TOLD THE SERVANTS, "FILL THE WATER JARS WITH WATER."

THEY FILLED THEM UP TO THE VERY TOP. THEN JESUS SAID TO THEM, "NOW DRAW SOME OUT AND CARRY IT TO THE MASTER STEWARD."

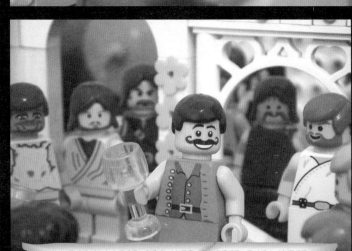

WHEN THE MASTER STEWARD TASTED THE WATER THAT HAD BEEN TURNED TO WINE, HE SAID TO THE BRIDEGROOM, "EVERYONE SERVES GOOD WINE FIRST. THEN INFERIOR WINE WHEN THE GUESTS ARE DRUNK, BUT YOU HAVE SAVED THE GOOD WINE UNTIL NOW!"

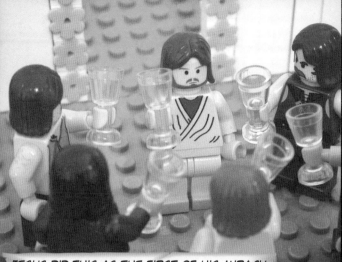

JESUS DID THIS AS THE FIRST OF HIS MIRACU-
LOUS SIGNS. IN THIS WAY HE DISPLAYED HIS
GLORY, AND HIS DISCIPLES BELIEVED IN HIM.

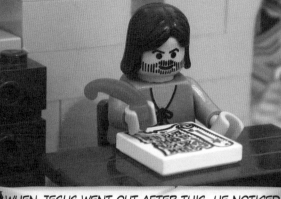

WHEN JESUS WENT OUT AFTER THIS, HE NOTICED
A TAX COLLECTOR NAMED LEVI SITTING AT THE
TAX OFFICE AND SAID TO HIM, "FOLLOW ME."

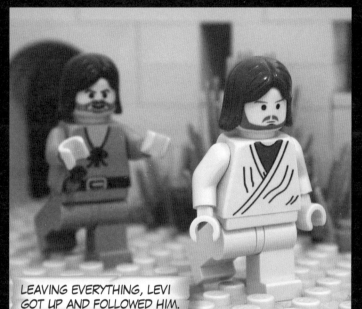

LEAVING EVERYTHING, LEVI
GOT UP AND FOLLOWED HIM.

AS JESUS WAS WALKING ON FROM THERE HE
SAW A MAN NAMED MATTHEW SITTING AT THE
TAX OFFICE, AND HE SAID TO HIM, "FOLLOW ME."

AND HE GOT UP AND
FOLLOWED HIM.

ANOTHER ONE OF HIS DISCIPLES SAID TO HIM,
"LORD, LET ME GO AND BURY MY FATHER FIRST."

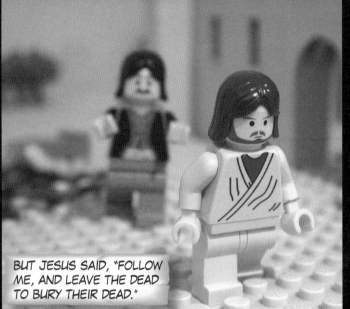

BUT JESUS SAID, "FOLLOW ME, AND LEAVE THE DEAD TO BURY THEIR DEAD."

NOW A MAN WITH LEPROSY CAME TO JESUS, BEGGING TO BE HEALED, SAYING, "IF YOU ARE WILLING, YOU CAN HEAL ME AND MAKE ME CLEAN."

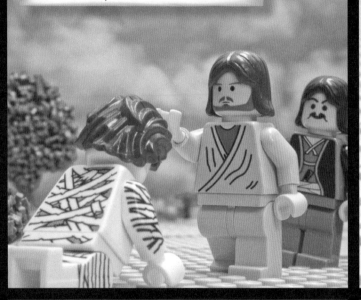

"I AM WILLING," SAID JESUS. "BE CLEAN!"

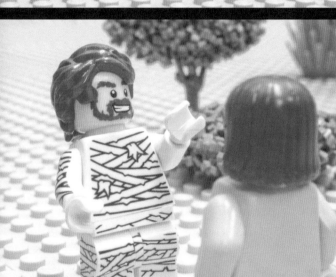

AND IMMEDIATELY THE LEPROSY LEFT HIM, AND HE WAS CLEANSED.

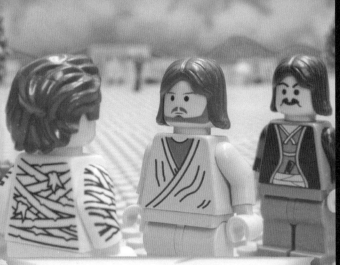

JESUS SENT HIM AWAY WITH A STERN WARNING: "MAKE SURE YOU DON'T TELL ANYONE ABOUT THIS!"

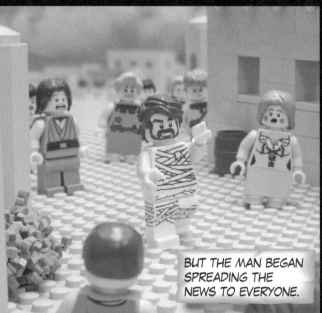

BUT THE MAN BEGAN SPREADING THE NEWS TO EVERYONE.

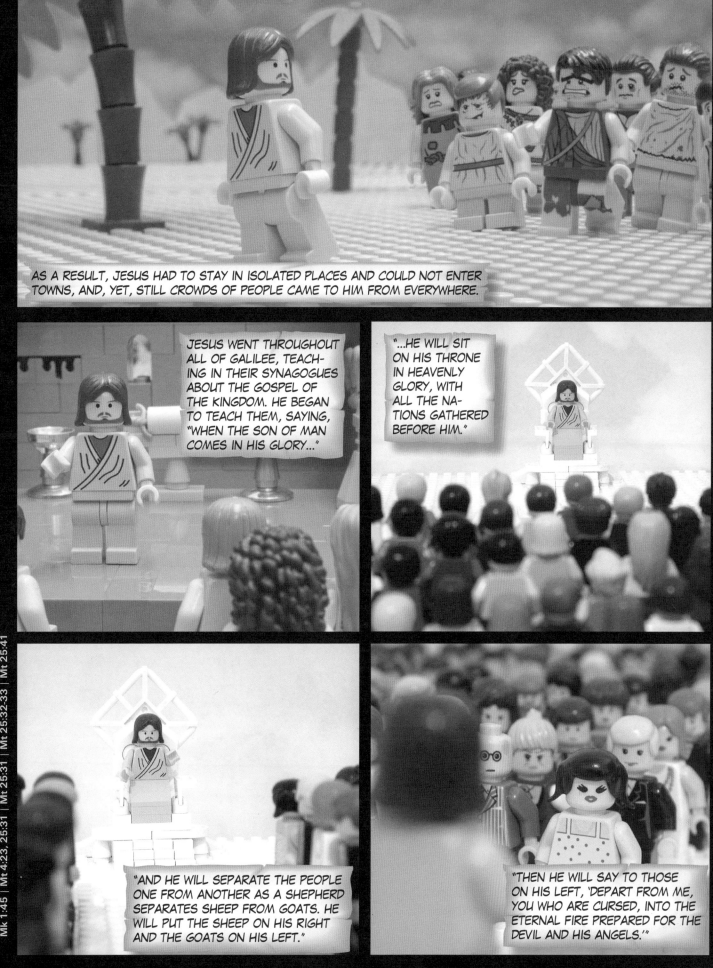

AS A RESULT, JESUS HAD TO STAY IN ISOLATED PLACES AND COULD NOT ENTER TOWNS, AND, YET, STILL CROWDS OF PEOPLE CAME TO HIM FROM EVERYWHERE.

JESUS WENT THROUGHOUT ALL OF GALILEE, TEACHING IN THEIR SYNAGOGUES ABOUT THE GOSPEL OF THE KINGDOM. HE BEGAN TO TEACH THEM, SAYING, "WHEN THE SON OF MAN COMES IN HIS GLORY..."

"...HE WILL SIT ON HIS THRONE IN HEAVENLY GLORY, WITH ALL THE NATIONS GATHERED BEFORE HIM."

"AND HE WILL SEPARATE THE PEOPLE ONE FROM ANOTHER AS A SHEPHERD SEPARATES SHEEP FROM GOATS. HE WILL PUT THE SHEEP ON HIS RIGHT AND THE GOATS ON HIS LEFT."

"THEN HE WILL SAY TO THOSE ON HIS LEFT, 'DEPART FROM ME, YOU WHO ARE CURSED, INTO THE ETERNAL FIRE PREPARED FOR THE DEVIL AND HIS ANGELS.'"

"THEN THEY WILL GO AWAY TO ETERNAL PUNISHMENT."

THEN JESUS WENT DOWN TO CAPERNAUM, A TOWN IN GALILEE.

AND ON THE SABBATH, HE BEGAN TO TEACH THE PEOPLE IN THE SYNAGOGUE, AND THEY WERE AMAZED BECAUSE HE SPOKE WITH AUTHORITY.

NOW THERE WAS A MAN WHO HAD THE SPIRIT OF AN EVIL DEMON, AND HE CRIED OUT WITH A LOUD VOICE, "WHAT BUSINESS DO YOU HAVE WITH US, JESUS OF NAZARETH? HAVE YOU COME TO DESTROY US? I KNOW WHO YOU ARE—THE HOLY ONE OF GOD!"

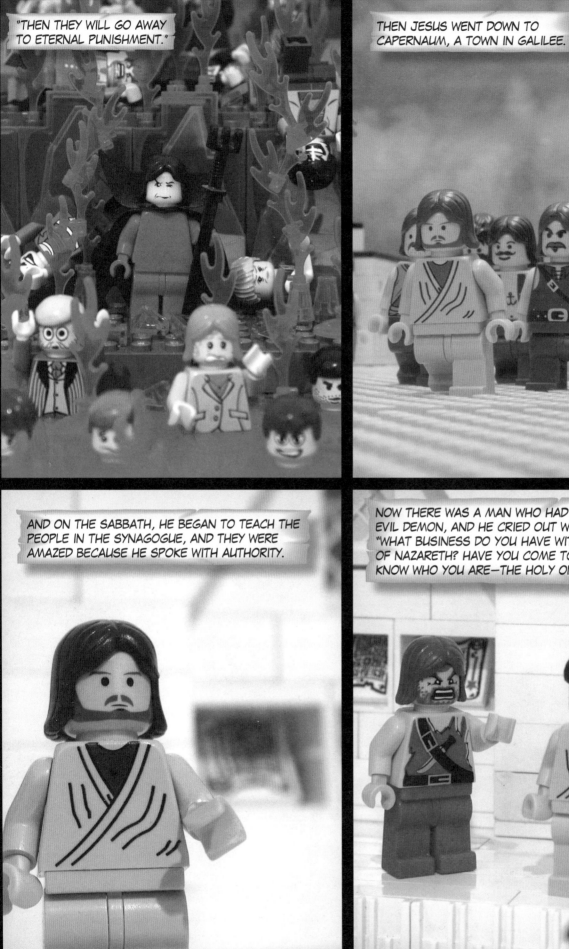

Mt 25:46 | Lk 4:31 | Lk 4:31-33 | Lk 4:33-34

JESUS REBUKED HIM, SAYING, "BE SILENT! COME OUT OF HIM!" THE DEMON THREW THE MAN DOWN IN THEIR MIDST AND CAME OUT OF HIM.

SO ALL THOSE WHO HAD ANY RELATIVES WITH VARIOUS DISEASES BROUGHT THEM TO JESUS. HE PLACED HIS HANDS ON THEM AND HEALED THEM. AND DEMONS CAME OUT OF MANY, CRYING OUT, "YOU ARE THE SON OF GOD!"

NEWS ABOUT HIM SPREAD ALL OVER SYRIA, AND LARGE CROWDS FOLLOWED JESUS FROM GALILEE, JERUSALEM, JUDEA, AND BEYOND THE JORDAN RIVER.

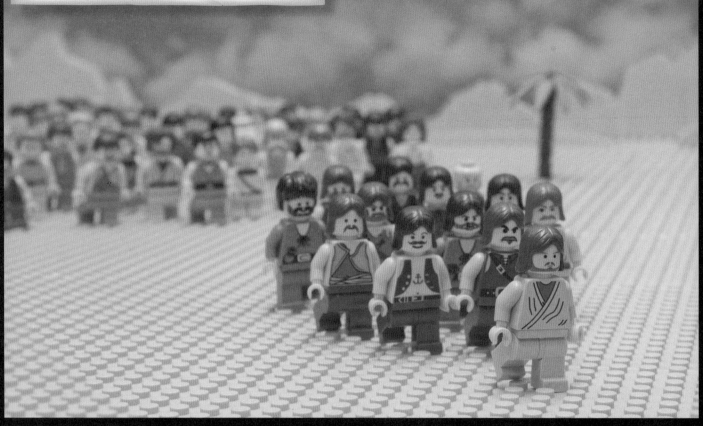

JESUS STOOD ON A LEVEL PLACE, AND A GREAT NUMBER OF PEOPLE CAME TO HEAR HIM. LIFTING HIS EYES, HE SAID TO THEM, "I SAY TO YOU WHO ARE LISTENING..."

Mt 4:24-25 | Lk 6:17, 6:20, 6:27

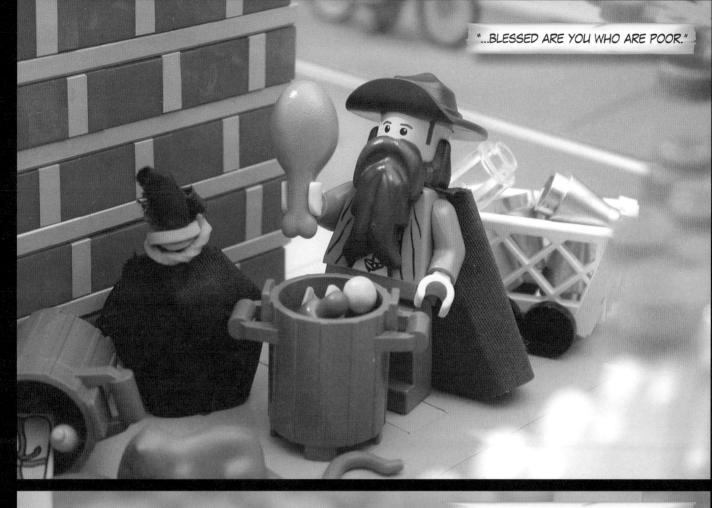

"...BLESSED ARE YOU WHO ARE POOR."

"FOR THE KINGDOM OF HEAVEN IS YOURS."

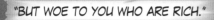

"BUT WOE TO YOU WHO ARE RICH."

"FOR YOU HAVE ALREADY RECEIVED YOUR COMFORT!"

"FOR IT IS EASIER FOR A CAMEL TO GO THROUGH THE EYE OF A NEEDLE..."

"...THAN FOR A RICH MAN TO ENTER THE KINGDOM OF GOD."

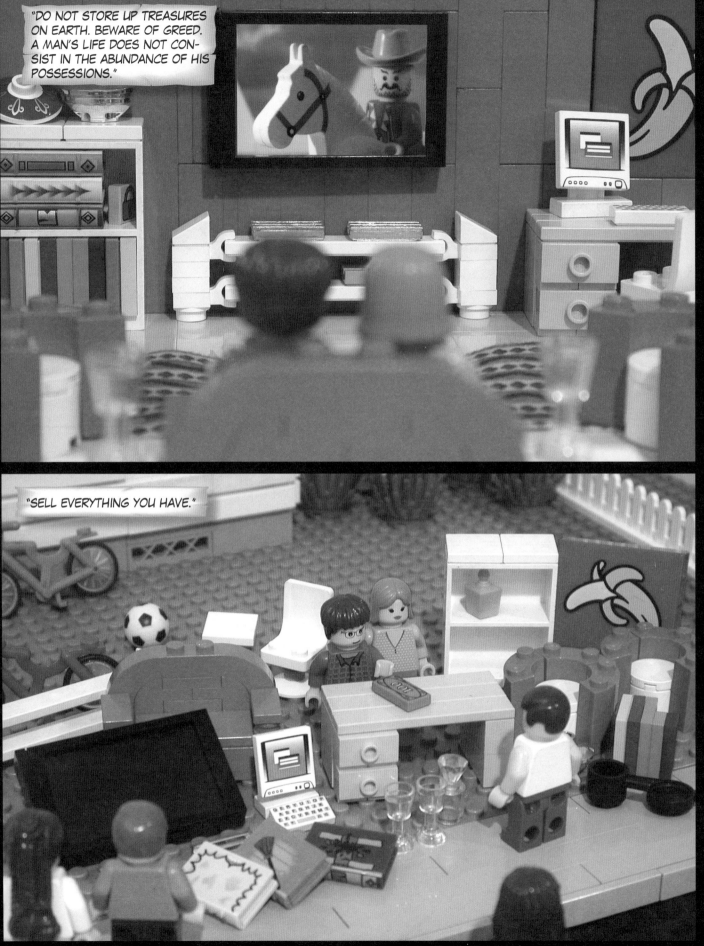

Mt 6:19; Lk 12:15 | Mk 6:21

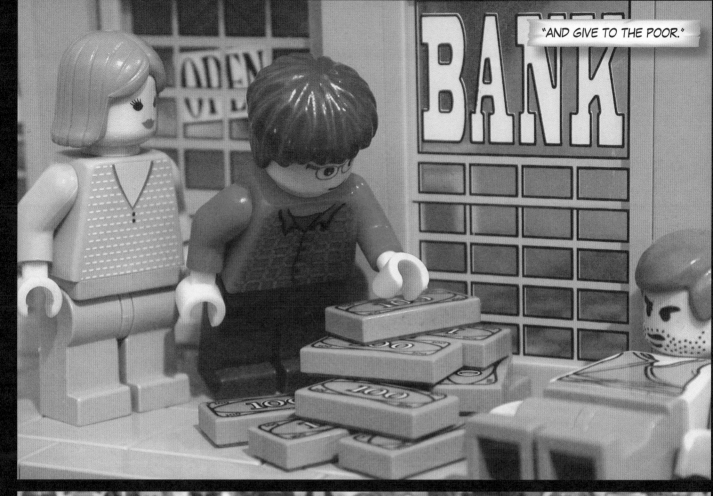

BUT JESUS SAID TO THEM, "WOE TO YOU, PHARISEES! YOU FOOLS! YOU BLIND FOOLS! YOU HYPOCRITES! HOW WILL YOU ESCAPE BEING CONDEMNED TO HELL?"

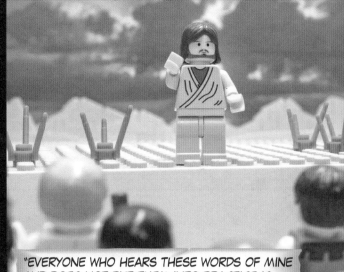

"EVERYONE WHO HEARS THESE WORDS OF MINE AND DOES NOT PUT THEM INTO PRACTICE IS LIKE A FOOLISH MAN!"

THEY SAILED TO THE REGION OF THE GERASENES, ACROSS THE LAKE FROM GALILEE. WHEN JESUS STEPPED ASHORE, HE WAS MET BY A MAN FROM THE TOWN WHO WAS POSSESSED BY DEMONS.

FOR A LONG TIME THIS MAN HAD WORN NO CLOTHES AND LIVED NOT IN A HOUSE BUT AMONG THE TOMBS.

HIS HANDS AND FEET HAD OFTEN BEEN BOUND WITH CHAINS AND SHACKLES.

Lk 16:15, 11:42, 11:40; Mt 23:13, 23:33 | Mt 7:26 | Lk 8:26-27 | Lk 8:27 | Mk 5:4

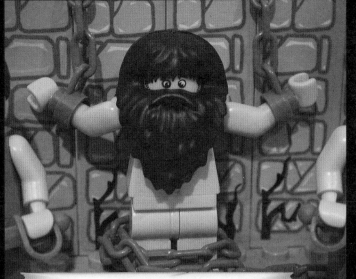

AND HE WOULD BE KEPT UNDER GUARD.

BUT HE HAD TORN THE CHAINS APART AND BROKEN THE SHACKLES IN PIECES. EACH NIGHT AND EVERY DAY AMONG THE TOMBS AND IN THE MOUNTAINS, HE WOULD CRY OUT AND CUT HIM-SELF WITH STONES.

WHEN HE SAW JESUS FROM A DISTANCE, HE RAN AND BOWED DOWN BEFORE HIM. THEN HE CRIED OUT WITH A LOUD VOICE, "WHAT DO YOU WANT WITH ME, JESUS, SON OF THE MOST HIGH GOD? I IMPLORE YOU—DO NOT TORTURE ME!"

"WHAT IS YOUR NAME?" JESUS ASKED HIM.

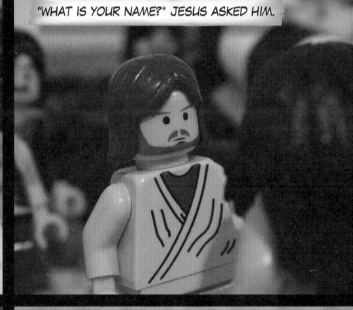

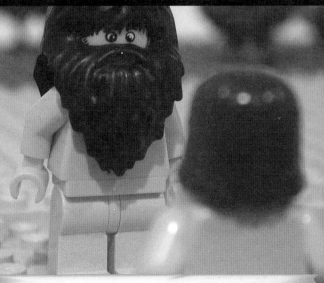

HE REPLIED, "MY NAME IS LEGION, FOR WE ARE MANY."

HE BEGGED JESUS REPEATEDLY NOT TO SEND THEM INTO THE ABYSS.

NOW THERE WAS A LARGE HERD OF PIGS FEEDING ON THE HILLSIDE NEARBY.

THE DEMONIC SPIRITS BEGGED HIM, "SEND US INTO THE PIGS. LET US ENTER THEM."

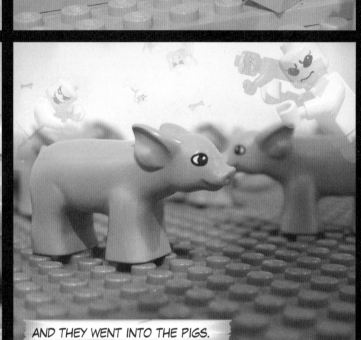

JESUS GAVE THEM PERMISSION, AND THE DEMONS CAME OUT OF THE MAN.

AND THEY WENT INTO THE PIGS.

THEN THE HERD OF ABOUT TWO THOUSAND PIGS RUSHED OVER THE CLIFF, INTO THE LAKE, AND DROWNED.

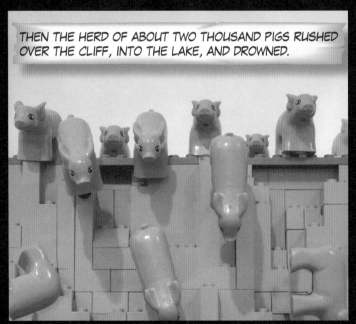

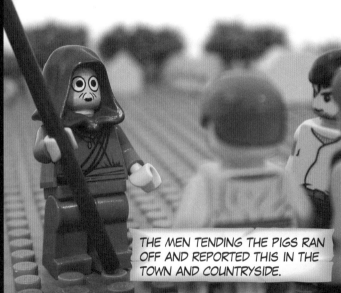

THE MEN TENDING THE PIGS RAN OFF AND REPORTED THIS IN THE TOWN AND COUNTRYSIDE.

Mk 5:11 | Mk 5:11 | Lk 8:32-33 | Lk 8:33 | Mk 5:13 | Mk 5:14

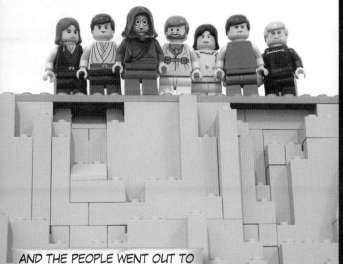

AND THE PEOPLE WENT OUT TO SEE WHAT HAD HAPPENED.

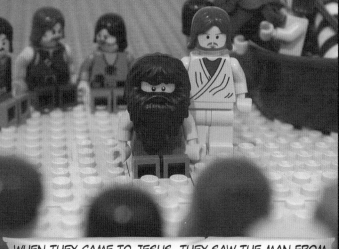

WHEN THEY CAME TO JESUS, THEY SAW THE MAN FROM WHOM THE DEMONS HAD GONE OUT SITTING AT THE FEET OF JESUS, CLOTHED AND IN HIS RIGHT MIND.

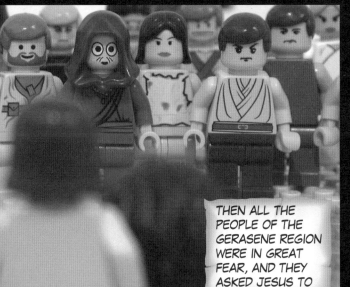

THEN ALL THE PEOPLE OF THE GERASENE REGION WERE IN GREAT FEAR, AND THEY ASKED JESUS TO LEAVE THEM.

WHEN JESUS HAD CROSSED AGAIN IN A BOAT TO THE OTHER SIDE, A LARGE CROWD GATHERED AROUND HIM.

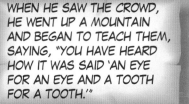

WHEN HE SAW THE CROWD, HE WENT UP A MOUNTAIN AND BEGAN TO TEACH THEM, SAYING, "YOU HAVE HEARD HOW IT WAS SAID 'AN EYE FOR AN EYE AND A TOOTH FOR A TOOTH.'"

"BUT I SAY TO YOU: IF SOMEONE STRIKES YOU ON THE RIGHT CHEEK..."

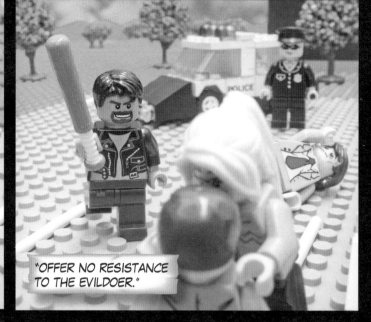

"...OFFER HIM THE OTHER AS WELL."

"OFFER NO RESISTANCE TO THE EVILDOER."

"DO NOT BE AFRAID OF THOSE WHO KILL THE BODY AND AFTER THAT CAN DO NO MORE HARM."

"I WILL TELL YOU WHO TO FEAR. FEAR THE ONE WHO, AFTER THE BODY IS KILLED, HAS THE AUTHORITY TO THROW YOU INTO HELL. YES, FEAR HIM!"

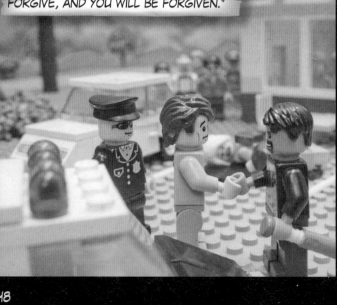

"DO NOT JUDGE AND DO NOT CONDEMN. FORGIVE, AND YOU WILL BE FORGIVEN."

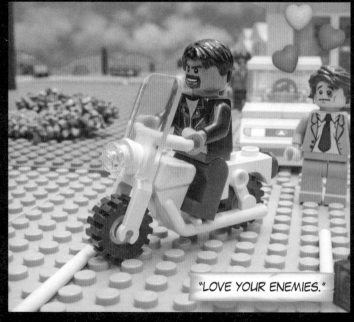

"LOVE YOUR ENEMIES."

Mt 5:39 | Mt 5:39 | Lk 12:4 | Lk 12:5 | Lk 6:37 | Lk 6:27

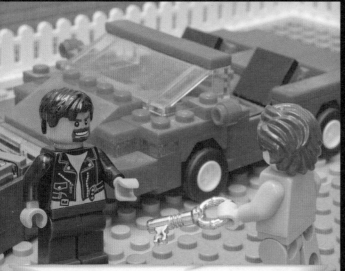

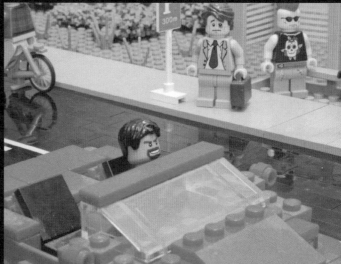

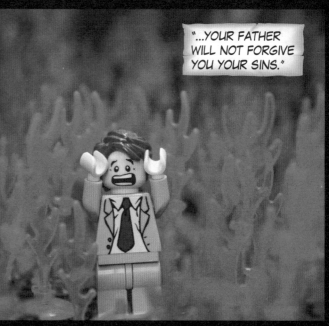

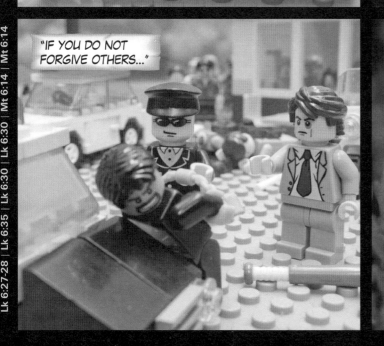

JESUS LEFT THERE AND CAME TO HIS HOMETOWN, AND HIS DISCIPLES FOLLOWED HIM.

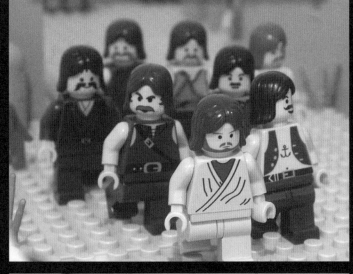

WHEN THE SABBATH CAME, HE BEGAN TO TEACH IN THE SYNAGOGUE: "DO NOT THINK THAT I HAVE COME TO BRING PEACE TO THE EARTH."

"I HAVE NOT COME TO BRING PEACE, BUT A SWORD."

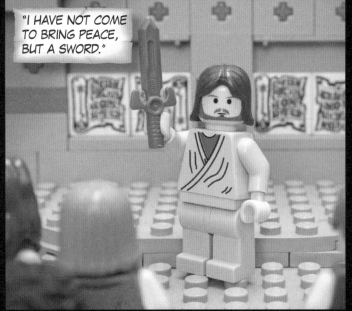

"I HAVE COME TO BRING FIRE TO THE EARTH."

"AND HOW I WISH IT WERE BLAZING ALREADY!"

"DO YOU THINK I HAVE COME TO BRING PEACE ON EARTH? NO, I TELL YOU, BUT HOSTILITY!"

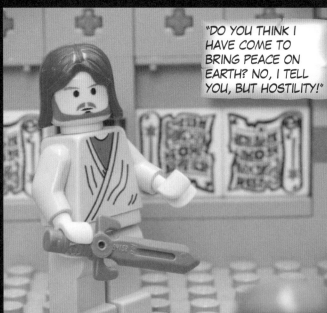

50

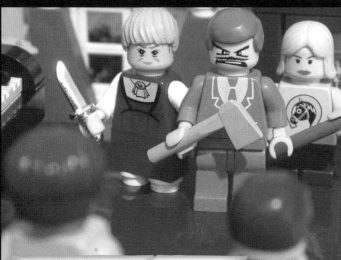

"FROM NOW ON THERE WILL BE FIVE IN ONE FAMILY DIVIDED AGAINST EACH OTHER, THREE AGAINST TWO..."

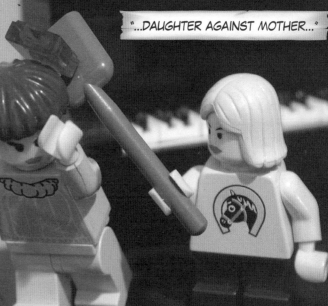

"...AND TWO AGAINST THREE."

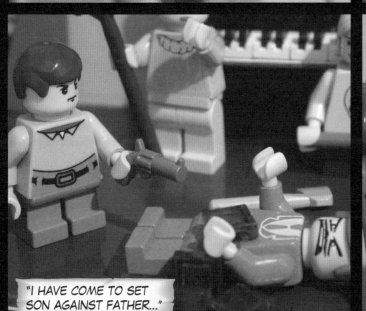

"I HAVE COME TO SET SON AGAINST FATHER..."

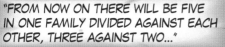

"...DAUGHTER AGAINST MOTHER..."

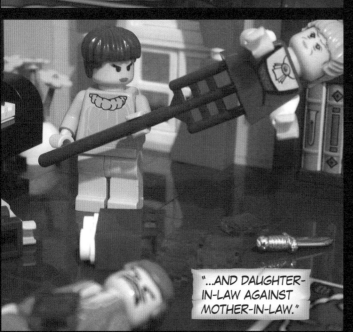

"...AND DAUGHTER-IN-LAW AGAINST MOTHER-IN-LAW."

"IF ANYONE DOES NOT HATE HIS FATHER, MOTHER, WIFE, CHILDREN, BROTHERS, SISTERS, AND YES, EVEN HIS OWN LIFE, HE CANNOT BE MY DISCIPLE."

MANY WHO HEARD HIM WERE ASTONISHED AND SAID, "WHERE DID HE GET THESE IDEAS?"

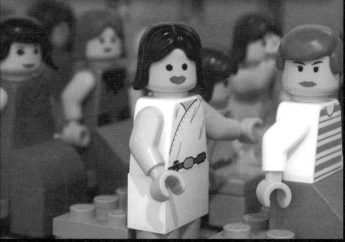

"ISN'T THIS THE CARPENTER? THE SON OF MARY AND BROTHER OF JAMES, JOSES, JUDAS, AND SIMON? AND AREN'T HIS SISTERS HERE WITH US?"

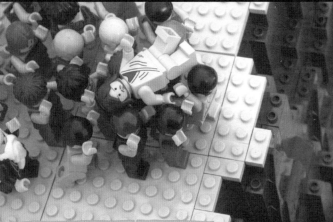

THE PEOPLE IN THE SYNAGOGUE WERE FURIOUS. THEY DROVE HIM OUT OF THE TOWN AND TOOK HIM TO THE EDGE OF THE HILL TO THROW HIM DOWN THE CLIFF.

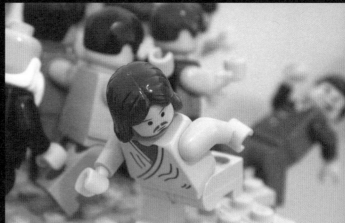

HE COULD DO NO MIRACLE THERE, BUT HE SLIPPED THROUGH THE CROWD AND WENT ON HIS WAY.

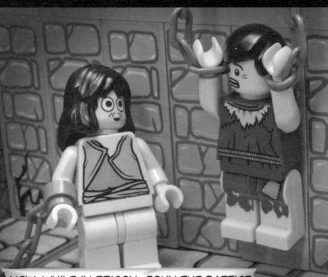

NOW, WHILE IN PRISON, JOHN THE BAPTIST HEARD ABOUT THE DEEDS OF THE CHRIST.

HERODIAS HELD A GRUDGE AGAINST JOHN AND WANTED TO KILL HIM, BUT SHE COULD NOT, BECAUSE HEROD FEARED JOHN, KNOWING HIM TO BE A JUST AND HOLY MAN, AND KEPT HIM SAFE.

Mk 6:2 | Mk 6:3 | Lk 4:28-29 | Mk 6:5; Lk 4:30 | Mt 11:2 | Mk 6:19-20

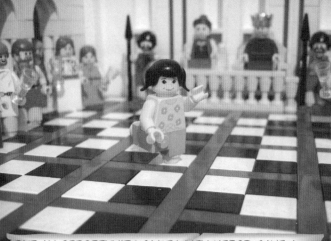

BUT AN OPPORTUNITY CAME WHEN HEROD GAVE A BANQUET ON HIS BIRTHDAY FOR HIS OFFICIALS, MILITARY COMMANDERS, AND LEADERS OF GALILEE, AND THE DAUGHTER OF HERODIAS DANCED BEFORE THEM.

SHE PLEASED HEROD AND HIS DINNER GUESTS, AND THE KING SAID TO THE GIRL, "ASK ME FOR WHATEVER YOU WANT, AND I WILL GIVE IT TO YOU, UP TO HALF MY KINGDOM."

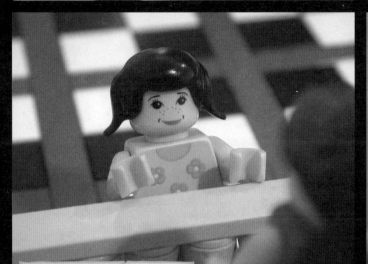

SO SHE WENT OUT AND SAID TO HER MOTHER, "WHAT SHOULD I ASK FOR?"

AND SHE SAID, "THE HEAD OF JOHN THE BAPTIZER."

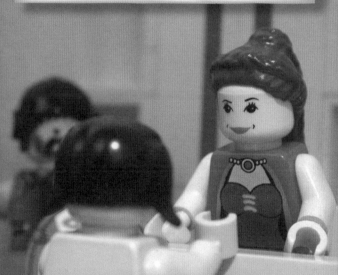

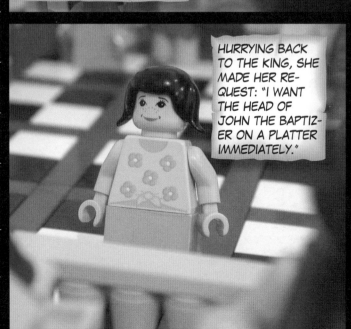

HURRYING BACK TO THE KING, SHE MADE HER REQUEST: "I WANT THE HEAD OF JOHN THE BAPTIZER ON A PLATTER IMMEDIATELY."

AND THE KING, THOUGH DEEPLY DISTRESSED, DID NOT WANT TO DENY HER REQUEST BECAUSE OF HIS OATH AND HIS DINNER GUESTS.

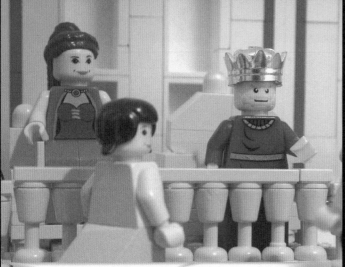

SO THE KING IMMEDIATELY SENT AN EXECUTIONER, COMMANDING HIM TO BRING JOHN'S HEAD.

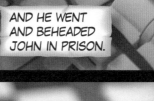

AND HE WENT AND BEHEADED JOHN IN PRISON.

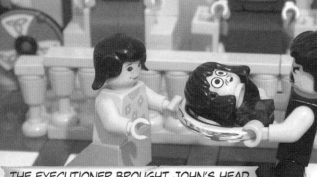

THE EXECUTIONER BROUGHT JOHN'S HEAD ON A PLATTER AND GAVE IT TO THE GIRL.

AND THE GIRL GAVE IT TO HER MOTHER.

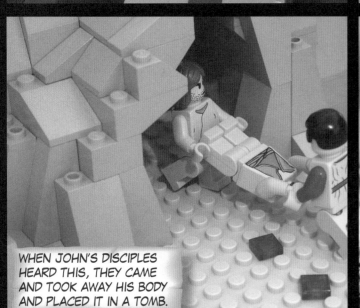

WHEN JOHN'S DISCIPLES HEARD THIS, THEY CAME AND TOOK AWAY HIS BODY AND PLACED IT IN A TOMB.

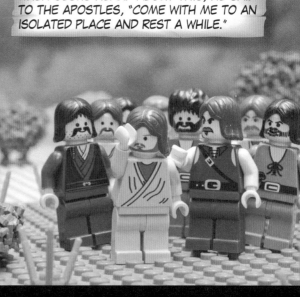

WHEN JESUS HEARD ABOUT THIS, HE SAID TO THE APOSTLES, "COME WITH ME TO AN ISOLATED PLACE AND REST A WHILE."

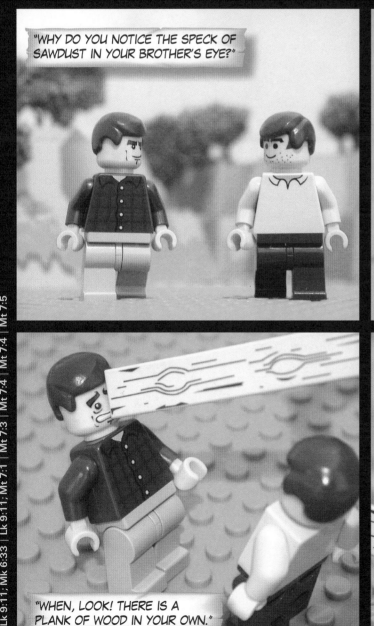

BUT THE CROWDS FOUND OUT AND FOLLOWED HIM, HURRYING FROM ALL THE TOWNS.

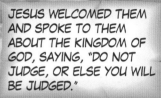

JESUS WELCOMED THEM AND SPOKE TO THEM ABOUT THE KINGDOM OF GOD, SAYING, "DO NOT JUDGE, OR ELSE YOU WILL BE JUDGED."

"WHY DO YOU NOTICE THE SPECK OF SAWDUST IN YOUR BROTHER'S EYE?"

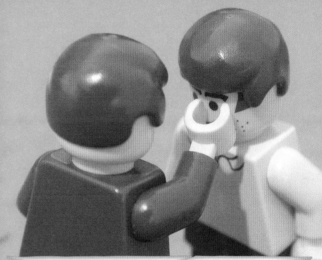

"HOW DARE YOU SAY TO YOUR BROTHER, 'LET ME TAKE THAT SPECK OF SAWDUST OUT OF YOUR EYE.'"

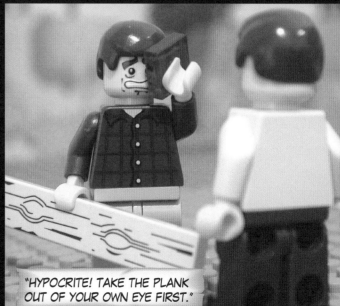

"WHEN, LOOK! THERE IS A PLANK OF WOOD IN YOUR OWN."

"HYPOCRITE! TAKE THE PLANK OUT OF YOUR OWN EYE FIRST."

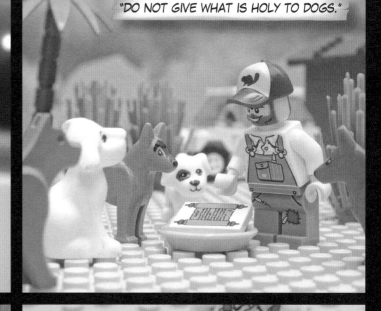

"THEN YOU WILL SEE CLEARLY ENOUGH TO TAKE THE SPECK OF SAWDUST OUT OF YOUR BROTHER'S EYE."

"DO NOT GIVE WHAT IS HOLY TO DOGS."

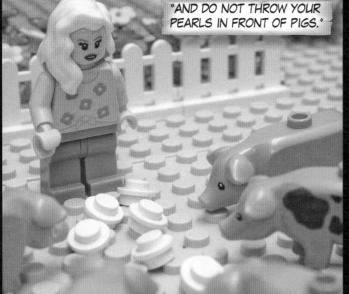

"AND DO NOT THROW YOUR PEARLS IN FRONT OF PIGS."

"FOR THEY MAY TRAMPLE THEM."

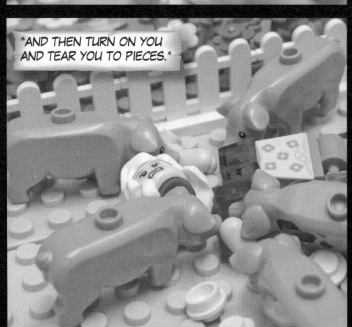

"AND THEN TURN ON YOU AND TEAR YOU TO PIECES."

THEN JESUS SAID, "WHEN YOU HOST A DINNER OR A BANQUET, DO NOT INVITE YOUR FRIENDS, YOUR BROTHERS OR SISTERS, YOUR RELATIVES, OR YOUR RICH NEIGHBORS."

Mt 7:5 | Mt 7:6 | Mt 7:6 | Mt 7:6 | Mt 7:6 | Lk 14:12

"WHEN YOU HOST A BANQUET, INVITE THE POOR, THE CRIPPLED, THE LAME, THE BLIND, AND YOU WILL BE BLESSED."

"WHENEVER YOU PRAY, DO NOT BE LIKE THE HYPOCRITES WHO LOVE TO PRAY WHILE STANDING IN CONGREGATIONS SO THAT PEOPLE CAN SEE THEM."

"WHEN YOU PRAY, GO INTO YOUR ROOM AND CLOSE THE DOOR."

"DO NOT BABBLE ON AND ON LIKE THE GENTILES DO."

JESUS SAID, "I TELL YOU THE TRUTH— IF YOU HAVE FAITH AND DO NOT DOUBT, YOU CAN SAY TO THIS MOUNTAIN, 'GO, THROW YOURSELF INTO THE SEA!'"

"IF ANYONE SAYS TO THIS MOUNTAIN, 'GO, THROW YOURSELF INTO THE SEA,' AND DOES NOT DOUBT IN HIS HEART BUT BELIEVES THAT WHAT HE SAYS WILL HAPPEN..."

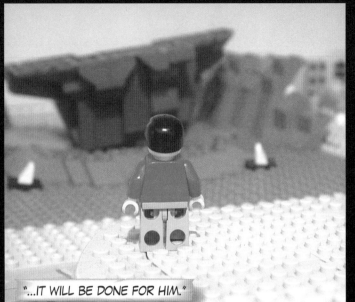

"...IT WILL BE DONE FOR HIM."

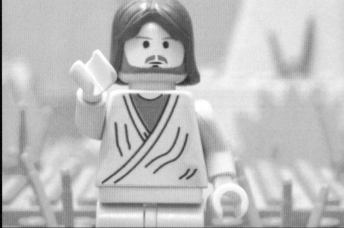

"I AM THE LIGHT OF THE WORLD. I TELL YOU THE TRUTH—WHATEVER YOU ASK THE FATHER FOR IN MY NAME HE WILL GIVE YOU."

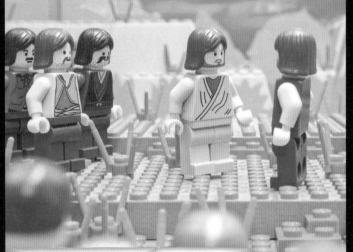

WHEN THE DAY WAS ENDING, JESUS SAID TO PHILIP, "WHERE CAN WE BUY BREAD SO THAT THESE PEOPLE MAY EAT?"

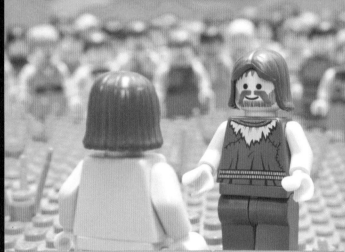

AND PHILIP SAID, "EVEN TWO HUNDRED SILVER COINS WORTH OF BREAD WOULD NOT BE ENOUGH TO GIVE THEM EACH A LITTLE!" (NOW ABOUT 5,000 MEN WERE THERE.)

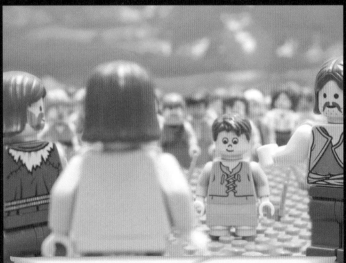

THEN PETER'S BROTHER ANDREW SAID TO JESUS, "THERE'S A BOY HERE WITH FIVE LOAVES AND TWO FISH, BUT WHAT USE IS THAT WITH ALL THESE PEOPLE?"

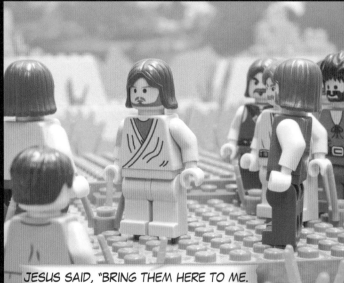

JESUS SAID, "BRING THEM HERE TO ME. MAKE THE PEOPLE SIT DOWN."

Mk 11:22 | Jn 8:12 | Lk 9:12-14 | Jn 6:5, 6:7 | Jn 6:8-9 | Mt 14:18; Jn 6:10

THEN JESUS TOOK THE FIVE LOAVES AND THE TWO FISH. LOOKING UP TO HEAVEN, HE GAVE THANKS.

THEN HE BROKE THEM AND GAVE THEM TO HIS DISCIPLES TO DISTRIBUTE AMONG THE PEOPLE, AND THEY ALL ATE UNTIL THEY WERE FULL.

THEN THEY GATHERED ALL THE LEFTOVER PIECES FROM THE FIVE LOAVES, AND THEY FILLED TWELVE BASKETS.

WHEN THE PEOPLE SAW THE SIGN HE PER-FORMED, JESUS KNEW THEY WERE GOING TO TAKE HIM BY FORCE AND MAKE HIM KING, SO HE DEPARTED TO THE MOUNTAINSIDE TO BE ALONE.

WHEN EVENING CAME, HIS DISCIPLES WENT DOWN TO THE LAKE, GOT INTO A BOAT, AND SET OFF ACROSS THE LAKE.

BY NOW IT WAS DARK, AND JESUS HAD NOT YET JOINED THEM. A STRONG WIND BLEW, AND THE WATERS GREW ROUGH.

Jn 6:14-15 | Jn 6:16-17 | Jn 6:17-18

THEN IN THE EARLY MORNING HOURS, JESUS CAME TOWARD THEM, WALKING ON THE LAKE.

WHEN THE DISCIPLES SAW HIM, THEY WERE TERRIFIED. "IT'S A GHOST!" THEY SAID, CRYING OUT IN FEAR.

BUT JESUS SAID TO THEM, "TAKE COURAGE! IT IS I. DON'T BE AFRAID."

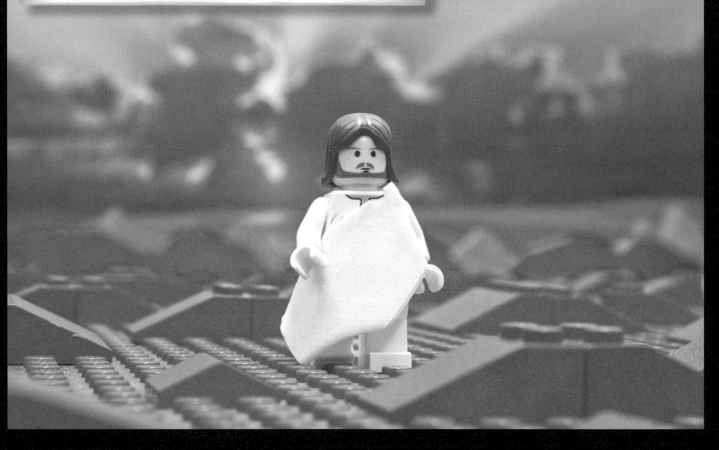

PETER SAID TO HIM, "LORD, IF IT'S YOU, ORDER
ME TO COME TO YOU, WALKING ON THE WATER."

JESUS SAID, "COME." AND PETER GOT OUT OF THE BOAT AND WALKED ON THE WATER.

BUT HE WAS AFRAID WHEN HE SAW THE WIND. HE BEGAN TO SINK AND CRIED OUT, "SAVE ME, LORD!"

JESUS REACHED OUT HIS HAND AND GRABBED HIM AND SAID, "YOU OF LITTLE FAITH, WHY DID YOU DOUBT?"

WHEN THEY CLIMBED INTO THE BOAT, THE WIND STOPPED. THOSE IN THE BOAT WORSHIPPED JESUS, SAYING, "TRULY, YOU ARE THE SON OF GOD."

Mt 14:31 | Mt 14:32-33

WHEN HE REACHED THE TERRITORY OF GADARENES ON THE OTHER SIDE, HE WAS MET BY TWO DEMONIACS COMING OUT OF THE TOMBS.

SUDDENLY THEY CRIED OUT, "WHAT DO YOU WANT WITH US, SON OF GOD? HAVE YOU COME HERE TO TORTURE US BEFORE THE TIME?"

SOME DISTANCE AWAY A LARGE HERD OF PIGS WAS FEEDING. THE DEMONS PLEADED WITH JESUS, "IF YOU DRIVE US OUT, SEND US INTO THE HERD OF PIGS!"

JESUS SAID, "GO." AND THEY CAME OUT AND MADE FOR THE PIGS.

THE WHOLE HERD CHARGED DOWN THE STEEP SLOPE INTO THE LAKE AND PER-ISHED IN THE WATERS.

THEN THE WHOLE TOWN SET OUT TO MEET JESUS, AND AS SOON AS THEY SAW HIM, THEY BEGGED HIM TO LEAVE THEIR REGION.

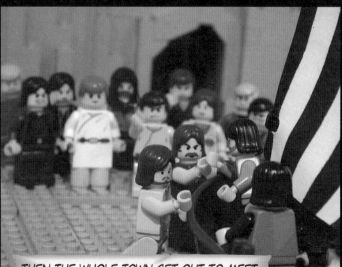

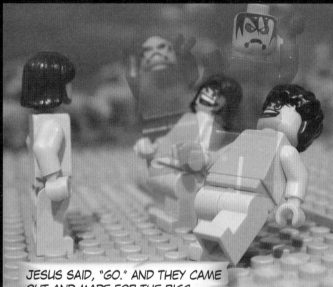
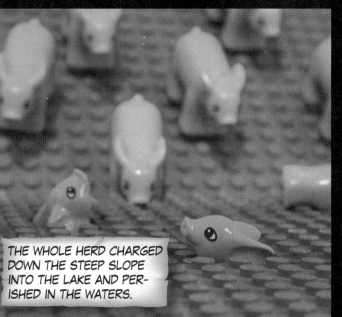

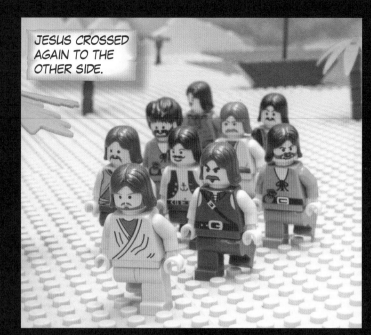

JESUS CROSSED AGAIN TO THE OTHER SIDE.

THEN JESUS BEGAN TO DENOUNCE THE TOWNS IN WHICH MANY OF HIS MIRACLES HAD BEEN PERFORMED, BECAUSE THEY DID NOT REPENT, SAYING, "WOE TO YOU, CHORAZIN! WOE TO YOU, BETHSAIDA!"

"CAPERNAUM, WILL YOU BE LIFTED TO HEAVEN?"

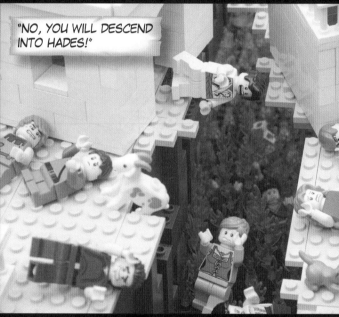

"NO, YOU WILL DESCEND INTO HADES!"

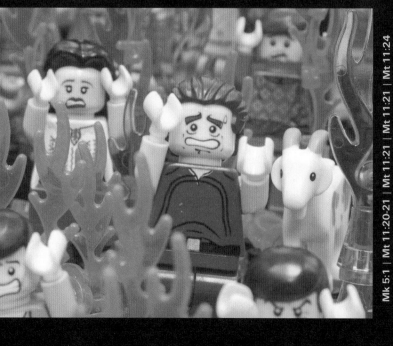

"I TELL YOU THAT IT WILL BE MORE BEARABLE FOR SODOM ON THE DAY OF JUDGMENT THAN FOR YOU."

NOW AN EXPERT IN THE LAW SAID TO JESUS, "TEACHER, WHAT MUST I DO TO INHERIT ETERNAL LIFE?"

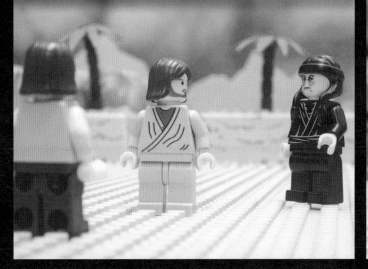

JESUS ASKED HIM, "WHAT DOES THE LAW OF MOSES SAY? HOW DO YOU INTERPRET IT?"

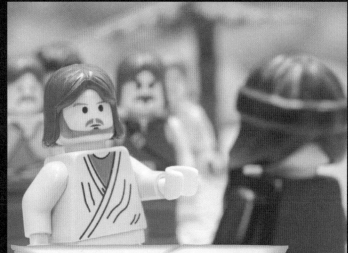

HE REPLIED, "LOVE GOD WITH ALL YOUR HEART, SOUL, AND STRENGTH. AND LOVE YOUR NEIGHBOR AS MUCH AS YOU LOVE YOURSELF."

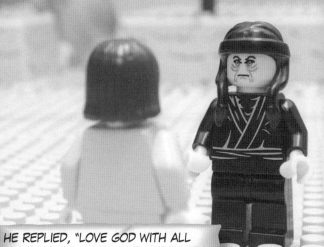

JESUS SAID TO HIM, "YOU ANSWER CORRECTLY. DO THIS AND YOU SHALL LIVE." BUT THE MAN ASKED, "AND WHO IS MY NEIGHBOR?"

JESUS ANSWERED, "A MAN WAS TRAVELING FROM JERUSALEM TO JERICHO WHEN HE WAS SET UPON BY ROBBERS."

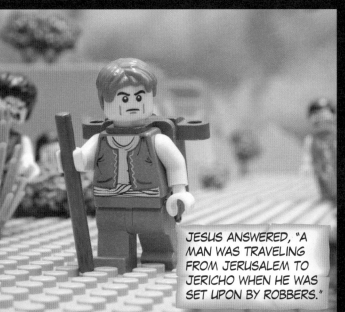

"THEY BEAT HIM, STRIPPED HIM, AND LEFT HIM HALF DEAD."

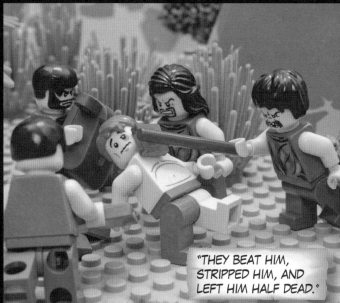

67

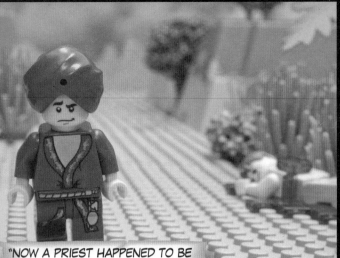

"NOW A PRIEST HAPPENED TO BE GOING ALONG THAT SAME ROAD, AND WHEN HE SAW THE MAN, HE PASSED BY ON THE OTHER SIDE."

"LIKEWISE, A LEVITE CAME TO THIS PLACE, AND HE ALSO PASSED HIM BY ON THE OTHER SIDE."

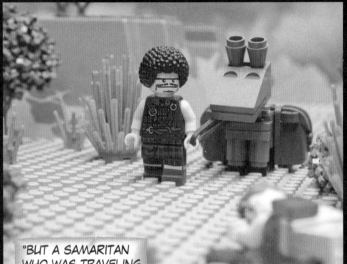

"BUT A SAMARITAN WHO WAS TRAVELING SAW THE MAN AND FELT COMPASSION."

"HE POURED OLIVE OIL AND WINE ON HIS WOUNDS AND BANDAGED THEM."

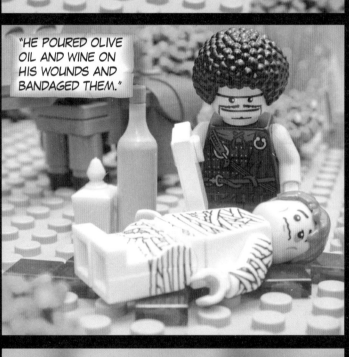

"HE BROUGHT HIM TO AN INN, GAVE THE INNKEEPER TWO SILVER COINS, AND SAID, "TAKE CARE OF HIM. WHATEVER ELSE YOU SPEND, I WILL PAY YOU BACK WHEN I RETURN.""

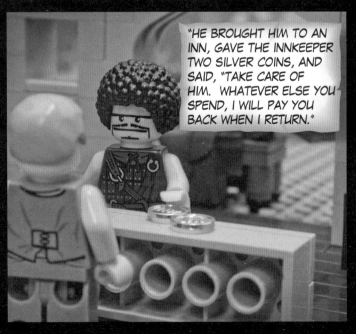

"WHICH OF THESE THREE DO YOU THINK WAS A NEIGHBOR TO THE MAN WHO WAS ATTACKED BY ROBBERS?"

THE EXPERT IN THE LAW REPLIED, "THE ONE WHO SHOWED MERCY TO HIM." AND JESUS SAID TO HIM, "GO AND DO THE SAME."

JESUS CALLED HIS TWELVE DISCIPLES AND GAVE THEM POWER OVER EVIL SPIRITS SO THEY COULD CAST THEM OUT.

JESUS SENT OUT THESE TWELVE AND INSTRUCTED THEM, SAYING, "DO NOT GO TO THE GENTILE REGIONS OR ENTER ANY SAMARITAN TOWNS."

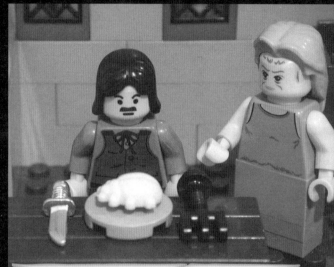

"WHEN YOU ENTER A TOWN AND ARE WELCOMED, EAT WHAT IS SET BEFORE YOU."

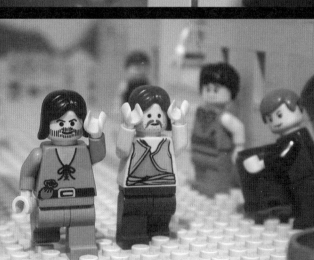

"PREACH THIS MESSAGE: 'THE KINGDOM OF HEAVEN DRAWS NEAR!' BUT WHENEVER YOU ENTER A TOWN AND ARE NOT WELCOMED..."

"...GO INTO ITS STREETS AND SAY, 'EVEN THE DUST OF YOUR TOWN THAT STICKS TO OUR FEET WE WIPE OFF AGAINST YOU!'"

"WHENEVER THEY PERSECUTE YOU IN ONE PLACE, FLEE TO ANOTHER.

"I TELL YOU THE TRUTH—IT WILL BE MORE BEARABLE FOR SODOM AND GOMORRAH ON THE DAY OF JUDGMENT THAN FOR THAT TOWN!"

"I TELL YOU THE TRUTH—YOU WILL NOT FINISH GOING THROUGH ALL THE TOWNS OF ISRAEL BEFORE THE SON OF MAN COMES."

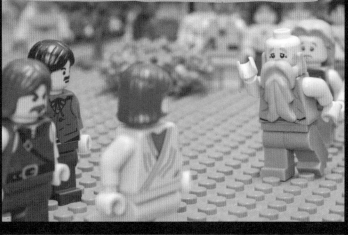

THE NEXT DAY, A MAN FROM THE CROWD CALLED OUT, "TEACHER, I BROUGHT MY SON WHO IS POSSESSED BY A SPIRIT. IT SEIZES HIM AND THROWS HIM TO THE GROUND. HE SCREAMS, CONVULSES, AND FOAMS AT THE MOUTH!"

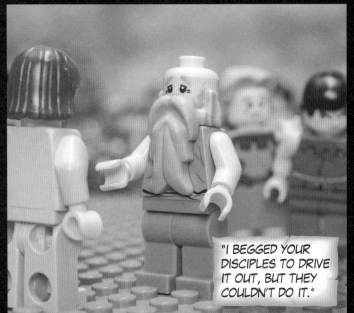

"I BEGGED YOUR DISCIPLES TO DRIVE IT OUT, BUT THEY COULDN'T DO IT."

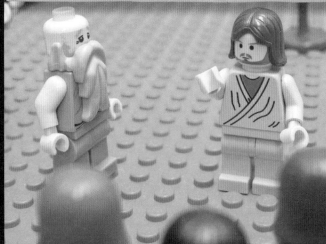

JESUS SAID TO THEM, "YOU UNBELIEVING AND PERVERSE GENERATION, HOW MUCH LONGER MUST I STAY WITH YOU AND PUT UP WITH YOU? BRING YOUR SON HERE."

Mt 10:23 | Mt 10:23 | Mt 10:23 | Lk 9:38-39; Mk 9:17 | Lk 9:39-40 | Lk 9:41

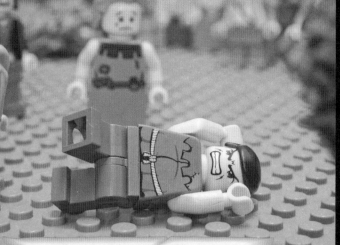

THEY BROUGHT HIM, AND WHEN IT SAW JESUS, THE DEMON THREW THE BOY INTO A CONVULSION, AND HE ROLLED AROUND ON THE GROUND, FOAMING AT THE MOUTH.

JESUS ASKED THE FATHER, "HOW LONG HAS THIS BEEN HAPPENING TO HIM?" THE FATHER REPLIED, "SINCE CHILDHOOD. IT HAS OFTEN THROWN HIM INTO FIRE OR WATER, TRYING TO KILL HIM."

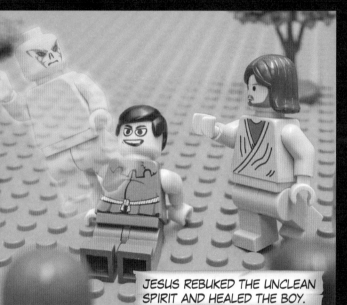

JESUS REBUKED THE UNCLEAN SPIRIT AND HEALED THE BOY.

THEN JESUS SAID TO THEM, "WHEN AN UNCLEAN SPIRIT GOES OUT OF A PERSON..."

"...IT PASSES THROUGH WATERLESS PLACES LOOKING FOR REST, BUT DOES NOT FIND IT."

"THEN IT SAYS, 'I WILL RETURN TO THE HOME I LEFT.'"

"WHEN IT COMES BACK, IT FINDS THE HOUSE EMPTY, SWEPT CLEAN, AND PUT IN ORDER."

"THEN IT GOES AND BRINGS WITH IT SEVEN OTHER SPIRITS MORE EVIL THAN ITSELF, AND THEY GO IN AND LIVE THERE."

"SO THE LAST STATE OF THAT PERSON IS WORSE THAN THE FIRST."

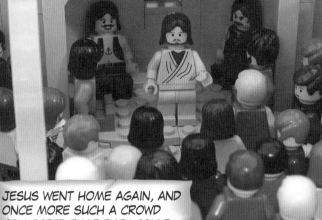

JESUS WENT HOME AGAIN, AND ONCE MORE SUCH A CROWD COLLECTED THAT THEY COULD NOT EVEN HAVE A MEAL.

HE WAS STILL SPEAKING TO THE CROWDS WHEN HIS MOTHER AND BROTHERS WERE STANDING OUTSIDE AND WERE ANXIOUS TO SPEAK WITH HIM.

BUT THEY COULD NOT GET TO HIM BECAUSE OF THE CROWD.

JESUS WAS TOLD, "YOUR MOTHER AND BROTHERS ARE STANDING OUTSIDE AND WANT TO SEE YOU."

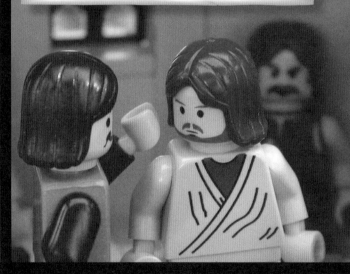

BUT JESUS REPLIED, "WHO IS MY MOTHER? AND WHO ARE MY BROTHERS? HERE ARE MY MOTHER AND BROTHERS: ANYONE WHO DOES THE WILL OF MY FATHER IN HEAVEN."

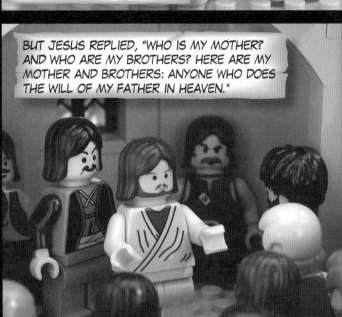

WHEN HIS FAMILY HEARD OF THIS, THEY WENT TO TAKE CUSTODY OF HIM. THEY SAID, "HE IS OUT OF HIS MIND!"

THAT SAME DAY, SUCH A LARGE CROWD GATHERED AROUND HIM THAT HE GOT INTO A BOAT ON THE LAKE WHILE THE WHOLE CROWD WAS ON THE SHORE.

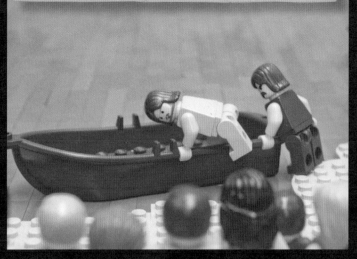

HE TAUGHT THEM MANY THINGS IN PARABLES, SAYING TO THEM, "THE KINGDOM OF HEAVEN IS LIKE A KING WHO DECIDED TO SETTLE HIS ACCOUNTS WITH HIS SLAVES."

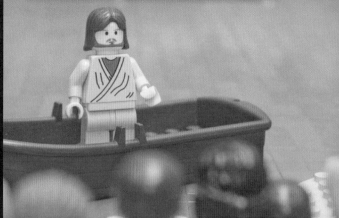

"WHEN HE BEGAN THE SETTLEMENT, THEY BROUGHT BEFORE THE KING A MAN WHO OWED HIM FIFTY MILLION SILVER PIECES."

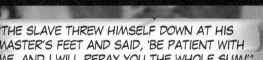

"SINCE HE WAS UNABLE TO REPAY, THE MASTER ORDERED THAT THE MAN BE SOLD, ALONG WITH HIS WIFE, CHILDREN, AND ALL HIS POSSESSIONS, SO THAT HIS DEBT COULD BE PAID."

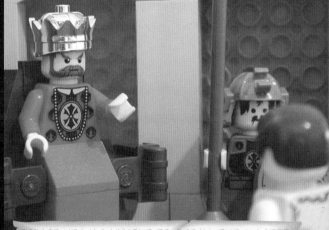

"THE SLAVE THREW HIMSELF DOWN AT HIS MASTER'S FEET AND SAID, 'BE PATIENT WITH ME, AND I WILL REPAY YOU THE WHOLE SUM!'"

"THE SLAVE'S MASTER, BEING MOVED BY COMPASSION, RELEASED HIM AND CANCELED HIS DEBT."

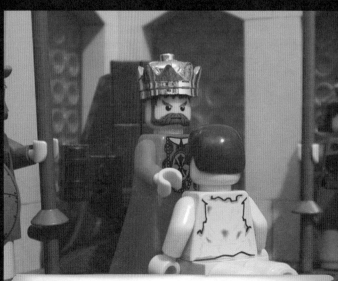

"AFTER LEAVING, THE SLAVE FOUND ONE OF HIS FELLOW SLAVES WHO OWED HIM ONE HUNDRED SILVER PIECES, GRABBED HIM BY THE THROAT, AND SAID, 'PAY WHAT YOU OWE ME!'"

"THE FELLOW SLAVE THREW HIMSELF DOWN AND PLEADED, 'HAVE PATIENCE WITH ME, AND I WILL REPAY YOU!'"

"BUT THE MAN WOULD NOT, AND HE HAD THE FELLOW SLAVE THROWN INTO PRISON UNTIL HE COULD PAY WHAT WAS OWED."

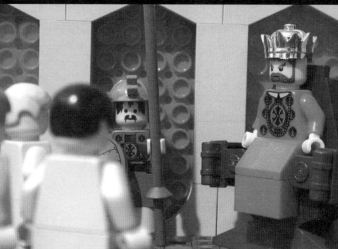

"HAVING SEEN WHAT HAPPENED, HIS FELLOW SLAVES WERE GREATLY DISTRESSED AND REPORTED TO THEIR MASTER ALL THAT HAD HAPPENED."

"THE MASTER THEN SENT FOR THE MAN AND SAID TO HIM, 'YOU WICKED SLAVE! I CANCELED YOUR DEBTS WHEN YOU PLEADED TO ME. SHOULD YOU NOT HAVE HAD PITY ON YOUR FELLOW SLAVE AS I HAD PITY ON YOU?'"

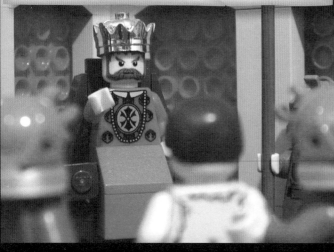

"AND IN HIS ANGER HIS MASTER SENT HIM TO THE TORTURERS UNTIL HE COULD REPAY ALL HE OWED. THAT IS HOW MY HEAVENLY FATHER WILL DEAL WITH YOU UNLESS YOU FORGIVE YOUR BROTHERS FROM YOUR HEART."

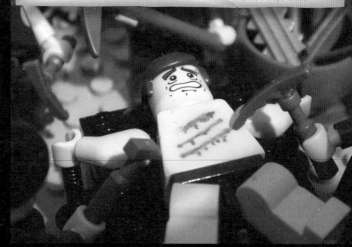

HE PRESENTED THEM WITH ANOTHER PARABLE.

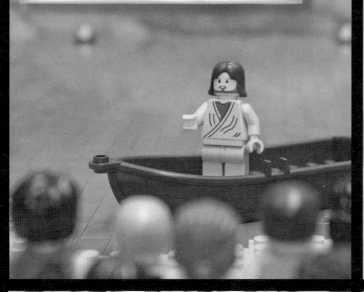

HE SAID, "THERE WAS ONCE A MAN OF NOBLE BIRTH WHO NEEDED TO TRAVEL TO A DISTANT LAND TO BECOME APPOINTED KING AND THEN RETURN."

"SO HE SUMMONED TEN OF HIS SLAVES AND GAVE THEM TEN POUNDS OF SILVER, TELLING THEM, 'DO BUSINESS WITH THIS MONEY UNTIL I COME BACK.'"

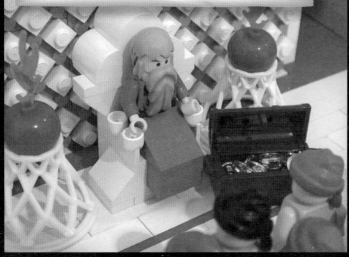

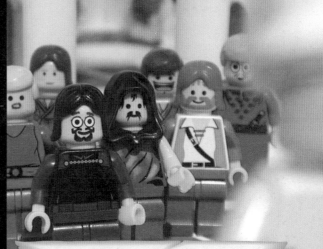

"BUT HIS SUBJECTS HATED HIM AND SENT A DELEGATION AFTER HIM WITH THIS MESSAGE: 'WE DON'T WANT THIS MAN TO BE OUR KING!'"

"NONETHELESS, HE WAS MADE KING."

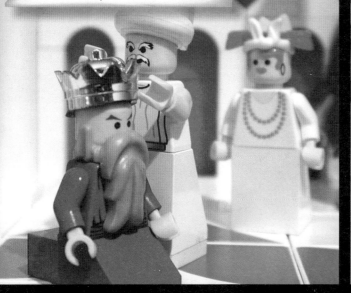

"AND ON HIS RETURN, HE SENT FOR THE SLAVES TO WHOM HE HAD GIVEN THE MONEY, TO FIND OUT WHAT PROFIT EACH HAD MADE."

"THE FIRST CAME IN AND SAID, 'SIR, YOUR ONE POUND OF SILVER HAS BROUGHT IN TEN.'"

"'WELL DONE, MY GOOD SLAVE,' THE KING REPLIED. 'SINCE YOU HAVE PROVEN YOURSELF TRUSTWORTHY IN A VERY SMALL MATTER, YOU SHALL RULE OVER TEN CITIES.'"

"THEN THE SECOND SAID, 'SIR, YOUR ONE POUND OF SILVER HAS MADE FIVE.'"

"TO THIS ONE HE SAID, 'AND YOU SHALL BE IN CHARGE OF FIVE CITIES.'"

"THEN ANOTHER SLAVE SAID, 'SIR, HERE IS YOUR POUND OF SILVER. I KEPT IT SAFELY HIDDEN AWAY, WRAPPED IN CLOTH BECAUSE I WAS AFRAID OF YOU. YOU ARE A HARSH MAN, TAKING WHAT ISN'T YOURS.'"

"'YOU WORTHLESS SLAVE!' SAID THE KING. 'YOU KNEW I WAS A HARSH MAN, TAKING WHAT IS NOT MINE. WHY DID YOU NOT PUT MY MONEY IN THE BANK SO THAT I COULD HAVE TAKEN IT OUT WITH INTEREST WHEN I RETURNED?'"

"AND TO THE ONES STANDING BY, THE KING SAID, 'TAKE THE POUND OF SILVER FROM HIM AND GIVE IT TO THE MAN WHO HAS TEN POUNDS.'"

"THEY SAID TO HIM, 'BUT SIR, HE ALREADY HAS TEN POUNDS!'"

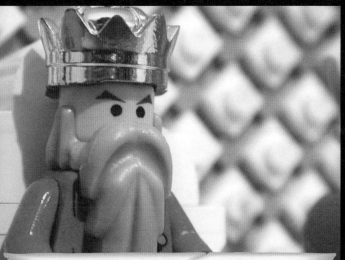

"THE KING REPLIED, 'I TELL YOU THAT EVERYONE WHO HAS WILL BE GIVEN MORE, BUT FROM THE ONE WHO HAS NOTHING, EVEN WHAT HE HAS WILL BE TAKEN AWAY.'"

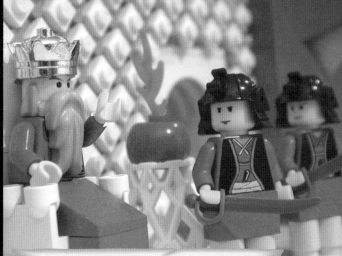

"'AS FOR MY ENEMIES WHO DID NOT WANT ME TO BE THEIR KING, BRING THEM HERE AND SLAUGHTER THEM IN FRONT OF ME.'"

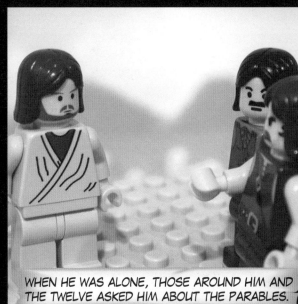

WHEN HE WAS ALONE, THOSE AROUND HIM AND THE TWELVE ASKED HIM ABOUT THE PARABLES.

HE SAID, "THE SECRET OF THE KINGDOM OF GOD IS GRANTED TO YOU."

"BUT TO THOSE ON THE OUTSIDE, EVERYTHING COMES IN PARABLES SO THAT THEY MAY LOOK AND LOOK BUT NEVER PERCEIVE, LISTEN AND LISTEN BUT NEVER UNDERSTAND."

"OTHERWISE THEY MIGHT CHANGE THEIR WAYS AND BE FORGIVEN."

THEN THEY CAME TO CAPERNAUM. THIS IS WHAT JESUS TAUGHT AT THE SYNAGOGUE IN CAPERNAUM: "I AM THE BREAD OF LIFE."

"YOUR FATHERS ATE MANNA IN THE DESERT AND THEY ARE DEAD. I AM THE LIVING BREAD. ANYONE WHO EATS THIS BREAD WILL LIVE FOREVER. AND THE BREAD THAT I SHALL GIVE IS MY FLESH."

THEN THE JEWS STARTED ARGUING AMONG THEMSELVES: "HOW CAN THIS MAN GIVE US HIS FLESH TO EAT?"

JESUS REPLIED TO THEM, "I TELL YOU THE TRUTH—IF YOU DO NOT EAT THE FLESH OF THE SON OF MAN OR DRINK HIS BLOOD, YOU HAVE NO LIFE IN YOU."

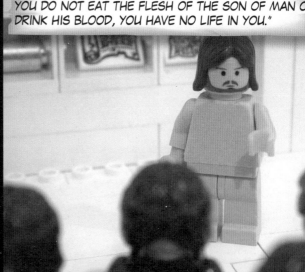

Mk 4:11-12 | Mk 4:12 | Mk 9:33; Jn 6:59 6:49; 6:51 6:48 | Jn 6:52 | Jn 6:53

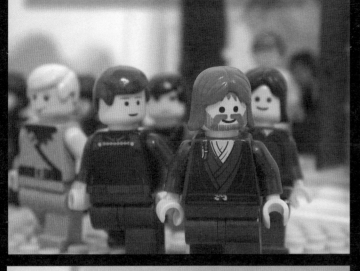

AFTER HEARING THIS, MANY OF HIS FOLLOWERS SAID, "THIS IS INTOLERABLE LANGUAGE. HOW COULD ANYONE ACCEPT IT?"

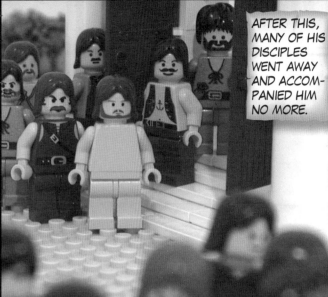

AFTER THIS, MANY OF HIS DISCIPLES WENT AWAY AND ACCOMPANIED HIM NO MORE.

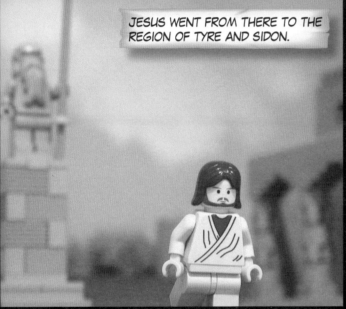

JESUS WENT FROM THERE TO THE REGION OF TYRE AND SIDON.

A CANAANITE WOMAN CAME TO HIM AND CRIED OUT, "LORD, SON OF DAVID, HAVE MERCY ON ME! MY DAUGHTER IS TERRIBLY DEMON POSSESSED!"

BUT JESUS DID NOT ANSWER HER A WORD.

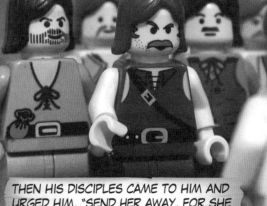

THEN HIS DISCIPLES CAME TO HIM AND URGED HIM, "SEND HER AWAY, FOR SHE KEEPS CRYING OUT AFTER US!"

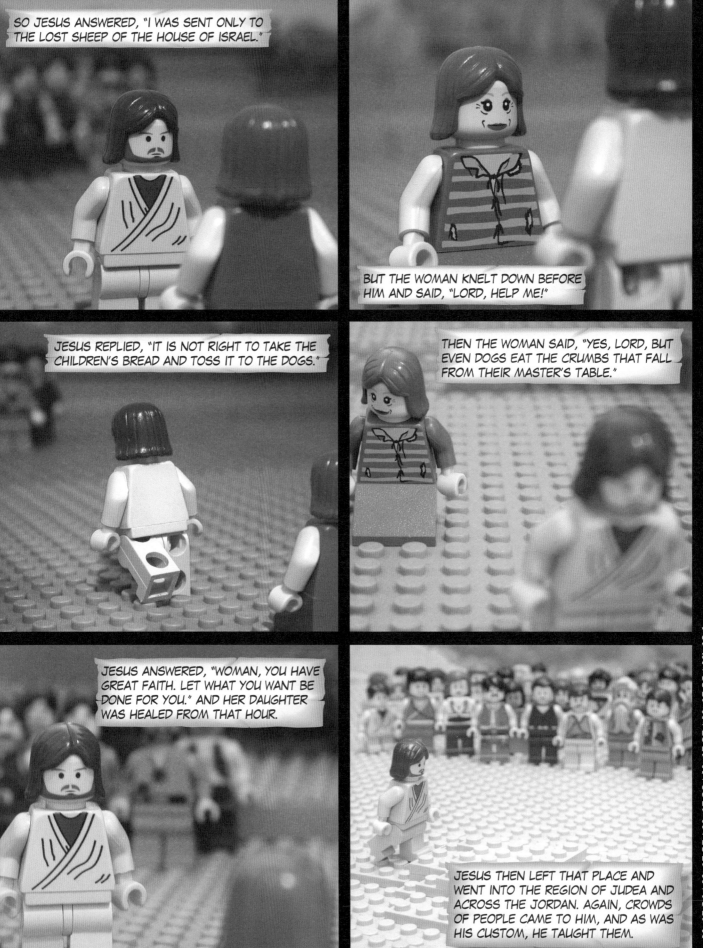

"DO NOT THINK THAT I HAVE COME TO ABOLISH THE LAW OF MOSES OR THE PROPHETS. I HAVE NOT COME TO ABOLISH THEM, BUT TO FULFILL THEM."

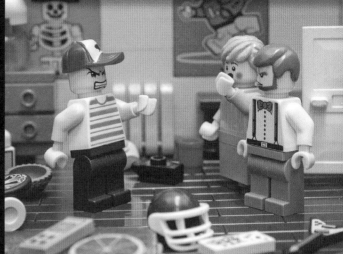

"MOSES SAID, 'HONOR YOUR FATHER AND MOTHER,' AND, 'ANYONE WHO INSULTS HIS FATHER OR MOTHER...'"

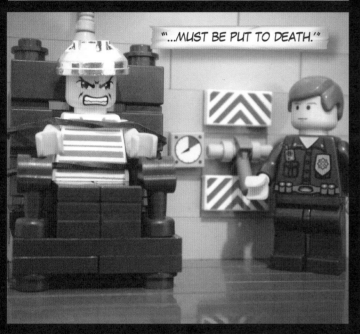

"...MUST BE PUT TO DEATH.'"

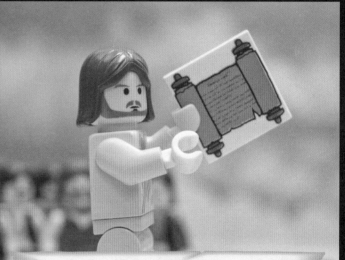

"I TELL YOU THE TRUTH—UNTIL HEAVEN AND EARTH PASS AWAY, NOT EVEN THE SMALLEST STROKE OF A LETTER WILL PASS AWAY FROM THE LAW OF MOSES."

"I SAY TO YOU THAT UNLESS YOUR RIGHTEOUSNESS SURPASSES THE EXPERTS IN THE LAW, YOU WILL CERTAINLY NOT ENTER THE KINGDOM OF HEAVEN."

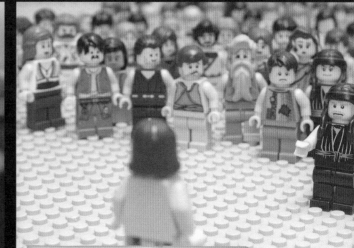

THEN SOME PHARISEES CHALLENGED JESUS, ASKING, "IS IT LAWFUL FOR A MAN TO DIVORCE HIS WIFE?"

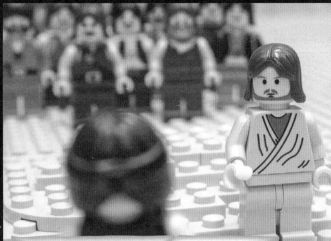

JESUS SAID, "THE TWO BECOME ONE FLESH. THEY ARE NO LONGER TWO, BUT ONE FLESH. SO WHAT GOD HAS JOINED TOGETHER, LET NO ONE SEPARATE."

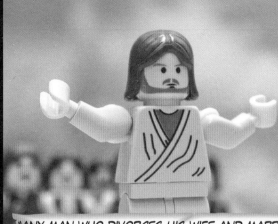

"ANY MAN WHO DIVORCES HIS WIFE AND MARRIES ANOTHER COMMITS ADULTERY. AND IF A WOMAN DIVORCES HER HUSBAND AND MARRIES ANOTHER, SHE COMMITS ADULTERY."

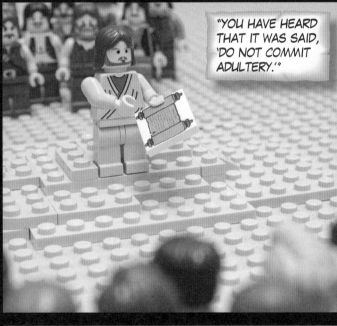

"YOU HAVE HEARD THAT IT WAS SAID, 'DO NOT COMMIT ADULTERY.'"

"I TELL YOU THAT ANYONE WHO LOOKS AT A WOMAN LUSTFULLY HAS ALREADY COMMITTED ADULTERY WITH HER IN HIS HEART."

THE DISCIPLES SAID TO HIM, "IF THIS IS THE SITUATION BETWEEN A MAN AND HIS WIFE, IT IS BETTER NOT TO MARRY."

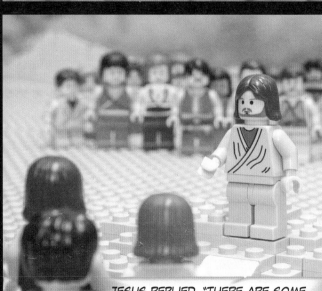

JESUS REPLIED, "THERE ARE SOME EUNUCHS WHO WERE BORN THAT WAY."

"AND THERE ARE SOME WHO MADE THEMSELVES EUNUCHS FOR THE SAKE OF THE KINGDOM OF HEAVEN."

"ANYONE WHO CAN ACCEPT THIS SHOULD ACCEPT IT."

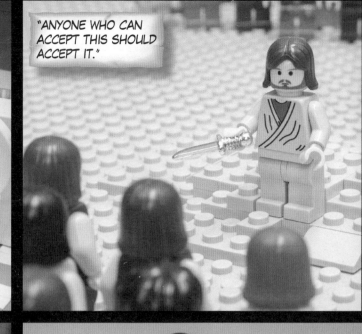

"IF YOUR RIGHT EYE SHOULD BE YOUR DOWNFALL..."

"...TEAR IT OUT AND THROW IT AWAY."

"FOR IT WILL DO YOU LESS HARM TO LOSE ONE PART OF YOURSELF THAN TO HAVE YOUR WHOLE BODY THROWN INTO HELL."

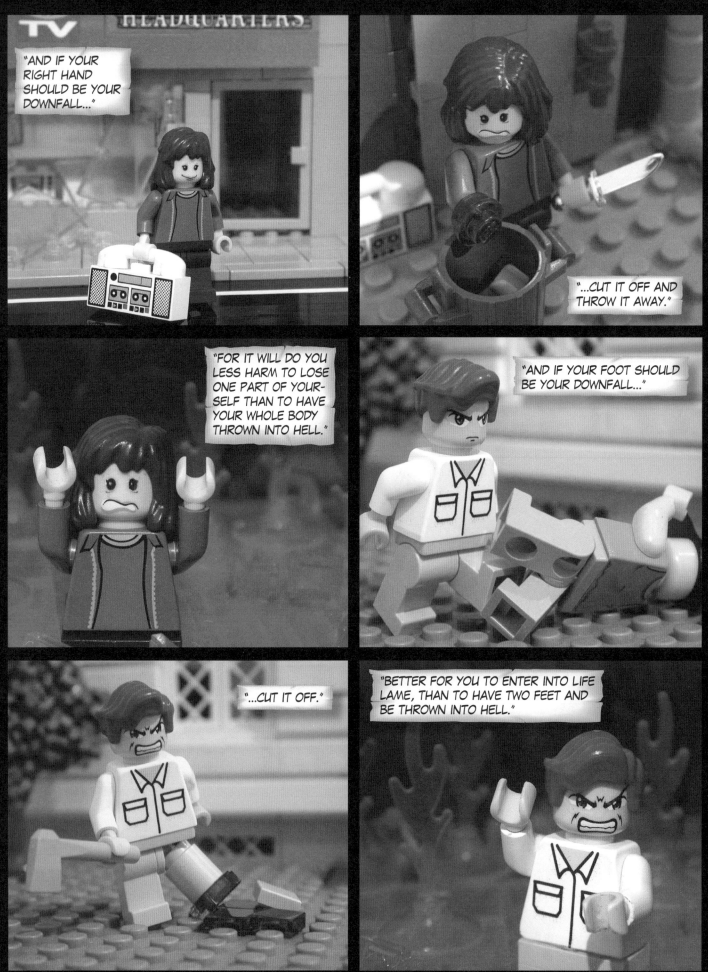

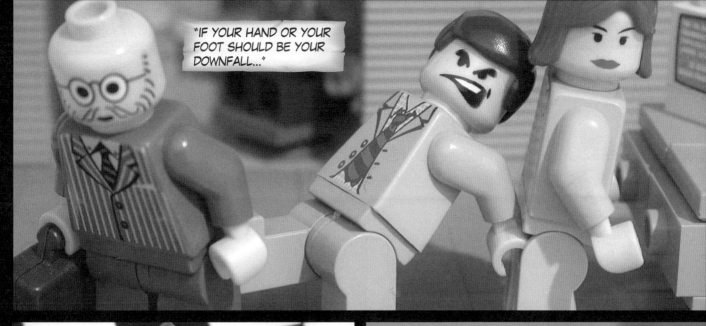

"IF YOUR HAND OR YOUR FOOT SHOULD BE YOUR DOWNFALL..."

"...CUT IT OFF AND THROW IT AWAY."

"BETTER FOR YOU TO ENTER INTO LIFE CRIPPLED OR LAME..."

"...THAN TO HAVE TWO HANDS OR TWO FEET AND BE THROWN INTO ETERNAL FIRE."

AS JESUS STARTED ON HIS WAY, A MAN RAN UP TO HIM AND FELL ON HIS KNEES BEFORE HIM, SAYING, "GOOD TEACHER, WHAT MUST I DO TO INHERIT ETERNAL LIFE?"

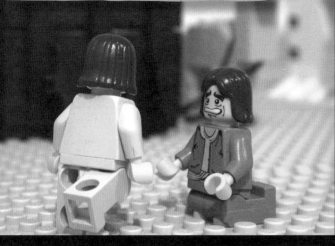

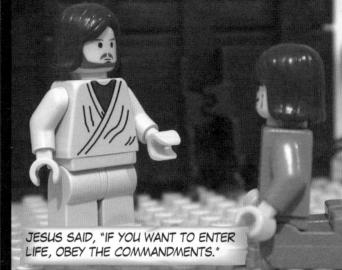

JESUS SAID, "IF YOU WANT TO ENTER LIFE, OBEY THE COMMANDMENTS."

"TEACHER," THE MAN SAID, "I HAVE OBEYED ALL THESE SINCE I WAS A BOY."

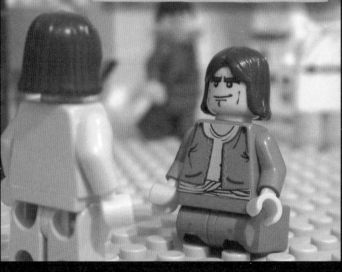

JESUS LOOKED AT HIM LOVINGLY AND SAID, "THERE IS ONE THING YOU LACK. GO AND SELL EVERYTHING YOU HAVE AND GIVE IT TO THE POOR. THEN COME AND FOLLOW ME."

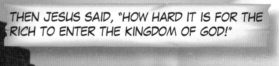

AT THIS, THE MAN WAS VERY SAD AND WENT AWAY GRIEVING, FOR HE HAD A GREAT MANY POSSESSIONS.

THEN JESUS SAID, "HOW HARD IT IS FOR THE RICH TO ENTER THE KINGDOM OF GOD!"

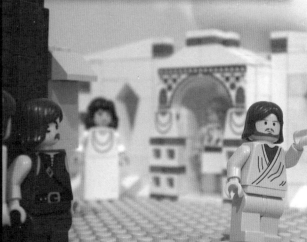

"IT IS EASIER FOR A CAMEL TO PASS THROUGH THE EYE OF A NEEDLE THAN FOR SOMEONE RICH TO ENTER THE KINGDOM OF HEAVEN."

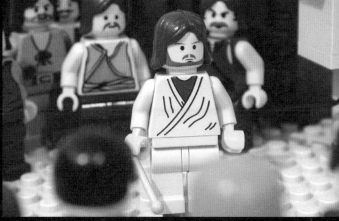

"SELL YOUR POSSESSIONS AND GIVE THE MONEY TO THE POOR. ANY ONE OF YOU WHO DOES NOT GIVE UP ALL HIS POSSESSIONS CANNOT BE MY DISCIPLE."

THEN JESUS SAID TO THEM, "THERE WAS A RICH MAN WHO DRESSED IN PURPLE AND FINE LINEN AND LIVED IN LUXURY EVERY DAY."

"NOW AT HIS GATE LAY A POOR MAN NAMED LAZARUS WHOSE BODY WAS COVERED WITH SORES, AND HE LONGED TO EAT THE SCRAPS THAT FELL OFF THE RICH MAN'S TABLE."

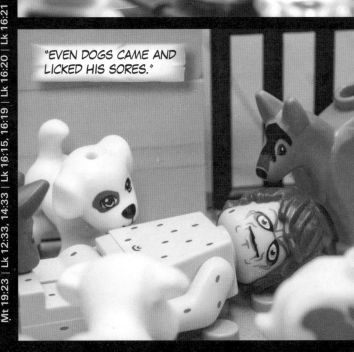

"EVEN DOGS CAME AND LICKED HIS SORES."

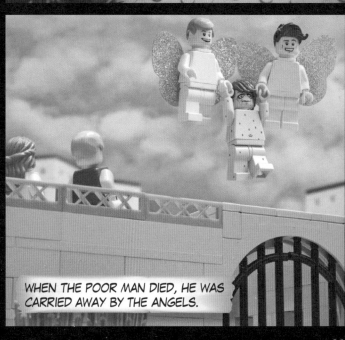

WHEN THE POOR MAN DIED, HE WAS CARRIED AWAY BY THE ANGELS.

89

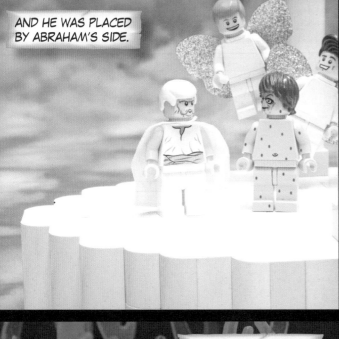

AND HE WAS PLACED BY ABRAHAM'S SIDE.

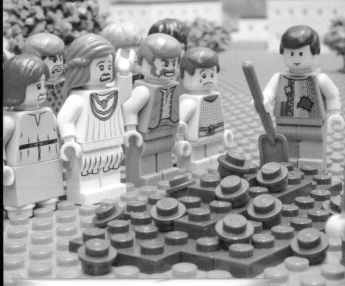

THE RICH MAN DIED, TOO, AND WAS BURIED.

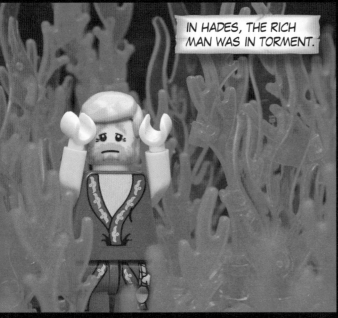

IN HADES, THE RICH MAN WAS IN TORMENT.

HE LOOKED UP AND FAR AWAY HE SAW ABRAHAM WITH LAZARUS BY HIS SIDE, AND HE CALLED OUT, "ABRAHAM, HAVE PITY ON ME! SEND LAZARUS TO DIP HIS FINGER IN WATER AND COOL MY TONGUE, FOR I AM IN AGONY IN THIS FIRE!"

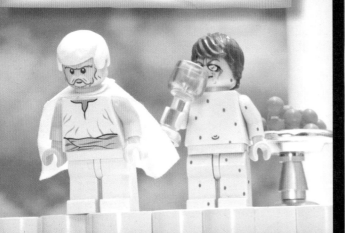

BUT ABRAHAM SAID TO HIM, "SON, REMEMBER THAT IN YOUR LIFETIME YOU GOT GOOD THINGS, WHILE LAZARUS GOT BAD THINGS, BUT NOW HE IS COMFORTED HERE AND YOU ARE IN AGONY."

"THERE IS A GREAT CHASM FIXED BETWEEN US NOW, AND NO ONE CAN CROSS FROM THERE TO HERE OR HERE TO THERE."

Lk 16:22 | Lk 16:22 | Lk 16:23 | Lk 16:23-24 | Lk 16:25 | Lk 16:26

THE RICH MAN SAID, "THEN I BEG OF YOU, WARN MY FIVE BROTHERS SO THAT THEY WILL NOT END UP IN THIS PLACE OF TORMENT!"

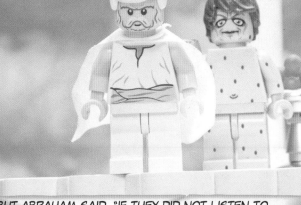

BUT ABRAHAM SAID, "IF THEY DID NOT LISTEN TO MOSES AND THE PROPHETS, THEY WILL NOT BE CONVINCED EVEN IF SOMEONE RISES FROM THE DEAD."

MARY AND MARTHA SENT WORD TO JESUS: "LORD, THE ONE YOU LOVE IS SICK."

NOW AT THIS TIME, THE BROTHER OF MARY AND MARTHA OF BETHANY, NAMED LAZARUS, WAS SICK.

WHEN JESUS HEARD THIS, HE SAID, "THIS SICKNESS WILL NOT END IN DEATH."

JESUS LOVED MARTHA AND HER SISTER AND LAZARUS. YET, WHEN HE HEARD THAT LAZARUS WAS SICK, HE STAYED WHERE HE WAS TWO MORE DAYS.

THEN HE SAID TO HIS DISCIPLES, "LET'S GO BACK TO JUDEA. LAZARUS IS DEAD."

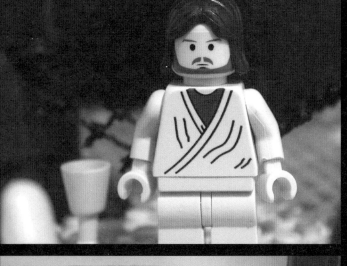

WHEN JESUS ARRIVED, LAZARUS HAD ALREADY BEEN IN THE TOMB FOR FOUR DAYS. MARTHA CAME OUT TO MEET HIM AND SAID, "LORD, IF YOU HAD BEEN HERE, MY BROTHER WOULD NOT HAVE DIED!"

AND WHEN MARY CAME TO WHERE JESUS WAS, SHE FELL AT HIS FEET AND SAID, "LORD, IF YOU HAD BEEN HERE, MY BROTHER WOULD NOT HAVE DIED!"

WHEN JESUS SAW MARY WEEPING AND THE WEEPING OF THE JEWS WHO HAD COME WITH HER, HE WAS DEEPLY TROUBLED AND DISTRESSED. JESUS WEPT.

SOME OF THE JEWS SAID, "COULDN'T HE HAVE DONE SOMETHING TO KEEP LAZARUS FROM DYING?"

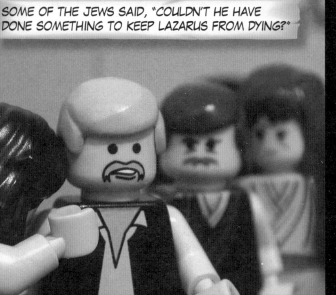

JESUS CAME TO THE TOMB. "TAKE AWAY THE STONE," HE SAID.

Jn 11:7, 11:14 | Jn 11:17, 11:20-21 | Jn 11:28, 11:32 | Jn 11:33, 11:35 | Jn 11:36-37 | Jn 11:38-39

MARTHA, THE SISTER OF THE DEAD MAN, SAID, "LORD, BY THIS TIME THERE IS A STENCH, FOR HE HAS BEEN THERE FOUR DAYS."

THEY TOOK AWAY THE STONE, AND JESUS CALLED IN A LOUD VOICE, "LAZARUS, COME OUT!"

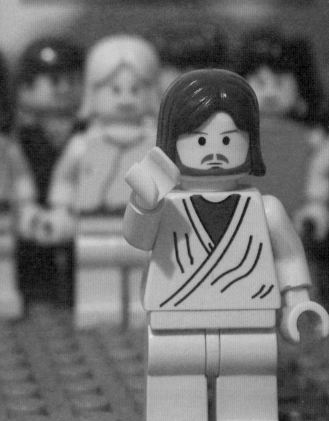

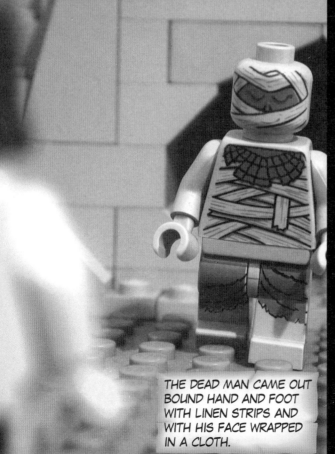

THE DEAD MAN CAME OUT BOUND HAND AND FOOT WITH LINEN STRIPS AND WITH HIS FACE WRAPPED IN A CLOTH.

JESUS SAID TO THEM, "UNWRAP HIM AND LET HIM GO."

SIX DAYS BEFORE THE PASSOVER, JESUS WAS IN BETHANY AT THE HOUSE OF SIMON THE LEPER. AND LAZARUS WAS AMONG THOSE PRESENT AT THE TABLE.

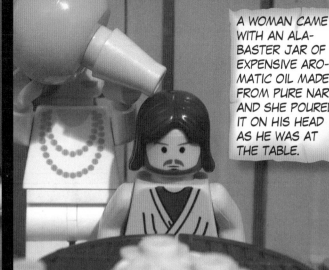

A WOMAN CAME WITH AN ALABASTER JAR OF EXPENSIVE AROMATIC OIL MADE FROM PURE NARD, AND SHE POURED IT ON HIS HEAD AS HE WAS AT THE TABLE.

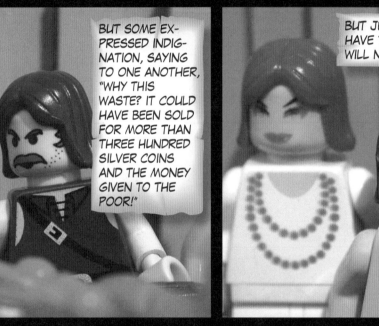

BUT SOME EXPRESSED INDIGNATION, SAYING TO ONE ANOTHER, "WHY THIS WASTE? IT COULD HAVE BEEN SOLD FOR MORE THAN THREE HUNDRED SILVER COINS AND THE MONEY GIVEN TO THE POOR!"

BUT JESUS SAID, "YOU WILL ALWAYS HAVE THE POOR WITH YOU, BUT YOU WILL NOT ALWAYS HAVE ME!"

THEN MARY TOOK A POUND OF EXPENSIVE AROMATIC OIL FROM PURE NARD AND ANOINTED THE FEET OF JESUS.

AND ONE OF THE DISCIPLES, JUDAS ISCARIOT, SAID, "WHY WASN'T THIS OIL SOLD FOR THREE HUNDRED SILVER COINS AND THE MONEY GIVEN TO THE POOR?"

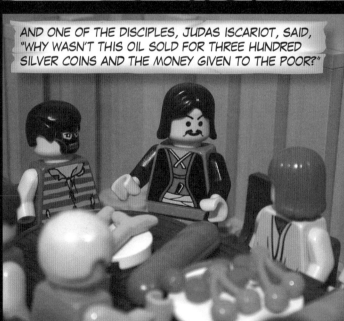

AND JESUS SAID, "YOU WILL ALWAYS HAVE THE POOR WITH YOU, BUT YOU WILL NOT ALWAYS HAVE ME!"

THE NEXT DAY, AS THEY WENT OUT FROM BETHANY, JESUS WAS HUNGRY. HE NOTICED A FIG TREE WITH LEAVES IN THE DISTANCE.

HE WENT TO SEE IF HE COULD FIND ANY FRUIT ON IT, BUT WHEN HE CAME TO IT HE FOUND NOTHING BUT LEAVES, FOR IT WAS NOT THE SEASON FOR FIGS.

JESUS SAID TO THE TREE, "MAY NO ONE EVER EAT FRUIT FROM YOU AGAIN." AND THE DISCIPLES HEARD THIS.

PETER SAID TO HIM, "RABBI, LOOK! THE FIG TREE YOU CURSED HAS WITHERED."

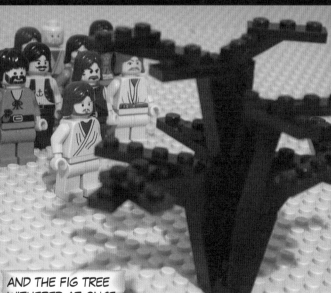

AND THE FIG TREE WITHERED AT ONCE.

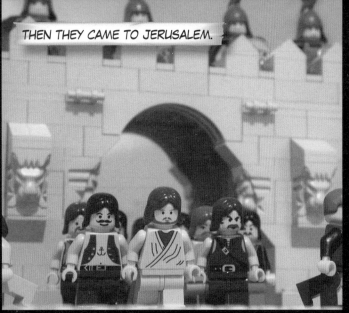

THEN THEY CAME TO JERUSALEM.

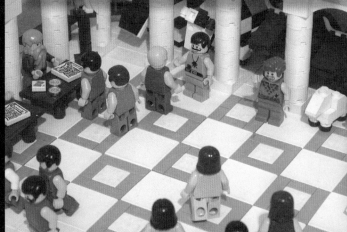

JESUS ENTERED THE TEMPLE COMPLEX, AND IN THE TEMPLE COURTS HE FOUND MEN SELLING CATTLE, SHEEP, AND DOVES, AND OTHERS SITTING AT TABLES-EXCHANGING MONEY.

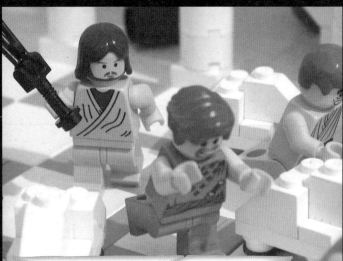

AND HE MADE A WHIP OF CORDS AND DROVE THEM ALL OUT OF THE TEMPLE COURTS, WITH THE SHEEP AND THE CATTLE.

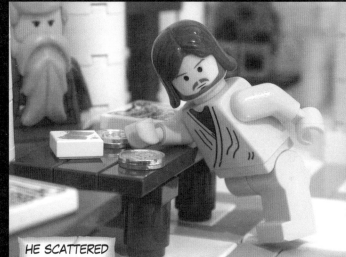

HE SCATTERED THE COINS OF THE MONEY CHANGERS.

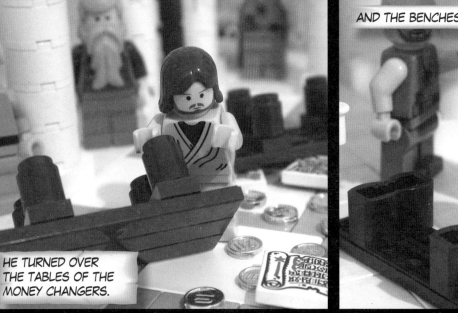

HE TURNED OVER THE TABLES OF THE MONEY CHANGERS.

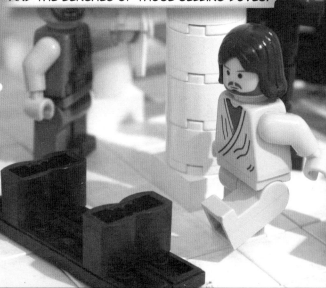

AND THE BENCHES OF THOSE SELLING DOVES.

Mk 11:15 | Mk 11:15; Jn 2:14 | Jn 2:15 | Mk 11:15 | Mk 11:15

HE WOULD NOT ALLOW ANYONE TO CARRY MERCHANDISE THROUGH THE TEMPLE COURTS.

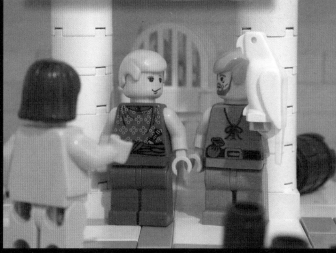

TO THOSE WHO SOLD THE DOVES HE SAID, "TAKE THESE THINGS AWAY! DO NOT MAKE MY FATHER'S HOUSE A MARKETPLACE!"

THE CHIEF PRIESTS AND THE SCRIBES HEARD THIS, AND THEY SOUGHT SOME WAY TO KILL JESUS, FOR THEY FEARED HIM.

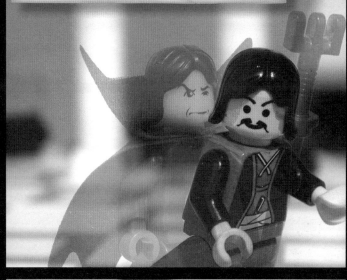

THEN SATAN ENTERED JUDAS, THE ONE CALLED ISCARIOT, WHO WAS ONE OF THE TWELVE.

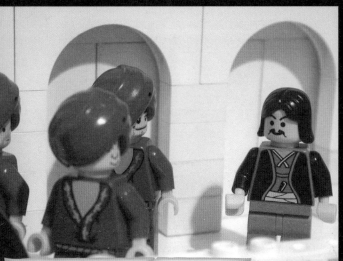

AND JUDAS WENT TO THE CHIEF PRIESTS AND SAID, "WHAT ARE YOU WILLING TO GIVE ME IF I HAND HIM OVER TO YOU?"

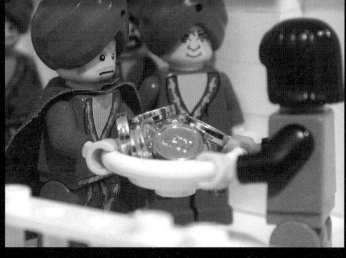

THEY PAID HIM THIRTY SILVER PIECES, AND FROM THEN ONWARDS HE BEGAN LOOKING FOR AN OPPORTUNITY TO HAND HIM OVER.

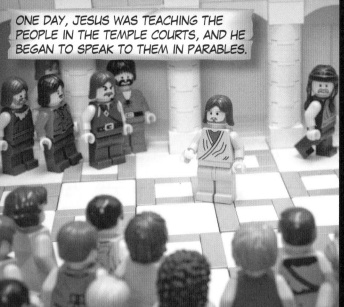

ONE DAY, JESUS WAS TEACHING THE PEOPLE IN THE TEMPLE COURTS, AND HE BEGAN TO SPEAK TO THEM IN PARABLES.

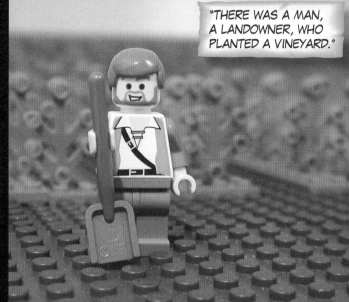

"THERE WAS A MAN, A LANDOWNER, WHO PLANTED A VINEYARD."

"HE LEASED IT TO TENANTS AND THEN WENT ABROAD."

"AT THE HARVEST TIME, HE SENT A SLAVE TO COLLECT HIS SHARE OF THE PRODUCE FROM THE VINEYARDS FROM THE TENANTS."

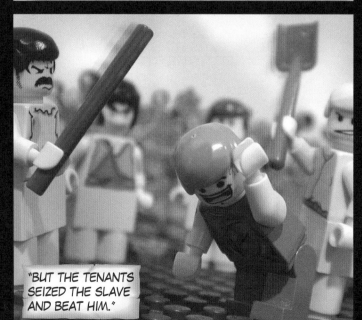

"BUT THE TENANTS SEIZED THE SLAVE AND BEAT HIM."

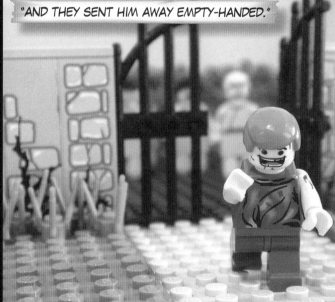

"AND THEY SENT HIM AWAY EMPTY-HANDED."

Lk 20:1 | Mk 12:1 | Mt 21:33 | Mk 12:1 | Mk 12:3 | Mk 12:2 | Mk 12:3 | Mk 12:3

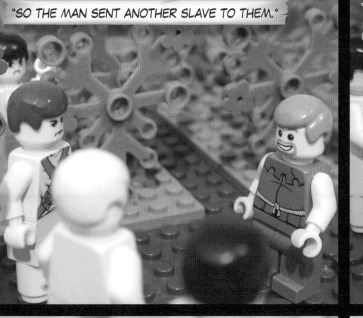

"SO THE MAN SENT ANOTHER SLAVE TO THEM."

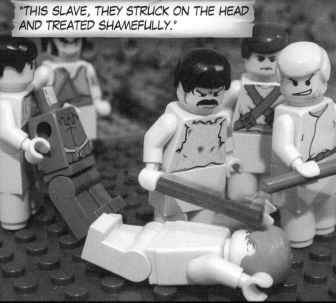

"THIS SLAVE, THEY STRUCK ON THE HEAD AND TREATED SHAMEFULLY."

"THE MAN SENT YET ANOTHER SLAVE."

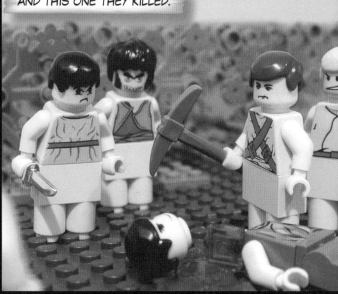

"AND THIS ONE THEY KILLED."

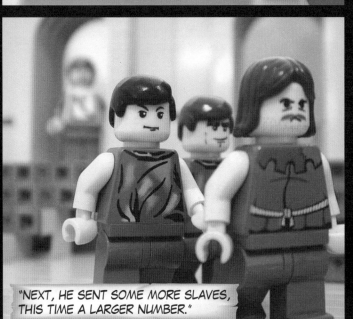

"NEXT, HE SENT SOME MORE SLAVES, THIS TIME A LARGER NUMBER."

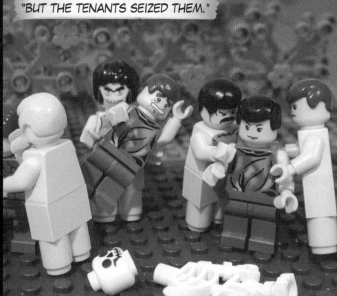

"BUT THE TENANTS SEIZED THEM."

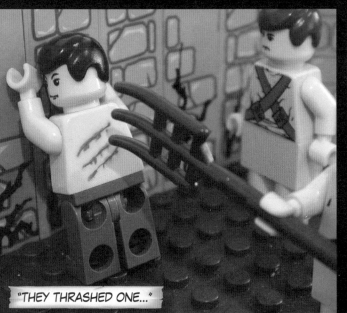

"THEY THRASHED ONE..."

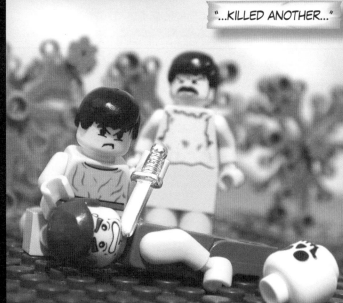

"...KILLED ANOTHER..."

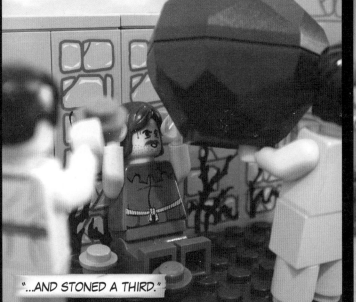

"...AND STONED A THIRD."

"MANY OTHERS WERE SENT."

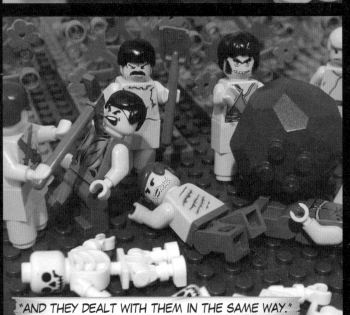

"AND THEY DEALT WITH THEM IN THE SAME WAY."

"THE MAN STILL HAD LEFT HIS BELOVED SON."

"FINALLY HE SENT HIS SON TO THEM, THINKING, 'THEY WILL RESPECT MY SON.'"

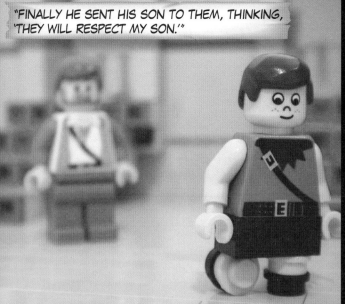

"BUT WHEN THE TENANTS SAW HIS SON, THEY SAID TO ONE ANOTHER, 'THIS IS THE HEIR. COME, LET'S KILL HIM AND TAKE HIS INHERITANCE.'"

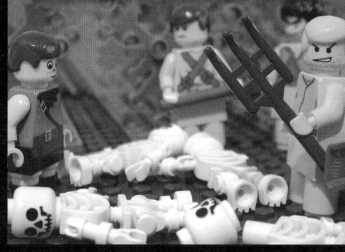

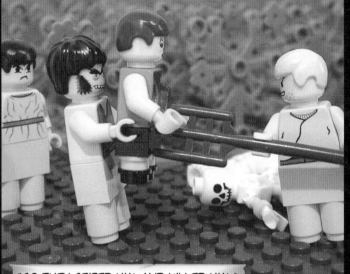

"SO THEY SEIZED HIM AND KILLED HIM."

"AND THEY THREW HIS BODY OUT OF THE VINEYARD."

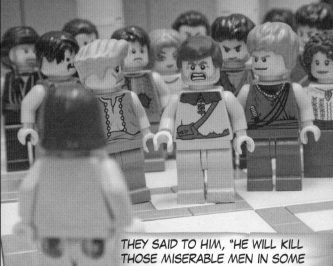

"NOW WHEN THE OWNER OF THE VINEYARD COMES, WHAT WILL HE DO TO THOSE TENANTS?"

THEY SAID TO HIM, "HE WILL KILL THOSE MISERABLE MEN IN SOME HORRIBLE WAY. THEN HE WILL LEASE THE VINEYARD TO OTHER TENANTS."

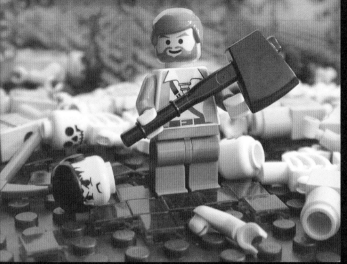

JESUS SAID TO THEM, "HE WILL COME AND DESTROY THE TENANTS."

"AND THEN ASSIGN THE VINEYARD TO OTHERS."

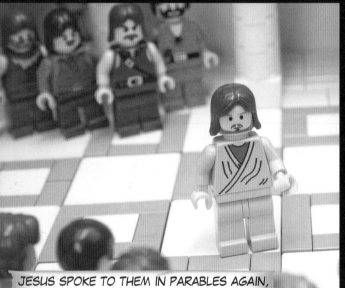

JESUS SPOKE TO THEM IN PARABLES AGAIN, SAYING, "LISTEN TO ANOTHER PARABLE."

"THE KINGDOM OF HEAVEN MAY BE COMPARED TO A KING WHO GAVE A WEDDING BANQUET FOR HIS SON."

"HE INVITED A LARGE NUMBER OF PEOPLE AND COMMANDED HIS SLAVE TO SAY, 'LOOK, THE BANQUET IS READY. MY OXEN AND FATTENED CATTLE HAVE BEEN SLAUGHTERED. EVERYTHING IS PREPARED. COME TO THE WEDDING.'"

Mt 21:42; Mk 12:9 | Mk 12:9 | Mt 22:1, 21:33 | Lk 14:16-17; Mt 22:3-4

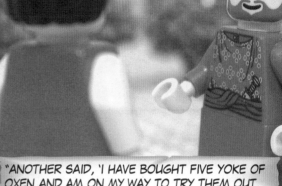

"BUT EACH ONE BEGAN TO MAKE EXCUSES. THE FIRST SAID, 'I HAVE BOUGHT A PIECE OF LAND AND MUST GO SEE IT. PLEASE ACCEPT MY APOLOGIES.'"

"ANOTHER SAID, 'I HAVE BOUGHT FIVE YOKE OF OXEN AND AM ON MY WAY TO TRY THEM OUT. PLEASE ACCEPT MY APOLOGIES.'"

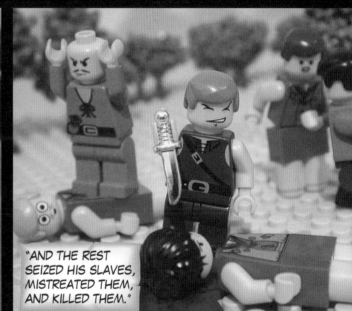

"YET ANOTHER SAID, 'I HAVE JUST GOTTEN MARRIED AND SO AM UNABLE TO COME.'"

"AND THE REST SEIZED HIS SLAVES, MISTREATED THEM, AND KILLED THEM."

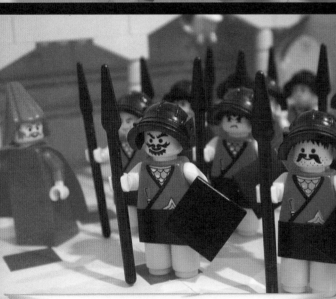

"THE KING WAS FURIOUS. HE SENT OUT HIS SOLDIERS."

"THEY PUT THE MURDERERS TO DEATH."

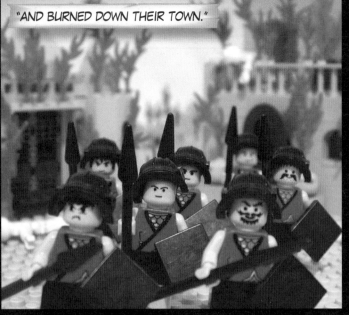

"AND BURNED DOWN THEIR TOWN."

"THEN THE KING SAID TO HIS SLAVES, 'GO INTO THE STREETS AND ALLEYS AND BRING IN THE POOR, THE CRIPPLED, THE BLIND, AND THE LAME.'"

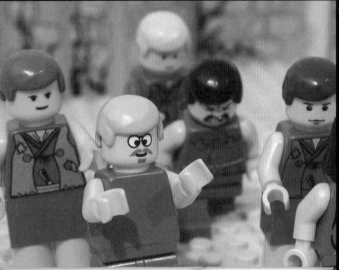

"THE SLAVES WENT OUT INTO THE STREETS AND GATHERED EVERYONE THEY COULD FIND, BOTH BAD AND GOOD."

"THE SLAVE THEN REPORTED TO HIS MASTER, 'YOUR INSTRUCTIONS HAVE BEEN CARRIED OUT, BUT THERE IS STILL ROOM.'"

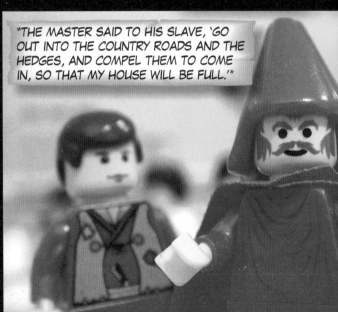

"THE MASTER SAID TO HIS SLAVE, 'GO OUT INTO THE COUNTRY ROADS AND THE HEDGES, AND COMPEL THEM TO COME IN, SO THAT MY HOUSE WILL BE FULL.'"

"AND SO THE WEDDING HALL WAS FULL OF GUESTS."

Mt 22:7 | Mt 22:8; Lk 14:8 | Mt 22:10 | Lk 14:22 | Lk 14:23 | Mt 22:10

Mt 22:11-12 | Mt 22:12 | Mt 22:13 | Jn 8:2 | Jn 8:3 | Jn 8:7

"WHEN THE KING CAME IN TO SEE THE GUESTS, HE CAME ACROSS A MAN WHO WAS NOT WEARING WEDDING CLOTHES, AND HE SAID TO HIM, 'FRIEND, HOW DID YOU COME IN HERE WITHOUT WEDDING CLOTHES?'"

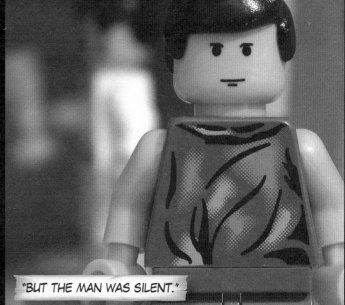

"BUT THE MAN WAS SILENT."

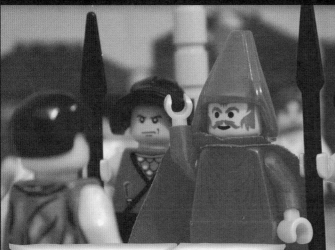

"THE KING THEN SAID TO HIS ATTENDANTS, 'TIE HIS HANDS AND FEET AND THROW HIM INTO THE OUTER DARKNESS WHERE THERE WILL BE WEEPING AND GNASHING OF TEETH!'"

IN THE EARLY MORNING, AGAIN JESUS WENT TO THE TEMPLE COURTS AND BEGAN TO TEACH THE PEOPLE.

THE EXPERTS IN THE LAW AND THE PHARISEES SAID TO JESUS, "THIS WOMAN WAS CAUGHT IN THE ACT OF ADULTERY. THE LAW OF MOSES COMMANDS US TO STONE SUCH WOMEN TO DEATH. WHAT DO YOU SAY?"

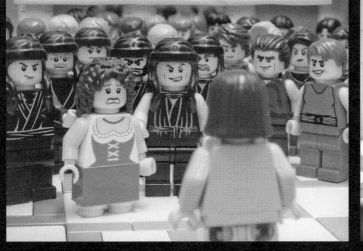

THEY PERSISTED IN ASKING HIM, AND JESUS REPLIED, "LET HE AMONG YOU THAT IS WITHOUT SIN BE THE FIRST TO THROW A STONE AT HER."

ON HEARING THIS, THEY BEGAN TO LEAVE ONE BY ONE, UNTIL ONLY JESUS WAS LEFT AND THE WOMAN. HE SAID TO HER, "WOMAN, WHERE ARE THEY? HAS NO ONE CONDEMNED YOU?"

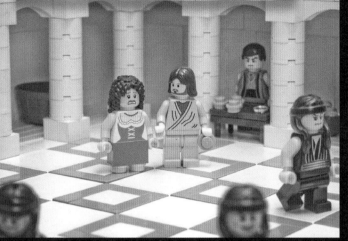

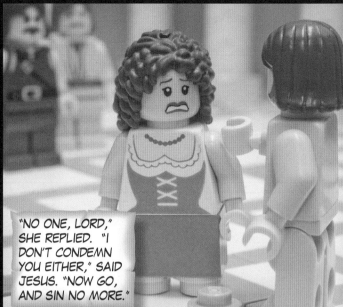

"NO ONE, LORD," SHE REPLIED. "I DON'T CONDEMN YOU EITHER," SAID JESUS. "NOW GO, AND SIN NO MORE."

THEN JESUS SAT DOWN AND WATCHED THE CROWD AS THEY PUT THEIR MONEY IN THE TEMPLE TREASURY.

MANY RICH PEOPLE WERE PUTTING IN LARGE AMOUNTS.

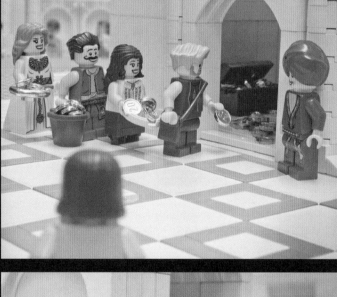

THEN A POOR WIDOW CAME AND PUT IN TWO COPPER COINS WORTH LESS THAN A PENNY.

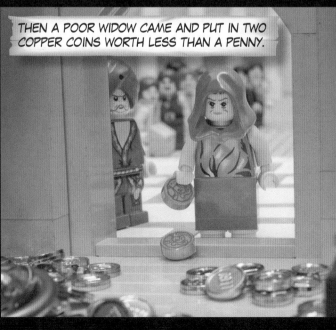

JESUS SAID TO HIS DISCIPLES, "I TELL YOU THE TRUTH— THIS POOR WIDOW HAS PUT IN MORE THAN ALL THE OTHERS. THEY GAVE OUT OF THEIR WEALTH, BUT IN HER POVERTY SHE GAVE EVERYTHING SHE HAD TO LIVE ON."

Jn 8:9-10 | Jn 8:11 | Mk 12:41 | Mk 12:41 | Mk 12:42 | Mk 12:43

THEN JESUS SAID TO THEM, "I HAVE COME DOWN FROM HEAVEN TO DO THE WILL OF MY FATHER, THE ONE WHO SENT ME—THAT EVERYONE WHO LOOKS TO THE SON AND BELIEVES IN HIM SHALL HAVE ETERNAL LIFE, AND I WILL RAISE THEM UP ON THE LAST DAY."

AT THIS, THE JEWS GRUMBLED AGAINST HIM AND SAID, "ISN'T THIS THE SON OF JOSEPH? WHOSE FATHER AND MOTHER WE KNOW? HOW CAN HE SAY 'I CAME DOWN FROM HEAVEN'?"

JESUS SAID, "STOP GRUMBLING TO EACH OTHER. I AM THE WAY, THE TRUTH, AND THE LIFE. NO ONE COMES TO THE FATHER EXCEPT THROUGH ME."

BUT THE PHARISEES SAID TO HIM, "YOU TESTIFY ON YOUR OWN BEHALF, BUT YOUR TESTIMONY IS WORTHLESS."

JESUS REPLIED, "YOUR LAW STATES 'THE TESTIMONY OF TWO WITNESSES IS TRUE.' I TESTIFY ABOUT MYSELF AND THE FATHER WHO SENT ME TESTIFIES ABOUT ME."

THEY ASKED HIM, "WHO IS YOUR FATHER?" AND JESUS SAID TO THEM, "YOU DON'T KNOW ME OR MY FATHER. IF YOU KNEW ME YOU WOULD KNOW MY FATHER TOO."

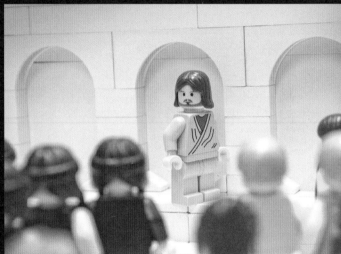

THEN JESUS SAID TO THEM, "I AM GOING AWAY, AND YOU WILL LOOK FOR ME, BUT YOU WILL DIE IN YOUR SIN. AND WHERE I AM GOING, YOU CANNOT COME."

AT THIS, THE JEWS ASKED EACH OTHER, "IS HE GOING TO KILL HIMSELF? IS THAT WHY HE SAYS 'WHERE I AM GOING, YOU CANNOT COME'?"

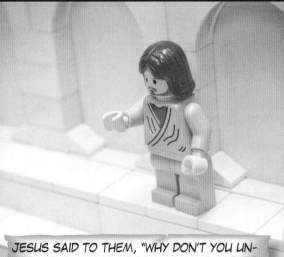

JESUS SAID TO THEM, "WHY DON'T YOU UNDERSTAND ME? IT'S BECAUSE YOUR FATHER IS THE DEVIL. THE REASON YOU DON'T HEAR ME IS THAT YOU DON'T BELONG TO GOD."

JESUS SAID TO THEM, "I TELL YOU THE SOLEMN TRUTH—BEFORE ABRAHAM WAS BORN, I AM."

THE JEWS SAID TO HIM, "WE ARE DESCENDANTS OF ABRAHAM! ABRAHAM IS OUR FATHER! YOU AREN'T GREATER THAN OUR FATHER ABRAHAM, ARE YOU?"

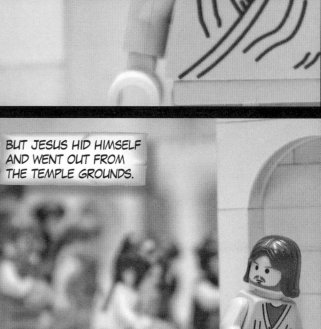

BUT JESUS HID HIMSELF AND WENT OUT FROM THE TEMPLE GROUNDS.

THEN THEY PICKED UP STONES TO STONE HIM, SAYING, "WE ARE GOING TO STONE YOU FOR BLASPHEMY, BECAUSE YOU ARE A MAN CLAIMING TO BE GOD."

"DO YOU SEE ALL THESE GREAT BUILDINGS?" REPLIED JESUS. "NOT ONE STONE HERE WILL BE LEFT ON ANOTHER!"

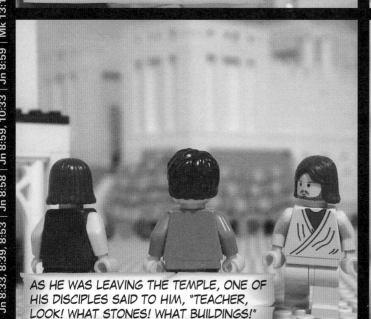

AS HE WAS LEAVING THE TEMPLE, ONE OF HIS DISCIPLES SAID TO HIM, "TEACHER, LOOK! WHAT STONES! WHAT BUILDINGS!"

109

"THEY WILL ALL BE THROWN DOWN!"

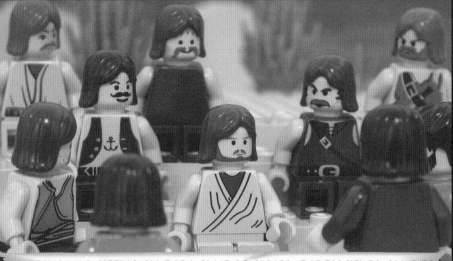

AS JESUS WAS SITTING ON THE MOUNT OF OLIVES, THE DISCIPLES CAME TO HIM PRIVATELY AND SAID, "TELL US WHEN THESE THINGS WILL HAPPEN, AND WHAT WILL BE THE SIGN OF YOUR COMING AND OF THE END OF THIS AGE?"

JESUS ANSWERED THEM, "NATION WILL RISE AGAINST NATION..."

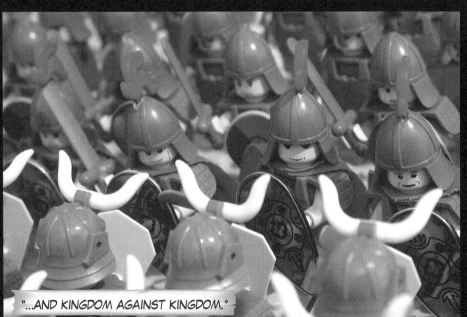

"...AND KINGDOM AGAINST KINGDOM."

"THERE WILL BE GREAT EARTHQUAKES..."

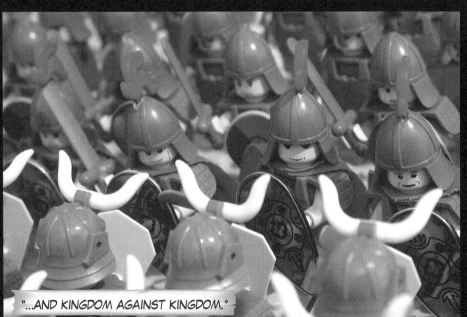

Mk 13:2 | Mt 24:3 | Mt 24:7 | Lk 21:11

"...FAMINES..."

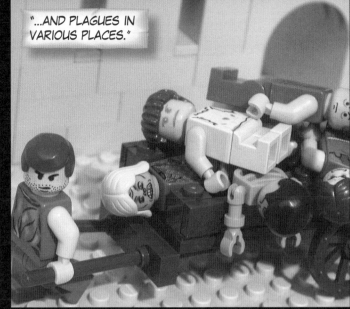

"...AND PLAGUES IN VARIOUS PLACES."

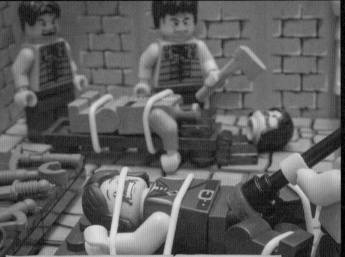

"THEN YOU WILL BE HANDED OVER TO BE PER-SECUTED AND PUT TO DEATH, AND YOU WILL BE HATED BY ALL NATIONS BECAUSE OF ME."

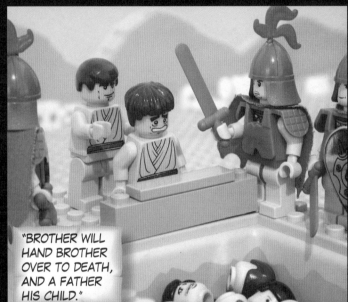

"BROTHER WILL HAND BROTHER OVER TO DEATH, AND A FATHER HIS CHILD."

"CHILDREN WILL RISE AGAINST PARENTS AND HAVE THEM PUT TO DEATH."

"WOE TO THOSE WHO ARE PREGNANT OR NURSING BABIES IN THOSE DAYS! THEY WILL FALL BY THE EDGE OF THE SWORD."

"THERE WILL BE GREAT SUFFERING UNLIKE ANY-
THING THAT HAS HAPPENED FROM THE BEGINNING
OF THE WORLD UNTIL NOW, OR EVER WILL HAPPEN."

"IMMEDIATELY AFTER THE SUFFERING OF
THOSE DAYS, THEY WILL SEE THE SON OF MAN
ARRIVING ON THE CLOUDS OF THE SKY WITH
HIS ANGELS, WITH POWER AND GREAT GLORY."

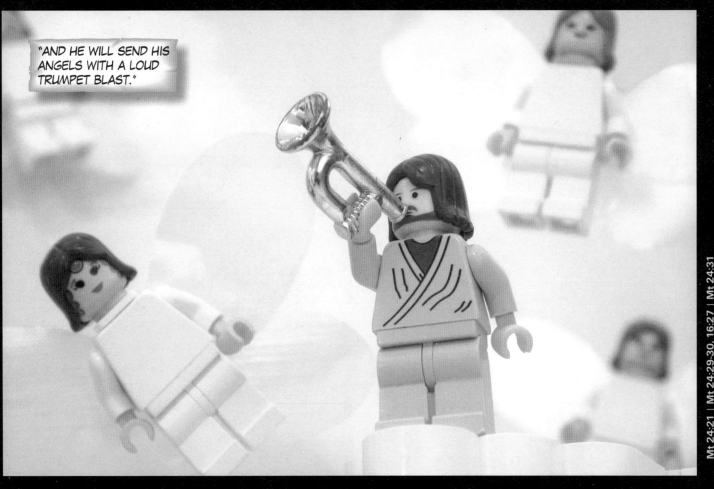

"AND HE WILL SEND HIS
ANGELS WITH A LOUD
TRUMPET BLAST."

Mt 24:21 | Mt 24:29-30, 16:27 | Mt 24:31

"AND THE SON OF MAN WILL SEND HIS ANGELS, AND THEY WILL GATHER FROM HIS KINGDOM ALL THINGS THAT OFFEND AND THOSE WHO PRACTICE LAWLESSNESS."

"AND THEY WILL GATHER HIS ELECT FROM THE FOUR WINDS, FROM THE ENDS OF THE EARTH TO THE ENDS OF HEAVEN."

"AND THEY WILL THROW THEM INTO THE FIERY FURNACE, WHERE THERE WILL BE WEEPING AND GNASHING OF TEETH."

AND THE DISCIPLES ASKED HIM, "TELL US, WHEN IS THIS GOING TO HAPPEN?"

"I TELL YOU THE TRUTH—THIS GENERATION WILL CERTAINLY NOT PASS AWAY UNTIL ALL THESE THINGS HAVE HAPPENED."

"I TELL YOU THE TRUTH—SOME STANDING HERE WILL NOT TASTE DEATH BEFORE THEY SEE THE SON OF MAN COMING IN HIS KINGDOM."

ON THE FIRST DAY OF THE FEAST OF UNLEAVENED BREAD, JESUS'S DISCIPLES CAME TO HIM AND SAID, "WHERE DO YOU WANT US TO PREPARE FOR YOU TO EAT THE PASSOVER?"

JESUS SAID, "GO INTO THE CITY TO A CERTAIN MAN AND TELL HIM, 'THE TEACHER SAYS, "MY TIME IS NEAR. I WILL OBSERVE THE PASSOVER WITH MY DISCIPLES AT YOUR HOUSE."'"

SO THE DISCIPLES DID AS JESUS HAD INSTRUCTED THEM, AND THEY PREPARED THE PASSOVER.

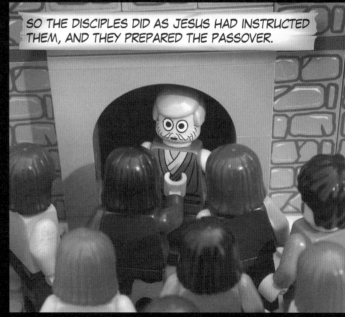

Mt 24:3 | Mk 13:4 | Mt 24:34 | Mt 16:28 | Mt 26:17 | Mt 26:18 | Mt 26:19

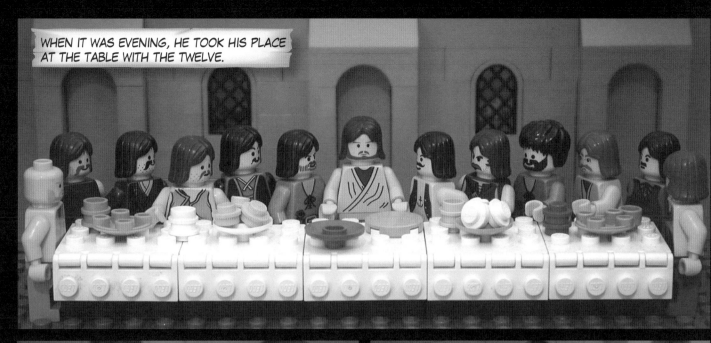

WHEN IT WAS EVENING, HE TOOK HIS PLACE AT THE TABLE WITH THE TWELVE.

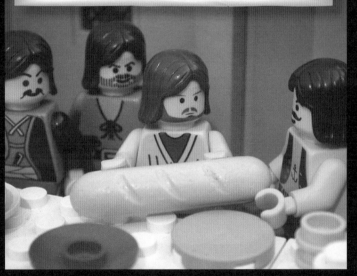

AS THEY WERE EATING, JESUS TOOK BREAD AND GAVE IT TO THE DISCIPLES. "TAKE IT AND EAT," HE SAID.

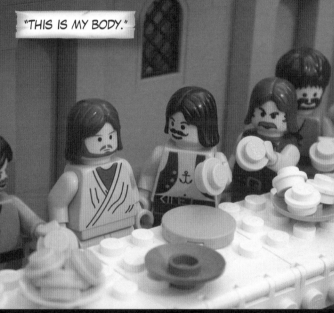

"THIS IS MY BODY."

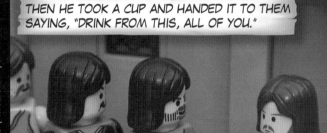

THEN HE TOOK A CUP AND HANDED IT TO THEM SAYING, "DRINK FROM THIS, ALL OF YOU."

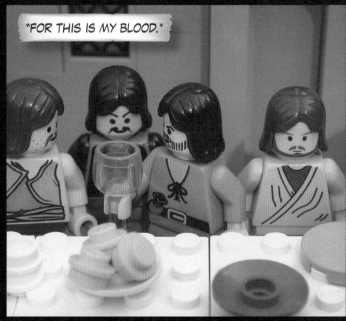

"FOR THIS IS MY BLOOD."

JESUS GOT UP FROM THE MEAL, REMOVED HIS OUTER CLOTHES, TOOK A TOWEL, AND WRAPPED IT AROUND HIS WAIST.

HE POURED WATER INTO THE BASIN AND BEGAN TO WASH THE DISCIPLES' FEET AND TO DRY THEM WITH THE TOWEL HE HAD WRAPPED AROUND HIM.

BUT PETER SAID, "YOU SHALL NEVER WASH MY FEET, EVER!"

JESUS ANSWERED, "HE WHO HAS BATHED NEEDS ONLY TO WASH HIS FEET."

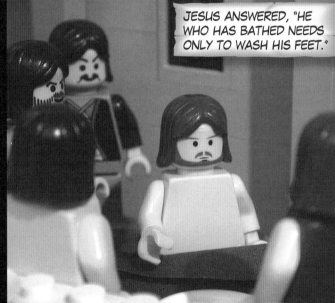

WHEN HE HAD FINISHED WASHING THEIR FEET, HE PUT ON HIS CLOTHES AND RETURNED TO HIS PLACE. "I HAVE SET AN EXAMPLE. YOU SHOULD DO AS I HAVE DONE FOR YOU. YOU SHOULD WASH ONE ANOTHER'S FEET."

AFTER HE HAD SAID THIS, JESUS WAS TROUBLED IN SPIRIT AND DECLARED, "I TELL YOU THE TRUTH—ONE OF YOU IS GOING TO BETRAY ME."

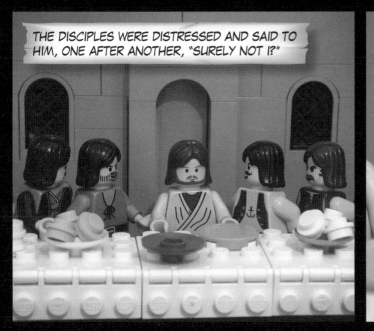

THE DISCIPLES WERE DISTRESSED AND SAID TO HIM, ONE AFTER ANOTHER, "SURELY NOT I?"

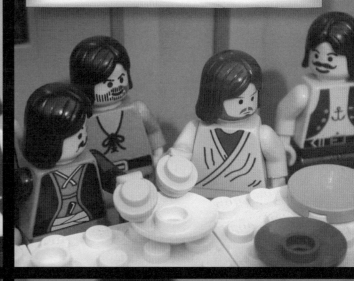

ONE OF THEM, THE DISCIPLE WHOM JESUS LOVED, WAS RECLINING NEXT TO JESUS. SIMON PETER MOTIONED TO THIS DISCIPLE AND SAID, "ASK HIM WHICH ONE HE MEANS."

THEN THE DISCIPLE WHOM JESUS LOVED LEANED BACK AGAINST JESUS'S CHEST AND ASKED HIM, "LORD, WHO IS IT?"

HE SAID TO THEM, "IT IS ONE OF THE TWELVE, ONE WHO DIPS HIS HAND WITH ME INTO THE BOWL."

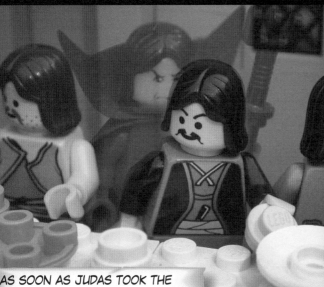

AS SOON AS JUDAS TOOK THE BREAD, SATAN ENTERED INTO HIM.

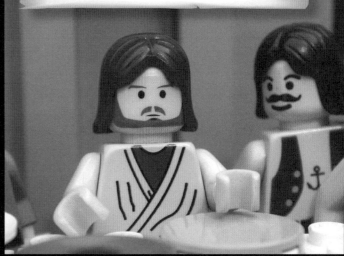

"BUT WOE TO THAT MAN WHO BETRAYS THE SON OF MAN!" HE SAID TO THEM. "IT WOULD BE BETTER FOR HIM IF HE HAD NEVER BEEN BORN."

117

AND JESUS SAID TO THEM, "ANYONE WHO HAS MONEY SHOULD TAKE IT. ANYONE WHO HAS NO SWORD SHOULD SELL HIS COAT AND BUY ONE."

SO THEY SAID, "LOOK, LORD, HERE ARE TWO SWORDS." THEN HE TOLD THEM, "IT IS ENOUGH."

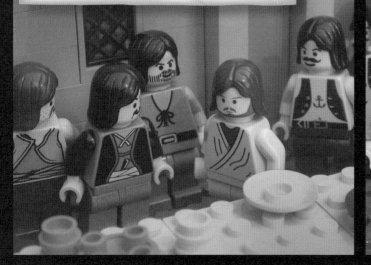

AFTER SINGING A HYMN, THEY WENT OUT TO THE MOUNT OF OLIVES, AND JESUS SAID TO THEM, "TONIGHT YOU WILL ALL DESERT ME."

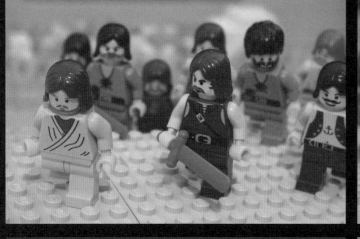

PETER SAID TO HIM, "EVEN IF THEY ALL DESERT YOU, I WILL NEVER DESERT YOU. EVEN IF I MUST DIE WITH YOU, I WILL NEVER DENY YOU!"

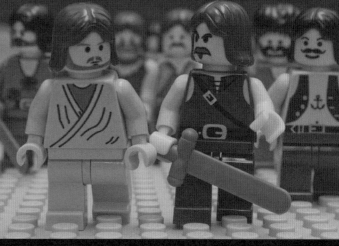

JESUS SAID TO HIM, "I TELL YOU THE TRUTH—TONIGHT, BEFORE THE ROOSTER CROWS, YOU WILL DENY ME THREE TIMES."

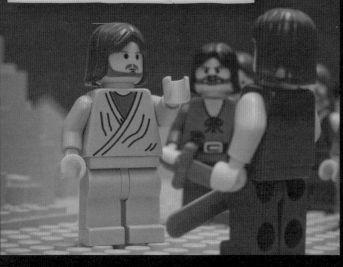

JESUS BECAME VERY TROUBLED AND DISTRESSED. HE SAID TO THEM, "MY SOUL IS DEEPLY GRIEVED TO THE POINT OF DEATH."

Lk 22:35-36 | Lk 22:38 | Mt 26:33, 26:35 | Mt 26:30-31 | Mt 26:35 | Mk 14:33-34

GOING A LITTLE FARTHER, HE THREW HIMSELF TO THE GROUND AND PRAYED THAT IF IT WERE POSSIBLE THE HOUR WOULD PASS FROM HIM. HE SAID, "FATHER, EVERYTHING IS POSSIBLE FOR YOU. TAKE THIS CUP FROM ME. LET THIS CUP PASS FROM ME!"

THEN AN ANGEL FROM HEAVEN APPEARED TO HIM AND STRENGTHENED HIM.

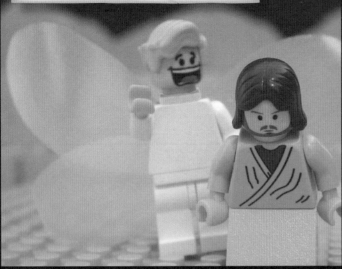

IN HIS ANGUISH HE PRAYED EVEN MORE EARNESTLY, AND HIS SWEAT FELL TO THE GROUND LIKE GREAT DROPS OF BLOOD.

SUDDENLY A CROWD APPEARED WITH SWORDS AND CLUBS, SENT BY THE CHIEF PRIESTS AND ELDERS OF THE PEOPLE AND LED BY THE MAN NAMED JUDAS, ONE OF THE TWELVE.

HE WENT UP TO JESUS AT ONCE AND SAID, "GREETINGS, RABBI," AND KISSED HIM.

HIS FOLLOWERS, SEEING WHAT WAS ABOUT TO HAPPEN, SAID, "LORD, SHALL WE USE OUR SWORDS?"

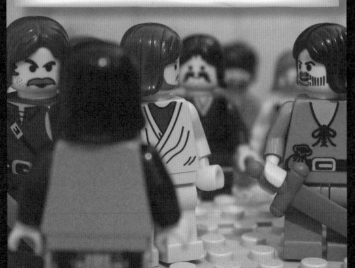

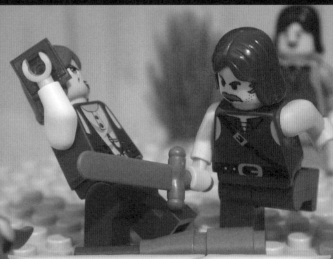

THEN SIMON PETER, WHO HAD A SWORD, PULLED IT OUT AND STRUCK THE HIGH PRIEST'S SLAVE, CUTTING OFF HIS RIGHT EAR. THE SLAVE'S NAME WAS MALCHUS.

Lk 22:43 | Lk 22:44 | Lk 22:47; Mt 26:47; Mt 26:49 | Lk 22:49 | Jn 18:10

BUT JESUS SAID TO PETER, "PUT YOUR SWORD BACK INTO ITS SHEATH! OR DO YOU THINK THAT I CANNOT CALL ON MY FATHER AND THAT HE WOULD SEND ME MORE THAN TWELVE LEGIONS OF ANGELS RIGHT NOW?"

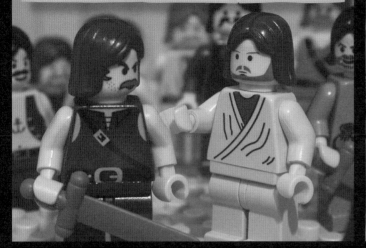

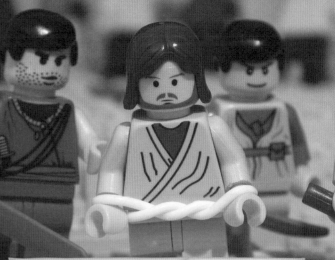

THE COHORT ARRESTED AND BOUND JESUS, AND ALL THE DISCIPLES LEFT HIM AND FLED.

A YOUNG MAN FOLLOWED HIM WITH NOTHING ON BUT A LINEN CLOTH.

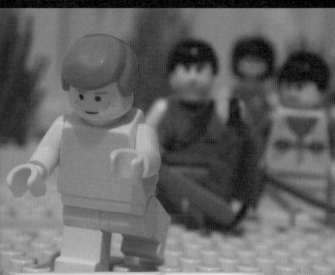

THEY SEIZED HIM, BUT HE RAN OFF NAKED, LEAVING HIS LINEN CLOTH BEHIND.

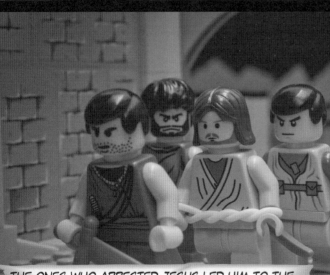

THE ONES WHO ARRESTED JESUS LED HIM TO THE HIGH PRIEST, AND PETER FOLLOWED AT A DISTANCE ALL THE WAY TO THE HIGH PRIEST'S COURTYARD.

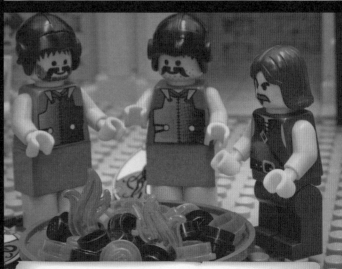

NOW THE GUARDS WERE WARMING THEMSELVES AROUND A FIRE BECAUSE IT WAS COLD, AND PETER STOOD WITH THEM, WARMING HIMSELF.

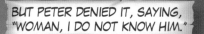
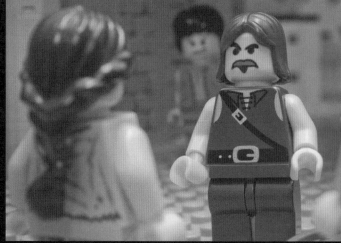

ONE OF THE HIGH PRIEST'S SLAVE GIRLS CAME BY AND SAW PETER IN THE FIRELIGHT. SHE LOOKED RIGHT AT HIM AND SAID, "YOU WERE WITH JESUS THE NAZARENE TOO!"

BUT PETER DENIED IT, SAYING, "WOMAN, I DO NOT KNOW HIM."

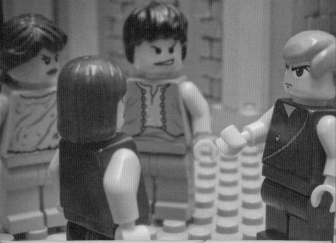
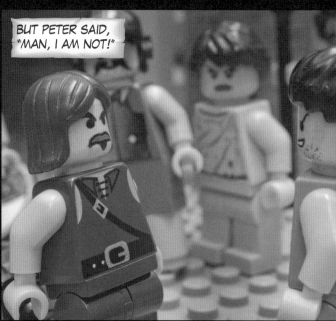

A LITTLE WHILE LATER, SOMEONE ELSE SAID, "SURELY, THIS MAN WAS WITH HIM, BECAUSE HE, TOO, IS A GALILEAN."

BUT PETER SAID, "MAN, I AM NOT!"

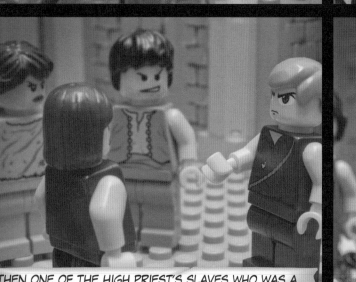

THEN ONE OF THE HIGH PRIEST'S SLAVES WHO WAS A RELATIVE OF THE MAN WHOSE EAR PETER CUT OFF SAID, "DIDN'T I SEE YOU IN THE ORCHARD WITH HIM?"

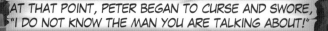

AT THAT POINT, PETER BEGAN TO CURSE AND SWORE, "I DO NOT KNOW THE MAN YOU ARE TALKING ABOUT!"

Mk 14:66-67 | Lk 22:56 | Lk 22:57 | Lk 22:58-59 | Lk 22:60 | Jn 18:26 | Mt 26:74

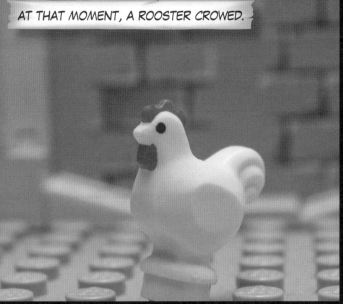

AT THAT MOMENT, A ROOSTER CROWED.

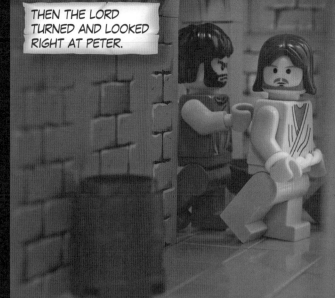

THEN THE LORD TURNED AND LOOKED RIGHT AT PETER.

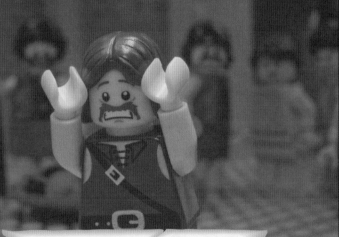

PETER REMEMBERED THE WORDS JESUS HAD SAID TO HIM: "BEFORE THE ROOSTER CROWS, YOU WILL DENY ME THREE TIMES." AND HE WENT OUTSIDE AND WEPT BITTERLY.

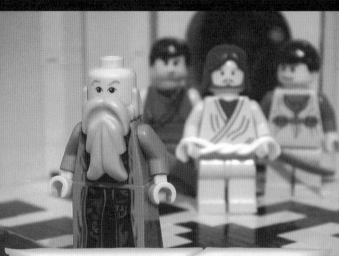

THEY TOOK JESUS FIRST TO ANNAS, BECAUSE ANNAS WAS THE FATHER-IN-LAW OF CAIAPHAS WHO WAS THE HIGH PRIEST THAT YEAR. THE HIGH PRIEST QUESTIONED HIM ABOUT HIS DISCIPLES AND HIS TEACHING.

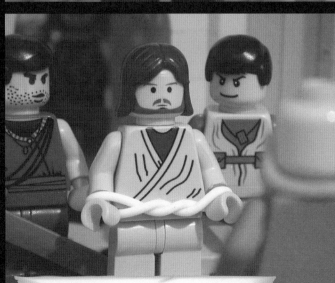

JESUS REPLIED, "WHY ASK ME? ASK THOSE WHO HEARD ME. THEY KNOW WHAT I SAID."

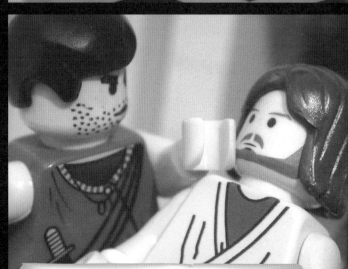

WHEN JESUS SAID THIS, ONE OF THE OFFICIALS NEARBY STRUCK HIM IN THE FACE, SAYING, "IS THIS THE WAY YOU ANSWER THE HIGH PRIEST?"

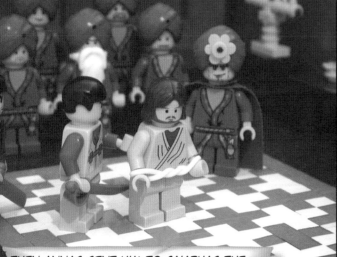

THEN ANNAS SENT HIM TO CAIAPHAS THE HIGH PRIEST, IN WHOSE HOUSE THE EXPERTS IN THE LAW AND THE ELDERS HAD GATHERED.

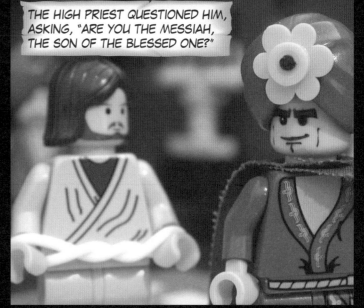

THE HIGH PRIEST QUESTIONED HIM, ASKING, "ARE YOU THE MESSIAH, THE SON OF THE BLESSED ONE?"

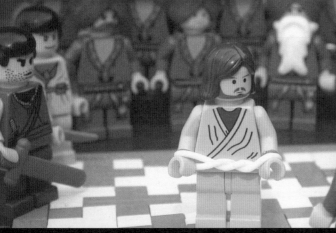

"I AM," SAID JESUS. "AND YOU WILL SEE THE SON OF MAN SITTING AT THE RIGHT HAND OF THE MIGHTY ONE AND COMING ON THE CLOUDS OF HEAVEN."

THE HIGH PRIEST SAID, "YOU HEARD THE BLASPHEMY. WHAT IS YOUR VERDICT?"

THEY ANSWERED, "HE IS GUILTY AND DESERVES DEATH."

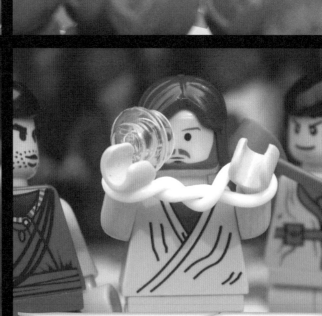

THE MEN WHO WERE GUARDING JESUS BEGAN MOCKING AND BEATING HIM, AND SOME BEGAN TO SPIT ON HIM.

Jn 18:24; Mt 26:57 | Mk 14:61 | Mk 14:62 | Mk 14:63-64 | Mt 26:66 | Lk 22:63; Mk 14:65

THEY BLINDFOLDED HIM AND STRUCK HIM WITH THEIR FISTS, SAYING, "PROPHESY! WHICH ONE OF US HIT YOU?" AND THEY SAID MANY OTHER INSULTING THINGS TO HIM.

WHEN IT WAS EARLY IN THE MORNING, THEY HAD JESUS BOUND AND HANDED HIM OVER TO PILATE THE GOVERNOR.

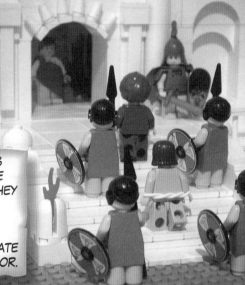

SO PILATE CAME OUT TO THEM AND ASKED, "WHAT ACCUSATION DO YOU BRING AGAINST THIS MAN?"

THEY REPLIED, "IF HE WERE NOT A CRIMINAL, WE WOULD NOT HAVE HANDED HIM OVER TO YOU."

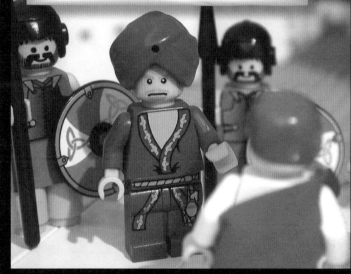

THEN PILATE SAID TO THEM, "TAKE HIM AND JUDGE HIM ACCORDING TO YOUR OWN LAW!" WHEN HE LEARNED JESUS WAS A GALILEAN FROM HEROD'S JURISDICTION, HE SENT HIM TO HEROD, WHO ALSO HAPPENED TO BE IN JERUSALEM AT THAT TIME.

HEROD WAS HAPPY TO SEE JESUS, FOR HE WAS HOPING TO SEE HIM PERFORM SOME MIRACULOUS SIGN, AND HE QUESTIONED HIM AT LENGTH.

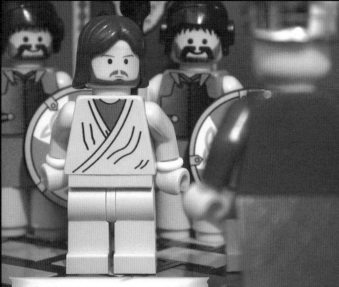

BUT JESUS GAVE HIM NO REPLY.

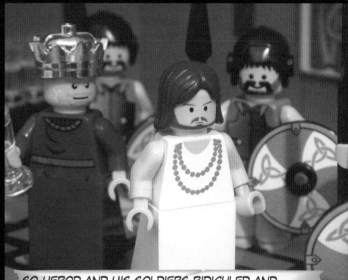

SO HEROD AND HIS SOLDIERS RIDICULED AND MOCKED HIM, DRESSING HIM IN AN ELEGANT ROBE.

HEROD SENT HIM BACK TO PILATE, AND ON THAT DAY HEROD AND PILATE BECAME FRIENDS THOUGH BEFORE THEY HAD BEEN ENEMIES. PILATE WENT INSIDE THE PRAETORIUM AND SUMMONED JESUS.

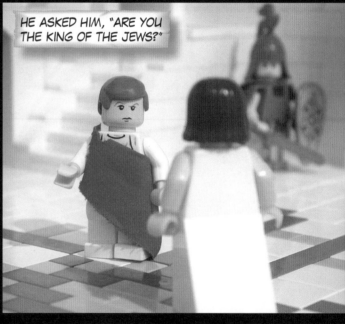

HE ASKED HIM, "ARE YOU THE KING OF THE JEWS?"

JESUS REPLIED, "YOU SAY SO."

PILATE SAID, "I AM NOT A JEW, AM I? YOUR OWN PEOPLE AND CHIEF PRIESTS HANDED YOU OVER TO ME. WHAT HAVE YOU DONE?"

Lk 23:9 | Lk 23:11-12; Jn 18:33 | Mt 27:11 | Jn 18:33 | Jn 18:35

BUT TO THE AMAZEMENT OF THE GOVERNOR, JESUS DID NOT ANSWER TO A SINGLE ACCUSATION.

SO PILATE TOOK JESUS AND HAD HIM FLOGGED.

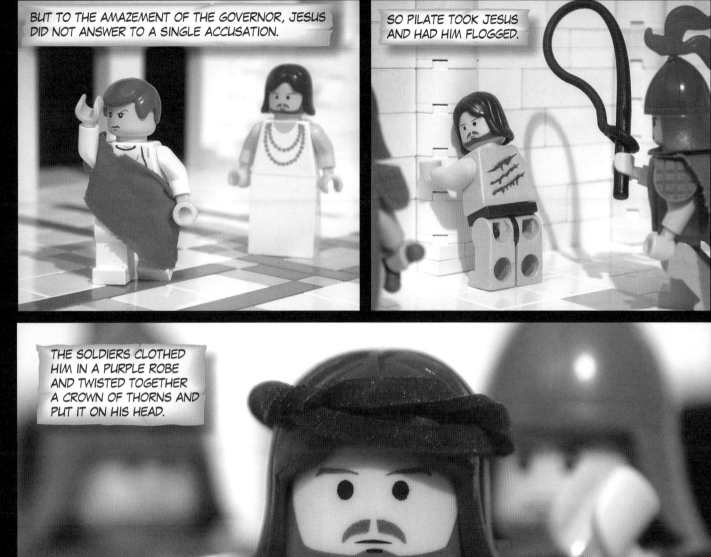

THE SOLDIERS CLOTHED HIM IN A PURPLE ROBE AND TWISTED TOGETHER A CROWN OF THORNS AND PUT IT ON HIS HEAD.

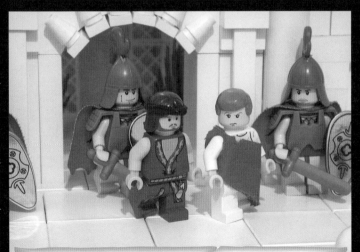

SO JESUS CAME OUTSIDE, WEARING THE CROWN OF THORNS AND THE PURPLE ROBE, AND PILATE SAID, "DO YOU REFUSE TO SPEAK TO ME? DON'T YOU KNOW I HAVE THE AUTHORITY TO RELEASE YOU OR TO CRUCIFY YOU?"

JESUS REPLIED, "YOU WOULD HAVE NO AUTHORITY OVER ME AT ALL, UNLESS IT WAS GIVEN TO YOU FROM ABOVE. THEREFORE THE ONE WHO HANDED ME OVER TO YOU IS GUILTY OF GREATER SIN."

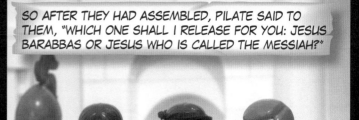

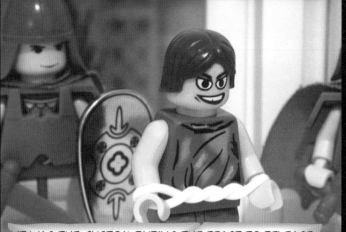

IT WAS THE CUSTOM DURING THE FEAST TO RELEASE A PRISONER THAT THE CROWD CHOSE. THEY HAD IN CUSTODY A NOTORIOUS PRISONER NAMED JESUS BARABBAS, WHO HAD BEEN THROWN IN PRISON FOR STARTING A RIOT IN THE CITY AND FOR MURDER.

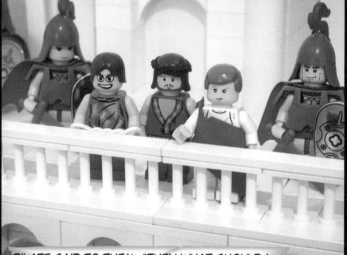

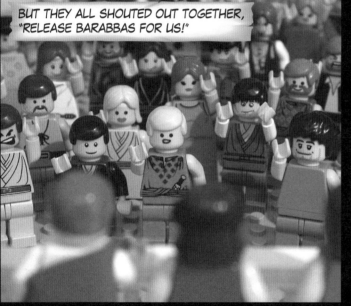

BUT THEY ALL SHOUTED OUT TOGETHER, "RELEASE BARABBAS FOR US!"

PILATE SAID TO THEM, "THEN WHAT SHOULD I DO WITH JESUS WHO IS CALLED THE MESSIAH?" AND THEY ALL SAID, "CRUCIFY HIM!"

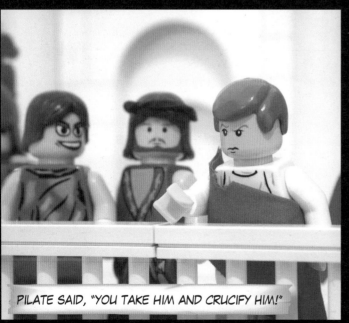

PILATE SAID, "YOU TAKE HIM AND CRUCIFY HIM!"

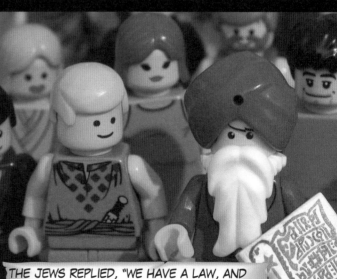

THE JEWS REPLIED, "WE HAVE A LAW, AND ACCORDING TO OUR LAW HE MUST DIE, BE-CAUSE HE CLAIMED TO BE THE SON OF GOD!"

Mt 27:15-16; Lk 23:18 | Mt 27:17 | Lk 23:19 | Mt 27:22 | Jn 19:6 | Jn 19:7

SO PILATE HANDED HIM OVER TO BE CRUCIFIED, AND THEY TOOK JESUS AWAY.

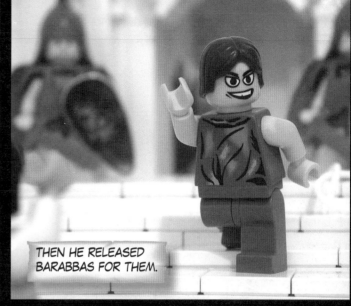

THEN HE RELEASED BARABBAS FOR THEM.

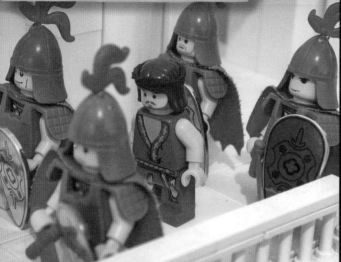

THEN THE GOVERNOR'S SOLDIERS TOOK JESUS INTO THE PRAETORIUM AND MOCKED HIM, SAYING, "HAIL, KING OF THE JEWS!" AND STRUCK HIM REPEATEDLY ON THE HEAD.

AFTER THEY HAD MOCKED HIM, THEY STRIPPED HIM OF THE ROBE AND PUT HIS OWN CLOTHES BACK ON HIM, AND THEY LED HIM AWAY TO CRUCIFY HIM. TWO OTHER CRIMINALS WERE ALSO TO BE EXECUTED WITH HIM.

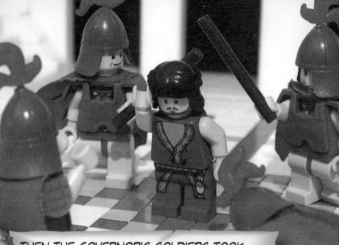

AS THEY WERE GOING OUT, THEY FOUND A MAN FROM CYRENE NAMED SIMON, AND THEY FORCED HIM TO CARRY THE CROSS.

AND JESUS, CARRYING HIS OWN CROSS, WENT OUT TO GOLGOTHA, THE PLACE OF THE SKULL.

THEN THEY CRUCIFIED HIM.

Jn 19:16-17 | Mk 15:24

NEAR THE CROSS OF JESUS STOOD HIS MOTHER AND HIS MOTHER'S SISTER, MARY THE WIFE OF CLOPAS, AND MARY OF MAGDALA, AND THE DISCIPLE WHOM HE LOVED.

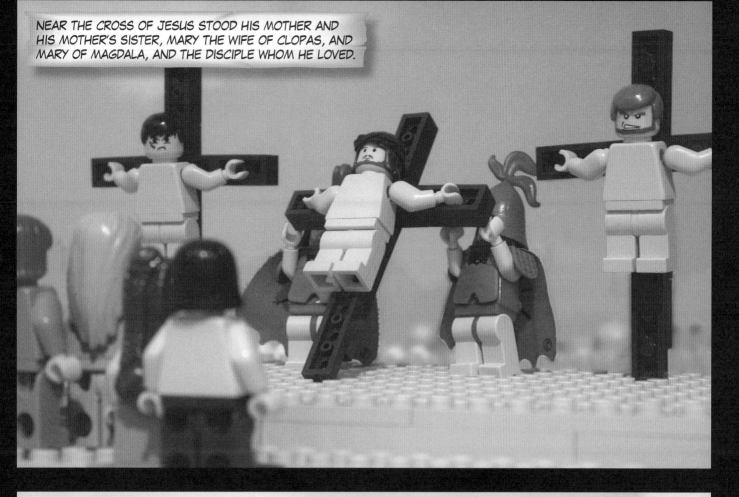

WHEN THE SOLDIERS HAD FINISHED CRUCIFYING JESUS, THEY TOOK HIS CLOTHING AND DIVIDED IT INTO FOUR SHARES, ONE FOR EACH SOLDIER.

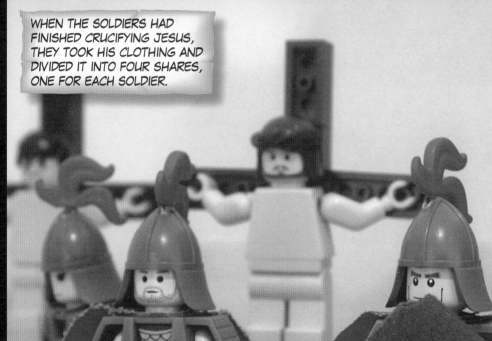

PASSERSBY MOCKED HIM, AND THE CHIEF PRIESTS AND THE EXPERTS IN THE LAW SAID, "HE SAVED OTHERS, BUT HE CAN'T SAVE HIMSELF! HE'S THE KING OF ISRAEL! LET HIM COME DOWN NOW FROM THE CROSS, AND WE WILL BELIEVE IN HIM."

"HE TRUSTS IN GOD," THEY SAID, "SO LET GOD RESCUE HIM NOW IF HE WANTS HIM. FOR HE SAID, 'I AM THE SON OF GOD.'"

THE SOLDIERS MOCKED HIM TOO, SAYING, "IF YOU ARE THE KING OF THE JEWS, SAVE YOURSELF."

EVEN THOSE WHO WERE CRUCIFIED WITH HIM TAUNTED HIM, SAYING, "ARE YOU NOT THE MESSIAH? SAVE YOURSELF AND US TOO!"

Mt 27:39, 27:41-42 | Mt 27:43 | Lk 23:39-37 | Mk 15:32; Lk 23:39

IT WAS NOW ABOUT NOON, AND DARKNESS CAME OVER THE WHOLE LAND. THE SUN WAS DARKENED FOR THREE HOURS.

THEN JESUS CRIED OUT IN A LOUD VOICE, "MY GOD, MY GOD, WHY HAVE YOU ABANDONED ME?" WHEN HE HAD SAID THIS, HE BREATHED HIS LAST.

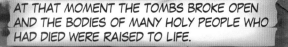

AT THAT MOMENT THE TOMBS BROKE OPEN AND THE BODIES OF MANY HOLY PEOPLE WHO HAD DIED WERE RAISED TO LIFE.

THEY CAME OUT OF THE TOMBS, AND AFTER JESUS'S RISING, THEY WENT INTO THE HOLY CITY AND APPEARED TO MANY PEOPLE.

THE JEWS DID NOT WANT BODIES LEFT ON THE CROSSES DURING THE SABBATH, SO THEY ASKED PILATE TO HAVE THE LEGS BROKEN AND THE BODIES TAKEN DOWN. SO THE SOLDIERS CAME AND BROKE THE LEGS OF THE FIRST MAN.

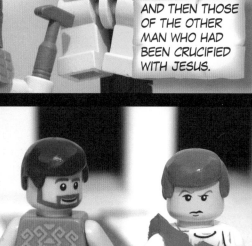

AND THEN THOSE OF THE OTHER MAN WHO HAD BEEN CRUCIFIED WITH JESUS.

BUT WHEN THEY CAME TO JESUS AND SAW THAT HE WAS ALREADY DEAD, THEY DID NOT BREAK HIS LEGS. INSTEAD, ONE OF THE SOLDIERS PIERCED HIS SIDE WITH A SPEAR, AND IMMEDIATELY BLOOD AND WATER FLOWED OUT.

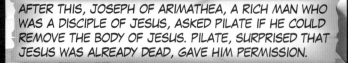

AFTER THIS, JOSEPH OF ARIMATHEA, A RICH MAN WHO WAS A DISCIPLE OF JESUS, ASKED PILATE IF HE COULD REMOVE THE BODY OF JESUS. PILATE, SURPRISED THAT JESUS WAS ALREADY DEAD, GAVE HIM PERMISSION.

Mt 27:51-54 | Mt 27:53 | Jn 19:31-32 | Jn 19:32 | Jn 19:33-34 | Mt 27:57; Mk 15:44

SO HE WENT AND TOOK THE BODY OF JESUS AWAY. HE WAS ACCOMPANIED BY NICODEMUS, THE MAN WHO HAD FIRST VISITED JESUS AT NIGHT.

THEY TOOK JESUS'S BODY AND WRAPPED IT IN STRIPS OF LINEN CLOTH, WITH ARO-MATIC SPICES, AC-CORDING TO JEWISH BURIAL CUSTOMS.

NEARBY WAS A NEW TOMB IN WHICH NO ONE HAD YET BEEN BURIED. THEY LAID JESUS THERE. AND MARY MAGDALENE AND MARY THE MOTHER OF JOSES SAW WHERE HE WAS LAID.

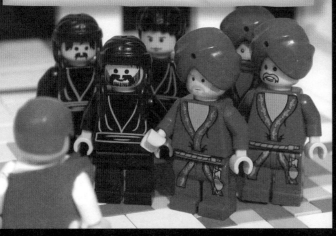

THE NEXT DAY, THE CHIEF PRIESTS AND THE PHARI-SEES CAME BEFORE PILATE AND SAID, "GIVE ORDERS TO GUARD THE TOMB, OTHERWISE HIS DISCIPLES MAY COME AND STEAL HIS BODY AND SAY TO THE PEOPLE, 'HE HAS BEEN RAISED FROM THE DEAD!'"

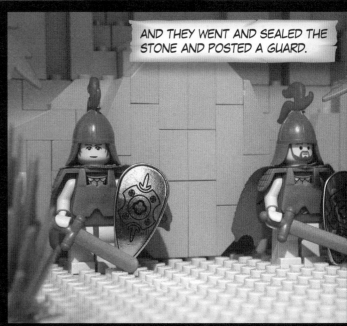

AND THEY WENT AND SEALED THE STONE AND POSTED A GUARD.

135

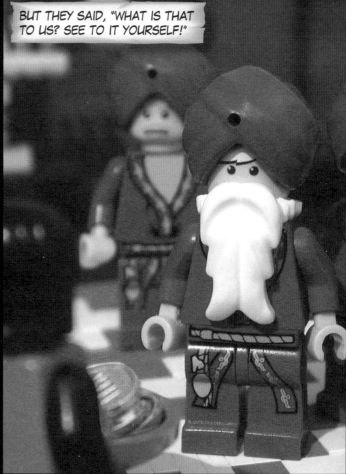

WHEN JUDAS SAW THAT JESUS HAD BEEN CON-DEMNED, HE REGRETTED WHAT HE HAD DONE AND RETURNED THE THIRTY SILVER COINS TO THE CHIEF PRIESTS AND THE ELDERS, SAYING, "I HAVE SINNED BY BETRAYING INNOCENT BLOOD!"

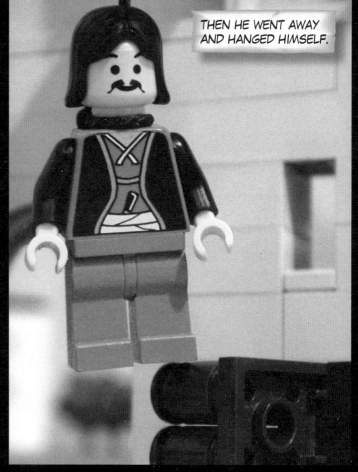

BUT THEY SAID, "WHAT IS THAT TO US? SEE TO IT YOURSELF!"

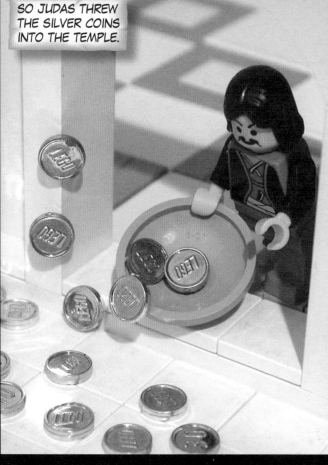

SO JUDAS THREW THE SILVER COINS INTO THE TEMPLE.

THEN HE WENT AWAY AND HANGED HIMSELF.

Mt 27:3-4 | Mt 27:4 | Mt 27:5 | Mt 27:5 | Mt 27:5

AT SUNRISE, MARY MAGDALENE, MARY THE MOTHER OF JAMES, AND SALOME WENT TO THE TOMB WITH AROMATIC SPICES TO ANOINT JESUS'S BODY, AND THEY WERE ASKING EACH OTHER, "WHO WILL ROLL AWAY THE STONE FOR US FROM THE ENTRANCE TO THE TOMB?"

SUDDENLY THERE WAS A SEVERE EARTHQUAKE, FOR AN ANGEL OF THE LORD DESCENDED FROM HEAVEN AND ROLLED AWAY THE STONE.

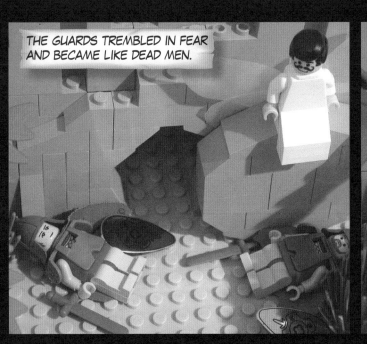

THE GUARDS TREMBLED IN FEAR AND BECAME LIKE DEAD MEN.

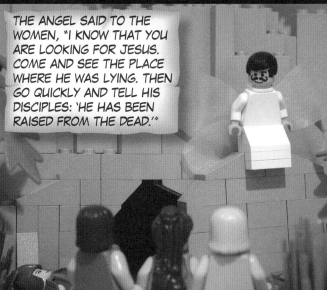

THE ANGEL SAID TO THE WOMEN, "I KNOW THAT YOU ARE LOOKING FOR JESUS. COME AND SEE THE PLACE WHERE HE WAS LYING. THEN GO QUICKLY AND TELL HIS DISCIPLES: 'HE HAS BEEN RAISED FROM THE DEAD.'"

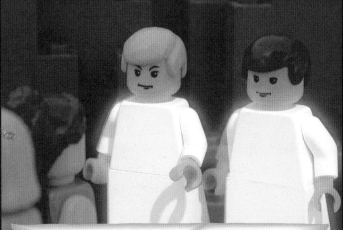

THEY WENT INTO THE TOMB AND SUDDENLY TWO MEN IN GLEAMING CLOTHES STOOD BESIDE THEM AND SAID, "WHY DO YOU LOOK FOR THE LIVING AMONG THE DEAD? HE IS NOT HERE, HE HAS RISEN!"

MARY MAGDALENE SAW TWO ANGELS IN WHITE SITTING WHERE JESUS'S BODY HAD BEEN LYING, AND THEY ASKED HER, "WOMAN, WHY ARE YOU CRYING?"

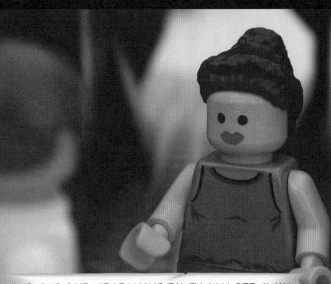

AND SHE SAID, "THEY HAVE TAKEN MY LORD AWAY, AND I DON'T KNOW WHERE THEY HAVE PUT HIM!"

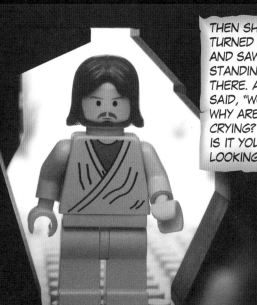

THEN SHE TURNED AROUND AND SAW JESUS STANDING THERE. AND HE SAID, "WOMAN, WHY ARE YOU CRYING? WHO IS IT YOU ARE LOOKING FOR?"

Mk 28:4 | Mt 28:5 | Mk 16:5 | Lk 24:4-5 | Jn 20:12-13 | Jn 20:13 | Jn 20:14

THINKING HE WAS THE GARDENER, SHE SAID, "SIR, IF YOU HAVE CARRIED HIM AWAY, TELL ME WHERE YOU HAVE PUT HIM."

JESUS SAID TO HER, "MARY." AND SHE TURNED AND SAID TO HIM, "RABBONI" (WHICH MEANS TEACHER).

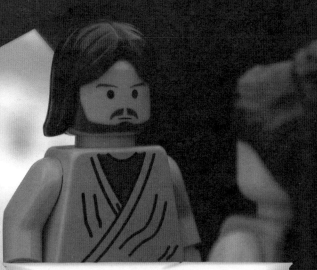

AND JESUS SAID TO HER, "DO NOT TOUCH ME, FOR I HAVE NOT YET ASCENDED TO MY FATHER."

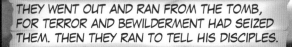
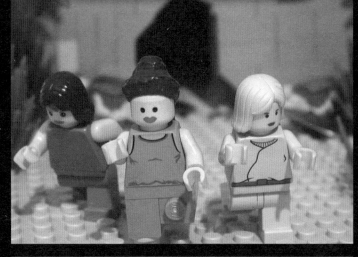

THEY WENT OUT AND RAN FROM THE TOMB, FOR TERROR AND BEWILDERMENT HAD SEIZED THEM. THEN THEY RAN TO TELL HIS DISCIPLES.

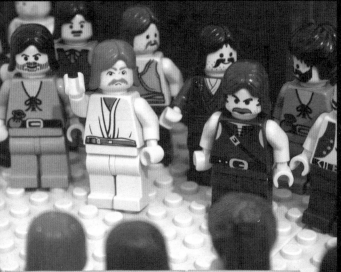

BUT THESE WORDS SEEMED LIKE PURE NONSENSE TO THEM, AND THEY DID NOT BELIEVE THEM.

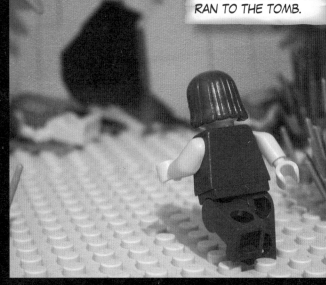

BUT PETER GOT UP AND RAN TO THE TOMB.

HE SAW ONLY THE STRIPS OF LINEN CLOTH.

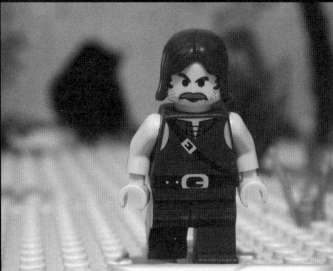

THEN HE HEADED HOME, WONDERING WHAT HAD HAPPENED.

Jn 20:17 | Mk 16:18; Mt 28:8 | Lk 24:10 | Lk 24:12 | Lk 24:12 | Lk 24:12

THE GUARDS WENT INTO THE CITY AND TOLD THE CHIEF PRIESTS EVERYTHING THAT HAD HAPPENED.

THEY FORMED A PLAN, GIVING THE SOLDIERS A LARGE SUM OF MONEY AND TELLING THEM, "YOU ARE TO SAY, 'HIS DISCIPLES CAME AT NIGHT AND STOLE HIS BODY WHILE WE WERE ASLEEP.'"

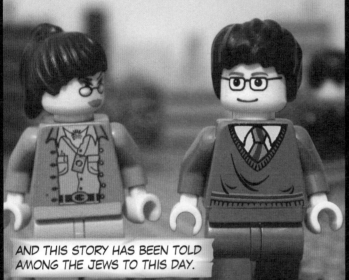

AND THIS STORY HAS BEEN TOLD AMONG THE JEWS TO THIS DAY.

THAT EVENING, THE DISCIPLES WERE TOGETHER WITH THE DOORS LOCKED FOR FEAR OF THE JEWS.

AND JESUS CAME, STANDING IN THEIR MIDST, AND SAID, "PEACE BE WITH YOU." BUT THEY WERE TERRIFIED AND THOUGHT THEY WERE SEEING A GHOST.

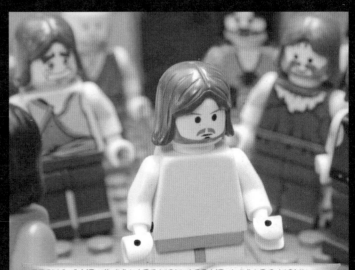

JESUS SAID, "WHY ARE YOU AFRAID. WHY DO YOU DOUBT? LOOK AT MY HANDS. TOUCH ME AND SEE! A GHOST DOES NOT HAVE FLESH AND BONES AS I HAVE."

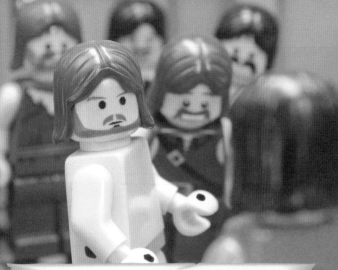

WHILE THEY WERE STILL IN DISBELIEF, JESUS ASKED THEM, "DO YOU HAVE ANYTHING TO EAT HERE?"

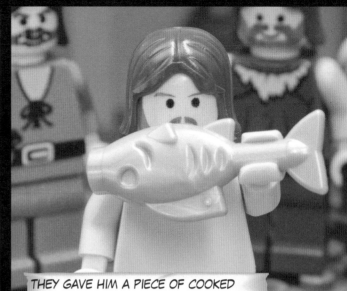

THEY GAVE HIM A PIECE OF COOKED FISH, AND HE ATE IT IN FRONT OF THEM.

NOW ONE OF THE TWELVE, THOMAS, WAS NOT THERE WHEN JESUS CAME. AND THE OTHER DISCIPLES SAID TO HIM, "WE HAVE SEEN THE LORD!"

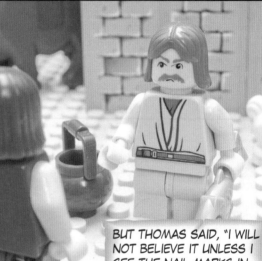

BUT THOMAS SAID, "I WILL NOT BELIEVE IT UNLESS I SEE THE NAIL MARKS IN HIS HANDS AND PUT MY HAND INTO HIS SIDE!"

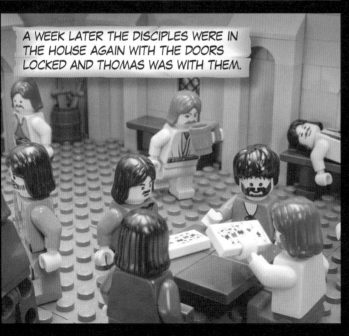

A WEEK LATER THE DISCIPLES WERE IN THE HOUSE AGAIN WITH THE DOORS LOCKED AND THOMAS WAS WITH THEM.

JESUS CAME AND STOOD IN THEIR MIDST AND SAID, "PEACE BE WITH YOU."

Lk 24:41 | Lk 24:42 | Jn 20:24-25 | Jn 20:25 | Jn 20:26 | Jn 20:26

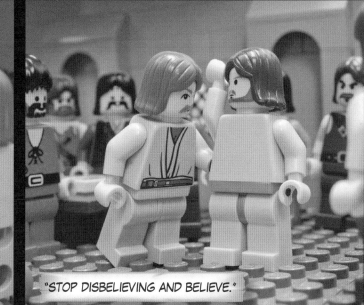

THEN HE SAID TO THOMAS, "LOOK AT MY HANDS. PUT YOUR HAND HERE IN MY SIDE."

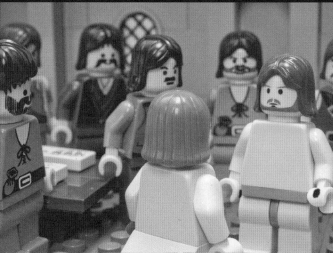

"STOP DISBELIEVING AND BELIEVE."

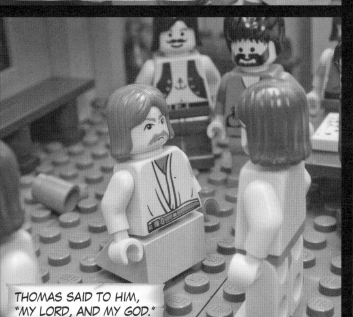

THOMAS SAID TO HIM, "MY LORD, AND MY GOD."

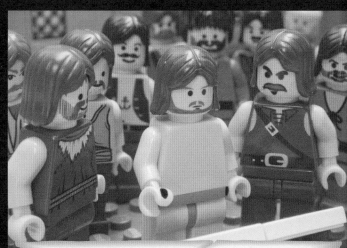

AND JESUS SAID, "THOMAS, YOU BELIEVE BECAUSE YOU HAVE SEEN. BLESSED ARE THOSE WHO HAVE NOT SEEN AND YET BELIEVE."

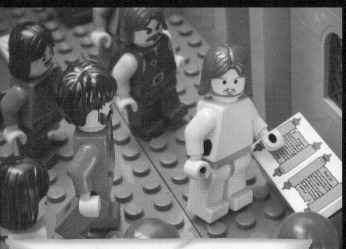

THEN HE OPENED THEIR MINDS SO THEY COULD UNDERSTAND THE SCRIPTURES, SAYING, "EVERYTHING WRITTEN ABOUT ME IN THE LAW OF MOSES, THE PROPHETS, AND THE PSALMS MUST BE FULFILLED."

"THUS IT IS WRITTEN THAT THE MESSIAH MUST SUFFER AND AFTER THREE DAYS RISE FROM THE DEAD. THE REPENTANCE FOR THE FORGIVENESS OF SINS MUST BE PREACHED TO ALL NATIONS, STARTING IN JERUSALEM."

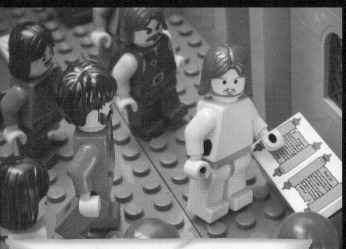

THEN HE BREATHED ON THEM, SAYING, "RECEIVE THE HOLY SPIRIT."

"IF YOU FORGIVE ANYONE'S SINS, THEY ARE FORGIVEN. IF YOU DON'T FORGIVE THEM, THEY AREN'T FORGIVEN."

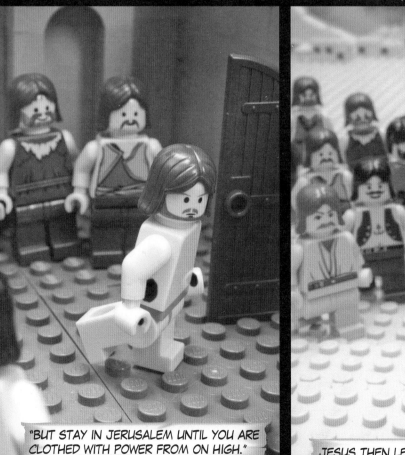

"BUT STAY IN JERUSALEM UNTIL YOU ARE CLOTHED WITH POWER FROM ON HIGH."

JESUS THEN LED THEM OUT AS FAR AS BETHANY.

Jn 20:22 | Jn 20:23 | Lk 24:49 | Lk 24:50

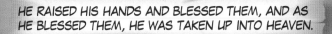

HE RAISED HIS HANDS AND BLESSED THEM, AND AS
HE BLESSED THEM, HE WAS TAKEN UP INTO HEAVEN.

Lk 24:50-51

145

LATER ON, SIMON PETER, THOMAS, NATHANEAL, THE SONS OF ZEBEDEE, AND TWO OTHER DISCIPLES WERE TOGETHER. SIMON PETER SAID, "I AM GOING FISHING." THEY REPLIED, "WE WILL GO WITH YOU."

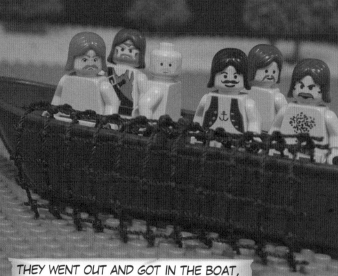

THEY WENT OUT AND GOT IN THE BOAT, BUT CAUGHT NOTHING THAT NIGHT.

IN THE EARLY MORNING, JESUS STOOD ON THE SHORE, THOUGH THE DISCIPLES DID NOT REALIZE THAT IT WAS JESUS. HE CALLED OUT, "HAVEN'T YOU CAUGHT ANY FISH, FRIENDS?"

"NO!" THEY ANSWERED, AND JESUS SAID, "THROW THE NET OUT TO THE RIGHT SIDE OF THE BOAT AND YOU'LL FIND SOME."

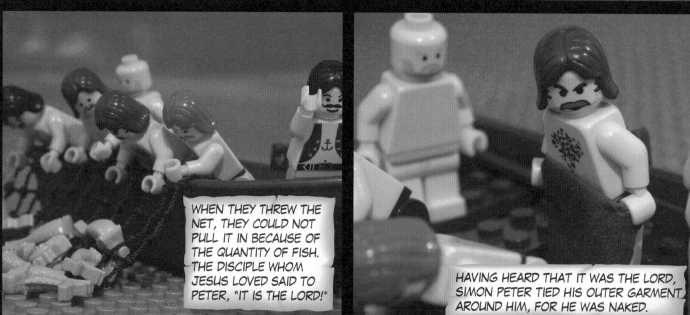

WHEN THEY THREW THE NET, THEY COULD NOT PULL IT IN BECAUSE OF THE QUANTITY OF FISH. THE DISCIPLE WHOM JESUS LOVED SAID TO PETER, "IT IS THE LORD!"

HAVING HEARD THAT IT WAS THE LORD, SIMON PETER TIED HIS OUTER GARMENT AROUND HIM, FOR HE WAS NAKED.

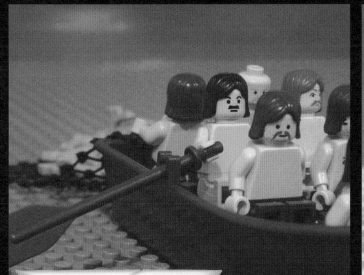

THE DISCIPLES TOOK THE BOAT IN, TOWING THE NET WITH THE FISH.

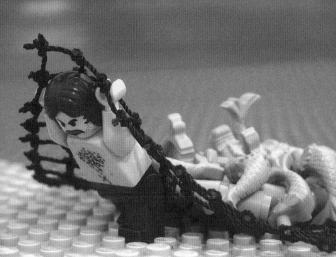

SIMON PETER DRAGGED THE NET ASHORE. IT WAS FULL OF BIG FISH—ONE HUNDRED AND FIFTY-THREE OF THEM.

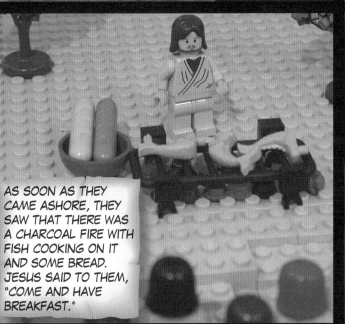

AS SOON AS THEY CAME ASHORE, THEY SAW THAT THERE WAS A CHARCOAL FIRE WITH FISH COOKING ON IT AND SOME BREAD. JESUS SAID TO THEM, "COME AND HAVE BREAKFAST."

WHEN THEY HAD EATEN, JESUS SAID TO SIMON PETER, "SIMON, SON OF JOHN, DO YOU LOVE ME MORE THAN THESE OTHERS DO?"

HE ANSWERED, "YES, LORD, YOU KNOW I LOVE YOU." JESUS SAID TO HIM, "FEED MY LAMBS."

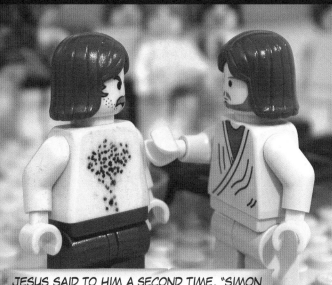

JESUS SAID TO HIM A SECOND TIME, "SIMON SON OF JOHN, DO YOU LOVE ME?"

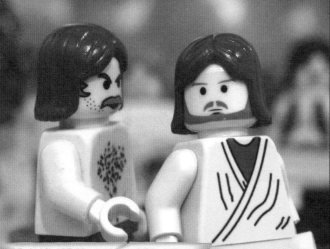

HE ANSWERED, "YES, LORD, YOU KNOW I LOVE YOU." JESUS SAID TO HIM, "TAKE CARE OF MY SHEEP."

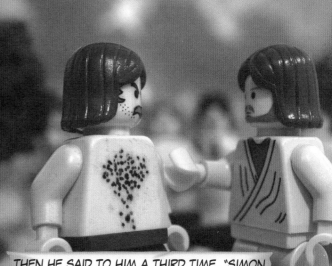

THEN HE SAID TO HIM A THIRD TIME, "SIMON SON OF JOHN, DO YOU LOVE ME?"

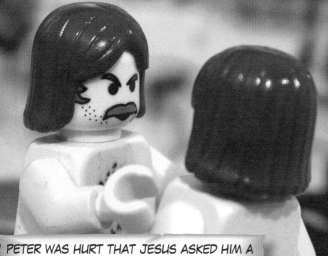

PETER WAS HURT THAT JESUS ASKED HIM A THIRD TIME AND HE SAID, "LORD, YOU KNOW EVERYTHING! YOU KNOW I LOVE YOU!"

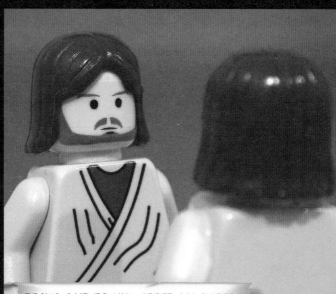
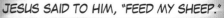

JESUS SAID TO HIM, "FEED MY SHEEP."

AFTER THIS, HE SAID TO PETER, "FOLLOW ME."

PETER TURNED AND SAW THE DISCIPLE WHOM JESUS LOVED FOLLOWING THEM.

AND SEEING HIM, PETER SAID TO JESUS, "WHAT ABOUT HIM, LORD?"

JESUS SAID, "IF I WANT HIM TO REMAIN UNTIL I COME, WHAT DOES IT MATTER TO YOU? YOU ARE TO FOLLOW ME."

THE RUMOR THEN STARTED AMONG THE BROTHERS THAT THIS DISCIPLE WOULD NOT DIE. BUT JESUS DID NOT SAY HE WOULD NOT DIE, ONLY "IF I WANT HIM TO REMAIN UNTIL I COME, WHAT DOES IT MATTER TO YOU?"

THIS IS THE DISCIPLE WHO TESTIFIES TO THESE THINGS AND WHO HAS WRITTEN THEM DOWN. WE KNOW THAT HIS TESTIMONY IS TRUE.

PART II.
ACTS OF THE APOSTLES

ONE DAY PETER STOOD UP IN FRONT OF THE BRETHREN WHO NUMBERED ABOUT ONE HUNDRED AND TWENTY.

HE SAID, "BROTHERS, THE SCRIPTURE HAD TO BE FULFILLED CONCERNING JUDAS, WHO SERVED AS GUIDE TO THOSE WHO ARRESTED JESUS."

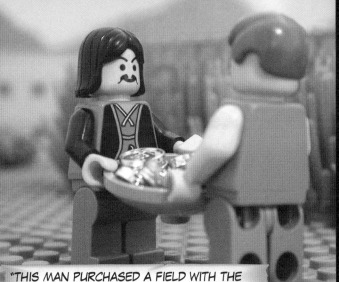

"THIS MAN PURCHASED A FIELD WITH THE MONEY HE WAS PAID FOR HIS WICKEDNESS."

"THERE HE FELL HEADFIRST."

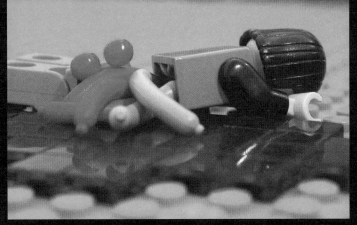

"AND HE BURST OPEN IN HIS MIDSECTION, AND ALL HIS INTESTINES GUSHED OUT."

"THIS BECAME KNOWN TO EVERYBODY IN JERUSALEM AND THAT FIELD WAS CALLED FIELD OF BLOOD."

PETER SAID, "IN THE BOOK OF PSALMS IT SAYS, 'LET ANOTHER TAKE OVER HIS OFFICE.' SO ONE OF THE MEN WHO HAS BEEN WITH US SINCE THE TIME OF JOHN'S BAPTISM MUST BECOME A WITNESS WITH US."

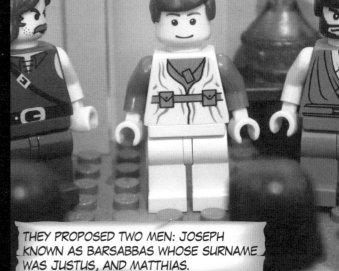

THEY PROPOSED TWO MEN: JOSEPH KNOWN AS BARSABBAS WHOSE SURNAME WAS JUSTUS, AND MATTHIAS.

THEN THEY PRAYED, "LORD, SHOW US WHICH OF THESE TWO YOU HAVE CHOSEN TO TAKE THE PLACE OF THE APOSTLESHIP JUDAS LEFT TO GO TO HIS PROPER PLACE."

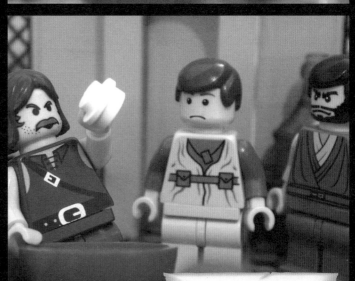

THEN THEY CAST LOTS, AND THE LOT FELL TO MATTHIAS.

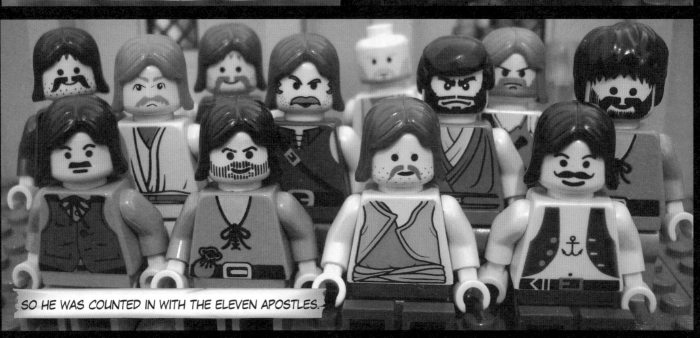

SO HE WAS COUNTED IN WITH THE ELEVEN APOSTLES.

WHEN THE DAY OF PENTECOST CAME, THEY WERE ALL TOGETHER WHEN SUDDENLY A SOUND CAME FROM THE SKY LIKE A VIOLENT WIND, AND TONGUES OF FIRE APPEARED THAT SEPARATED AND CAME TO REST ON EACH OF THEM.

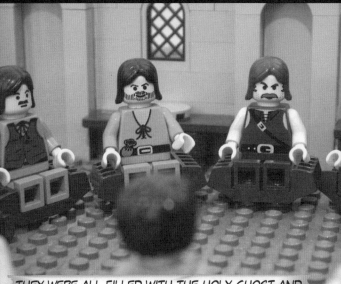

THEY WERE ALL FILLED WITH THE HOLY GHOST AND BEGAN TO SPEAK IN DIFFERENT LANGUAGES.

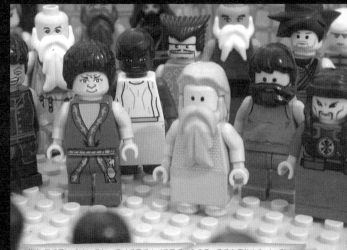

IN JERUSALEM THERE WERE GOD-FEARING MEN FROM EVERY NATION, AND AT THIS SOUND THEY ASSEMBLED IN CONFUSION, BECAUSE EACH ONE HEARD THEM SPEAKING IN HIS OWN LANGUAGE.

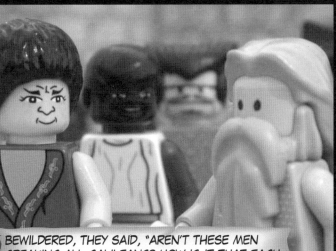

BEWILDERED, THEY SAID, "AREN'T THESE MEN SPEAKING ALL GALILEANS? HOW IS IT THAT EACH ONE OF US HEARS THEM IN HIS OWN NATIVE LANGUAGE?" AMAZED AND CONFUSED, THEY SAID TO ONE ANOTHER, "WHAT DOES THIS MEAN?"

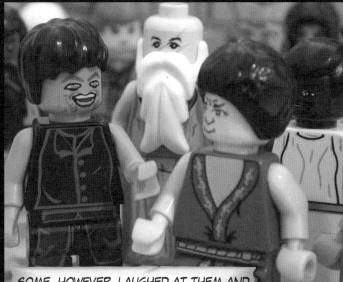

SOME, HOWEVER, LAUGHED AT THEM AND SAID, "THEY HAVE HAD TOO MUCH WINE!"

BUT PETER GOT UP, RAISED HIS VOICE, AND DECLARED TO THEM, "THESE MEN ARE NOT DRUNK! IT IS ONLY NINE O'CLOCK IN THE MORNING!"

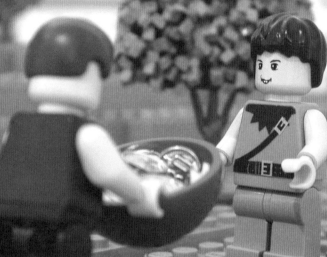

THE ENTIRE GROUP OF BELIEVERS HELD EVERYTHING IN COMMON, AND NO ONE CLAIMED PRIVATE OWNERSHIP OF ANY POSSESSIONS. ANY WHO OWNED HOUSES OR LAND SOLD THEM, AND THE MONEY THEY LAID AT THE FEET OF THE APOSTLES.

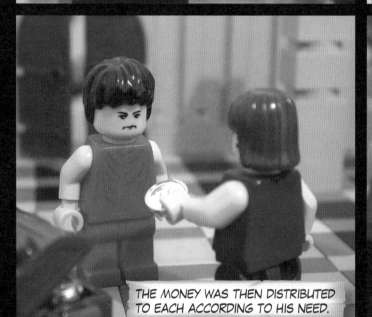

THE MONEY WAS THEN DISTRIBUTED TO EACH ACCORDING TO HIS NEED.

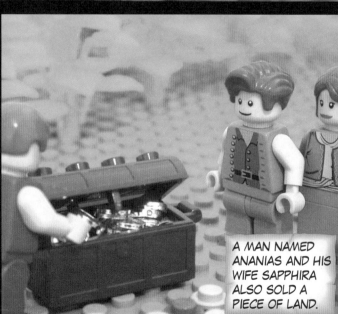

JOSEPH OF CYPRUS, WHO THE APOSTLES CALLED BARNABAS, SOLD SOME LAND THAT BELONGED TO HIM.

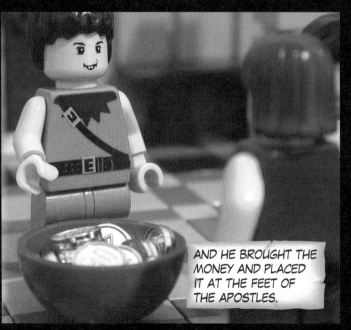

AND HE BROUGHT THE MONEY AND PLACED IT AT THE FEET OF THE APOSTLES.

A MAN NAMED ANANIAS AND HIS WIFE SAPPHIRA ALSO SOLD A PIECE OF LAND.

BUT WITH HIS WIFE'S FULL KNOWLEDGE, HE HELD BACK PART OF THE MONEY.

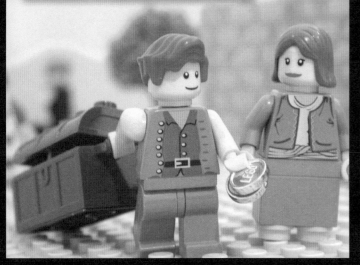

AND HE BROUGHT THE REST AND PLACED IT AT THE FEET OF THE APOSTLES.

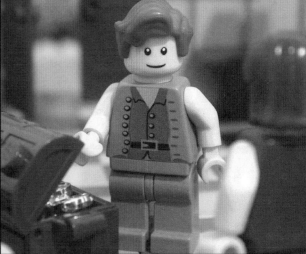

BUT PETER SAID, "ANANIAS, HOW COULD SATAN SO FILL YOUR HEART THAT YOU HAVE LIED TO THE HOLY SPIRIT AND KEPT SOME OF THE MONEY? YOU HAVE LIED NOT TO MEN, BUT TO GOD!"

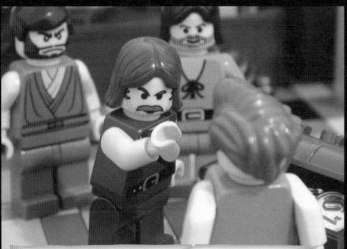

WHEN HE HEARD THIS, ANANIAS FELL DOWN DEAD.

AND A GREAT FEAR CAME OVER ALL WHO HEARD OF IT.

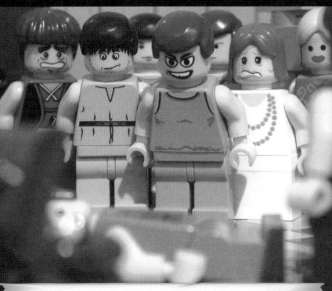

THEN THE YOUNG MEN WRAPPED HIM UP, CARRIED HIM OUTSIDE, AND BURIED HIM.

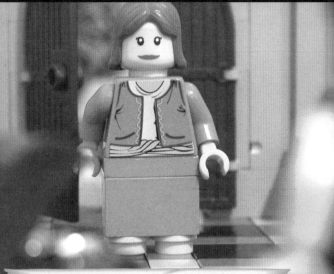

ABOUT THREE HOURS LATER HIS WIFE CAME IN, UNAWARE OF WHAT HAD HAPPENED.

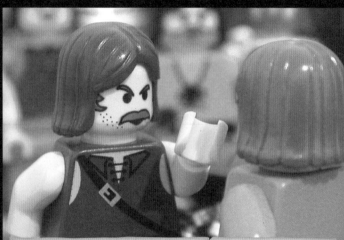

AND PETER SAID TO HER, "TELL ME, WAS THIS THE AMOUNT YOU WERE PAID FOR THE LAND?"

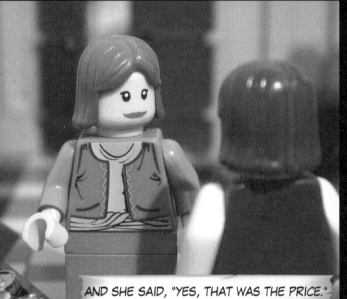

AND SHE SAID, "YES, THAT WAS THE PRICE."

THEN PETER SAID, "HOW COULD YOU AGREE TO TEST THE SPIRIT OF THE LORD? LISTEN! IT IS THE FOOT-STEPS OF THE MEN WHO JUST BURIED YOUR HUSBAND, AND THEY WILL CARRY YOU OUT AS WELL!"

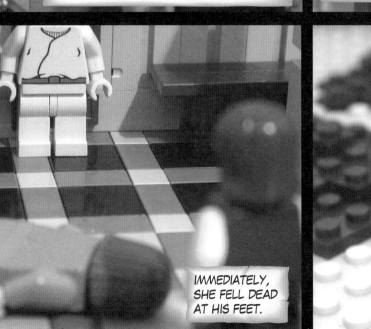

IMMEDIATELY, SHE FELL DEAD AT HIS FEET.

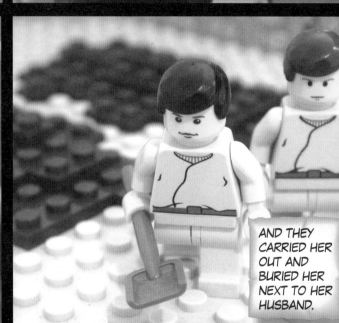

AND THEY CARRIED HER OUT AND BURIED HER NEXT TO HER HUSBAND.

AND A GREAT FEAR CAME OVER THE WHOLE CHURCH AND EVERYONE WHO HEARD ABOUT IT.

THE APOSTLES PERFORMED MANY SIGNS AND WONDERS AMONG THE PEOPLE.

CROWDS CAME FROM THE TOWNS AROUND JERUSALEM, BRINGING WITH THEM THOSE TORMENTED BY EVIL SPIRITS.

AND ALL OF THEM WERE CURED.

THEN THE HIGH PRIEST AND THE SADDUCEES, FILLED WITH JEALOUSY, ARRESTED THE APOSTLES.

AND THEY WERE PUT IN THE PUBLIC JAIL.

BUT DURING THE NIGHT, THE ANGEL OF THE LORD OPENED THE PRISON DOORS AND LED THEM OUT.

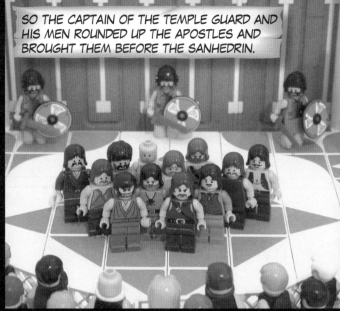

SO THE CAPTAIN OF THE TEMPLE GUARD AND HIS MEN ROUNDED UP THE APOSTLES AND BROUGHT THEM BEFORE THE SANHEDRIN.

AT DAWN THEY WENT TO THE TEMPLE AND BEGAN TO PREACH. PETER SAID, "THE SUN WILL BE CHANGED TO DARKNESS AND THE MOON TO BLOOD BEFORE THE GREAT AND GLORIOUS DAY OF THE LORD COMES."

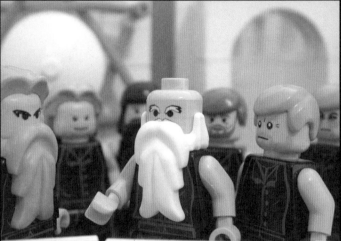

THEY WERE FURIOUS AND WANTED TO PUT THEM TO DEATH, BUT A PHARISEE NAMED GAMALIEL SPOKE UP AND SAID, "MEN OF ISRAEL, BE CAUTIOUS WITH WHAT YOU DO TO THESE MEN."

"SOME TIME AGO A MAN NAMED THEUDAS AROSE AND CLAIMED TO BE IMPORTANT AND ABOUT FOUR HUNDRED MEN JOINED HIM."

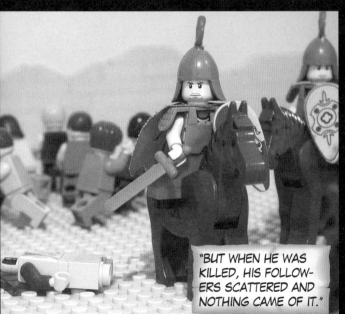

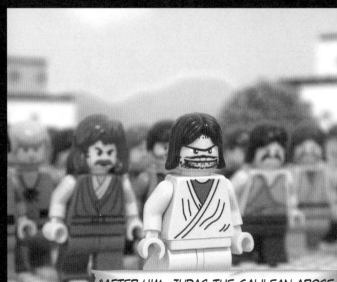

"BUT WHEN HE WAS KILLED, HIS FOLLOWERS SCATTERED AND NOTHING CAME OF IT."

"AFTER HIM, JUDAS THE GALILEAN AROSE AND ACQUIRED MANY FOLLOWERS."

"BUT HE TOO WAS KILLED, AND ALL HIS FOLLOWERS SCATTERED."

"SO LEAVE THESE MEN ALONE, AND IF THIS MOVEMENT OF THEIRS IS OF HUMAN ORIGINS, NOTHING WILL COME OF IT. BUT IF IT IS FROM GOD, YOU WILL NOT BE ABLE TO DESTROY THEM."

SO THEY TOOK HIS ADVICE. THEY CALLED THE APOSTLES IN AND HAD THEM FLOGGED.

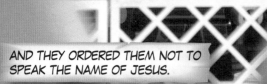

AND THEY ORDERED THEM NOT TO SPEAK THE NAME OF JESUS.

SO THE APOSTLES LEFT THE SANHEDRIN, REJOICING IN THE HONOR OF HAVING SUFFERED DISGRACE FOR THE NAME.

NOW STEPHEN WAS PERFORMING MANY SIGNS AND WONDERS AMONG THE PEOPLE.

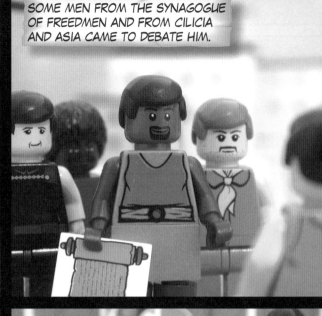

SOME MEN FROM THE SYNAGOGUE OF FREEDMEN AND FROM CILICIA AND ASIA CAME TO DEBATE HIM.

BUT THEY WERE UNABLE TO STAND AGAINST THE WISDOM AND SPIRIT WITH WHICH STEPHEN SPOKE.

SO THEY INSTIGATED SOME MEN TO SAY, "WE HAVE HEARD STEPHEN SPEAK WORDS OF BLASPHEMY AGAINST MOSES AND GOD." AND STEPHEN WAS SEIZED AND BROUGHT BEFORE THE SANHEDRIN.

AND THE HIGH PRIEST ASKED HIM, "IS THIS TRUE?"

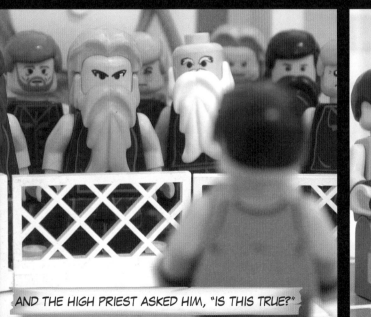

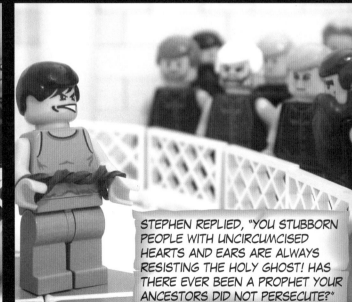

STEPHEN REPLIED, "YOU STUBBORN PEOPLE WITH UNCIRCUMCISED HEARTS AND EARS ARE ALWAYS RESISTING THE HOLY GHOST! HAS THERE EVER BEEN A PROPHET YOUR ANCESTORS DID NOT PERSECUTE?"

Acts 6:8 | Acts 6:9 | Acts 6:10 | Acts 6:11-12 | Acts 7:1 | Acts 7:2, 7:51-52

"THEY KILLED THOSE WHO PREDICTED THE COMING OF THE RIGHTEOUS ONE WHOM YOU HAVE NOW BE-TRAYED AND MURDERED. YOU WERE GIVEN THE LAW THROUGH ANGELS, BUT YOU HAVE NOT OBEYED IT!"

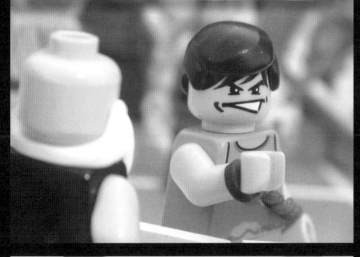

HEARING THIS, THEY WERE FURIOUS AND THEY RUSHED AT HIM AND TOOK HIM OUTSIDE.

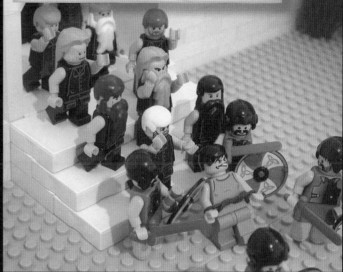

THE WITNESSES LAID THEIR CLOAKS AT THE FEET OF A MAN NAMED SAUL, AND THEY BEGAN TO STONE STEPHEN.

AS THEY WERE STONING HIM, STEPHEN KNELT DOWN AND SAID, "LORD, DO NOT HOLD THIS SIN AGAINST THEM."

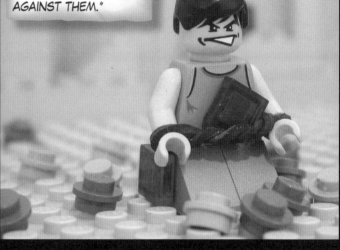

THEN HE DIED. AND SAUL FULLY APPROVED OF THE KILLING.

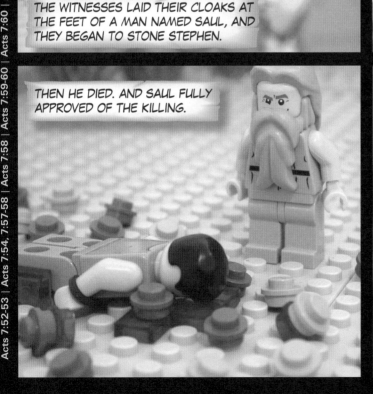

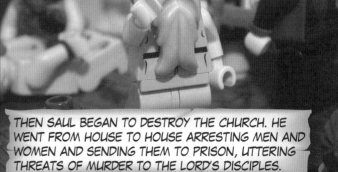

THEN SAUL BEGAN TO DESTROY THE CHURCH. HE WENT FROM HOUSE TO HOUSE ARRESTING MEN AND WOMEN AND SENDING THEM TO PRISON, UTTERING THREATS OF MURDER TO THE LORD'S DISCIPLES.

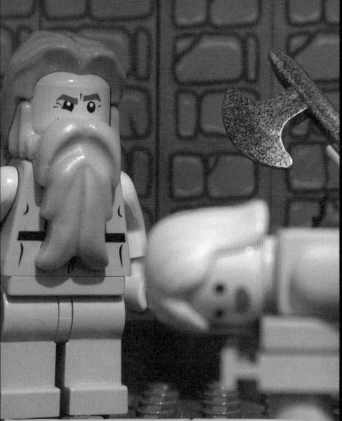

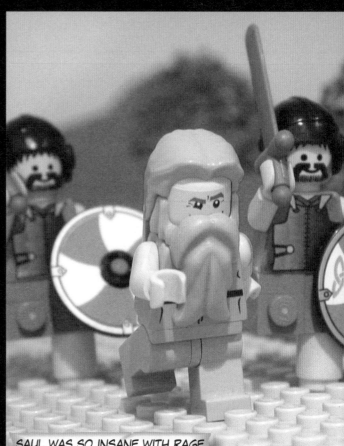

IN JERUSALEM HE PUT MANY OF THE HOLY ONES IN PRISON, AND WHEN THEY WERE EXECUTED, HE CAST HIS VOTE AGAINST THEM.

SAUL WAS SO INSANE WITH RAGE AGAINST THEM, HE PURSUED THEM TO FOREIGN CITIES.

WHILE TRAVELING AND APPROACHING DAMASCUS, SUDDENLY A LIGHT FROM HEAVEN MORE BRILLIANT THAN THE SUN SHONE ALL AROUND HIM, AND HE HEARD A VOICE SAYING, "SAUL, SAUL, WHY ARE YOU PERSECUTING ME?"

THE MEN TRAVELING WITH SAUL STOOD SPEECHLESS, FOR THOUGH THEY COULD SEE THE LIGHT, THEY COULD NOT HEAR THE VOICE. SAUL FELL TO THE GROUND AND SAID, "WHO ARE YOU, LORD?" AND HE REPLIED, "I AM JESUS, WHOM YOU ARE PERSECUTING."

"NOW GET UP AND GO INTO THE CITY, AND YOU WILL BE TOLD WHAT TO DO."

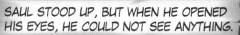

SAUL STOOD UP, BUT WHEN HE OPENED HIS EYES, HE COULD NOT SEE ANYTHING.

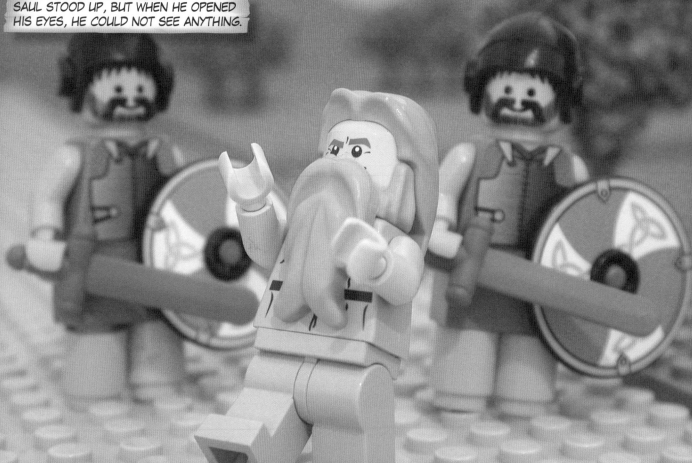

THEY LED HIM BY HAND TO DAMASCUS, AND FOR THREE DAYS HE COULD NOT SEE, AND HE DID NOT EAT OR DRINK ANYTHING.

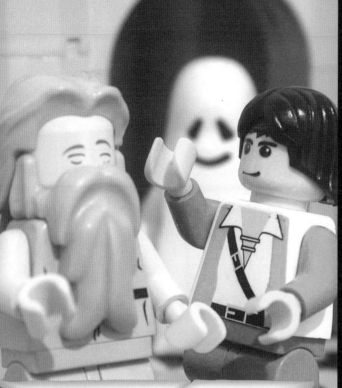

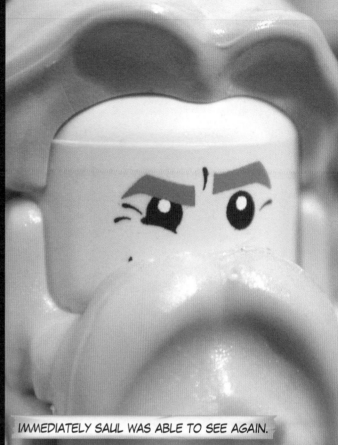

THEN A DISCIPLE WHO WAS IN DAMASCUS, NAMED ANANIAS, ENTERED THE HOUSE AND LAID HIS HANDS ON SAUL, SAYING, "I HAVE BEEN SENT BY THE LORD JESUS SO THAT YOU MAY RECOVER YOUR SIGHT AND BE FILLED WITH THE HOLY GHOST."

IMMEDIATELY SAUL WAS ABLE TO SEE AGAIN.

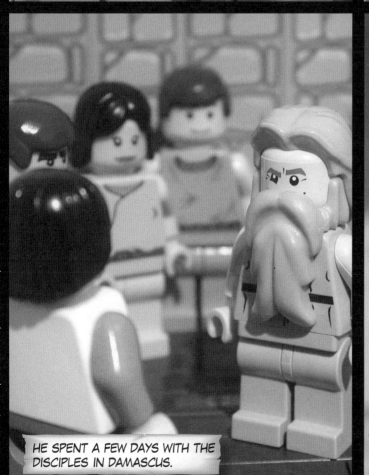

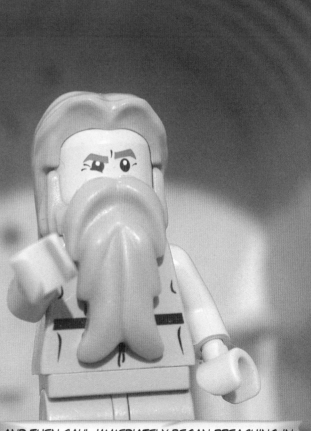

HE SPENT A FEW DAYS WITH THE DISCIPLES IN DAMASCUS.

AND THEN SAUL IMMEDIATELY BEGAN PREACHING IN THE SYNAGOGUES: "JESUS IS THE SON OF GOD."

SAUL BAFFLED THE JEWS LIVING IN DAMASCUS BY DEMONSTRATING THAT JESUS IS THE MESSIAH.

AFTER SOME TIME, THE JEWS PLOTTED TO KILL SAUL, BUT HE LEARNED OF THEIR PLOT.

THEY WERE GUARDING THE CITY GATES DAY AND NIGHT SO THEY COULD KILL SAUL, BUT HIS FOLLOWERS TOOK HIM BY NIGHT AND LOWERED HIM IN A BASKET THROUGH AN OPENING IN THE WALL.

AROUND THIS TIME, KING HEROD ARRESTED SOME MEMBERS OF THE CHURCH AND HAD JAMES THE BROTHER OF JOHN BEHEADED.

SEEING THAT THIS PLEASED THE JEWS, HE HAD PETER ARRESTED AS WELL, PUTTING HIM IN PRISON WITH FOUR SQUADS OF FOUR SOLDIERS TO GUARD HIM.

ON THE NIGHT BEFORE HEROD WAS TO BRING HIM TO TRIAL, PETER WAS ASLEEP BETWEEN TWO SOLDIERS AND BOUND BY TWO CHAINS.

Acts 9:22 | Acts 9:23 | Acts 9:24-25 | Acts 12:12 | Acts 12:3 | Acts 12:6

SUDDENLY THE ANGEL OF THE LORD APPEARED AND STRUCK PETER ON THE SIDE, WAKING HIM UP, AND SAID, "GET UP! QUICKLY!" AND THE CHAINS FELL AWAY FROM HIS HANDS.

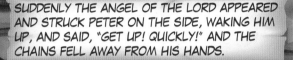

PETER FOLLOWED HIM, AND THEY PASSED THROUGH THE FIRST AND SECOND SETS OF GUARDS.

WHEN THEY CAME TO THE IRON CITY GATE, IT OPENED ITSELF. THEY WENT THROUGH AND THEN SUDDENLY THE ANGEL LEFT HIM.

PETER WENT STRAIGHT TO THE HOUSE OF MARY THE MOTHER OF JOHN, WHO WAS CALLED MARK, WHERE MANY HAD GATHERED TOGETHER TO PRAY, AND HE KNOCKED ON THE DOOR.

A SLAVE GIRL NAMED RHODA CAME TO ANSWER THE DOOR. RECOGNIZING PETER'S VOICE, SHE WAS SO OVERJOYED THAT SHE DID NOT OPEN THE DOOR BUT RAN BACK INSIDE TO SAY THAT PETER WAS AT THE DOOR.

THEY SAID TO HER, "YOU HAVE LOST YOUR MIND! IT MUST BE HIS ANGEL!"

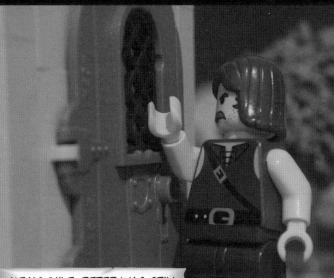

MEANWHILE, PETER WAS STILL KNOCKING AT THE DOOR.

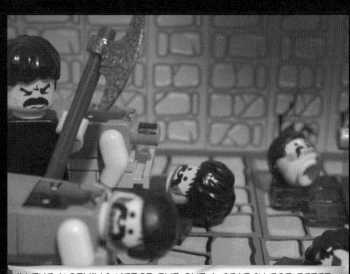

IN THE MORNING HEROD PUT OUT A SEARCH FOR PETER BUT DID NOT FIND HIM. AFTER QUESTIONING THE GUARDS HE GAVE ORDERS FOR THEM TO BE EXECUTED.

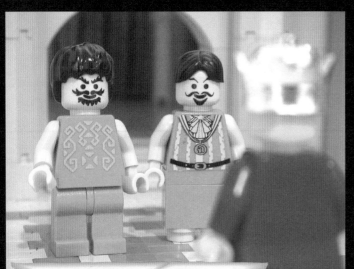

HEROD WAS HAVING A QUARREL WITH THE PEOPLE OF TYRE AND SIDON, AND THEY CAME TO HIM SEEKING RECONCILIATION.

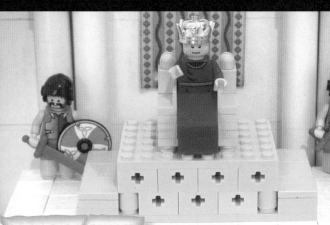

SO ON THE ARRANGED DAY, HEROD, WEARING HIS ROYAL ROBES AND SEATED ON HIS THRONE, MADE A PUBLIC ADDRESS TO THEM.

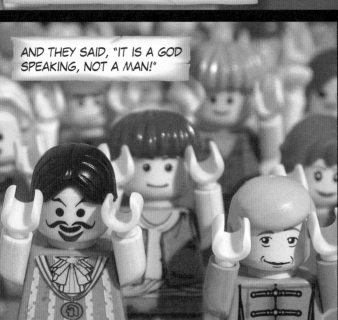

AND THEY SAID, "IT IS A GOD SPEAKING, NOT A MAN!"

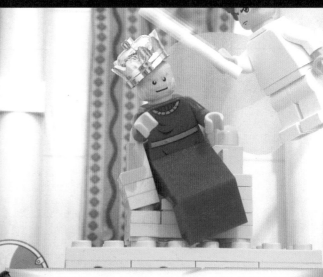

IMMEDIATELY THE ANGEL OF THE LORD STRUCK HEROD DOWN BECAUSE HE HAD NOT GIVEN PRAISE TO GOD.

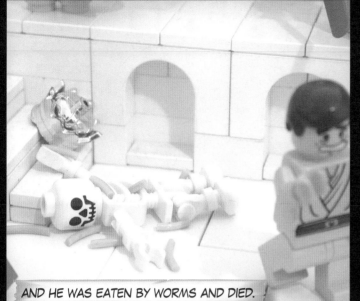

AND HE WAS EATEN BY WORMS AND DIED.

THESE WERE THE PROPHETS AND TEACHERS AT THE CHURCH IN ANTIOCH: BARNABAS, SIMEON CALLED NIGER, LUCIUS OF CYRENE, MANAEN (WHO HAD BEEN RAISED WITH HEROD THE TETRARCH), AND SAUL.

WHILE THEY WERE SERVING THE LORD AND FASTING, THE HOLY GHOST SAID, "SET APART BARNABAS AND SAUL FOR THE WORK TO WHICH I HAVE CALLED THEM."

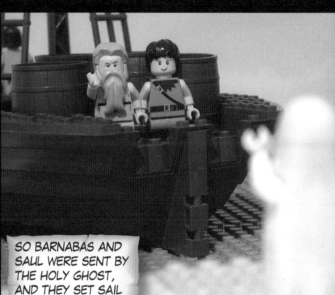

SO BARNABAS AND SAUL WERE SENT BY THE HOLY GHOST, AND THEY SET SAIL FOR CYPRUS.

THEY TRAVELED THE WHOLE ISLAND UNTIL THEY CAME TO PAPHOS WHERE THEY MET A JEWISH MAGICIAN AND FALSE PROPHET NAMED SON-OF-JESUS, AN ATTENDANT OF THE PROCONSUL SERGIUS PAULUS.

NOW SERGIUS PAULUS WAS AN INTELLIGENT MAN AND SUMMONED BARNABAS AND SAUL, WANTING TO HEAR THE WORD OF GOD. BUT THE MAGICIAN OPPOSED THEM, TRYING TO KEEP THE PROCONSUL FROM THE FAITH.

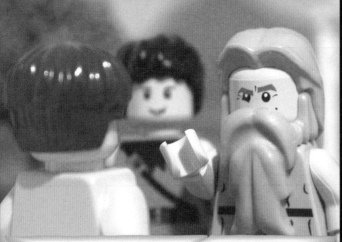

FILLED WITH THE HOLY GHOST, SAUL, WHO WAS ALSO CALLED PAUL, STARED RIGHT AT HIM AND SAID, "SON OF THE DEVIL, FULL OF DECEIT AND TRICKERY! WILL YOU NEVER STOP TWISTING THE WAYS OF THE LORD?"

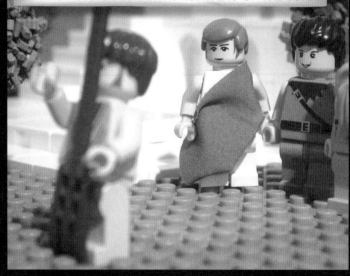

"NOW LOOK! THE HAND OF GOD IS AGAINST YOU, AND YOU WILL BE BLIND FOR A TIME, UNABLE TO SEE BY THE SUN!"

IMMEDIATELY MIST AND DARKNESS CAME OVER HIM, AND HE GROPED ABOUT TO FIND SOMEONE TO LEAD HIM BY HAND.

UPON SEEING THIS, THE PROCONSUL BELIEVED, FOR HE WAS ASTOUNDED AT THE TEACHING OF THE LORD.

WHILE IN LYSTRA, SOME JEWS ARRIVED FROM ANTIOCH AND ICONIUM AND TURNED THE PEOPLE AGAINST PAUL AND BARNABAS, AND THEY STONED PAUL.

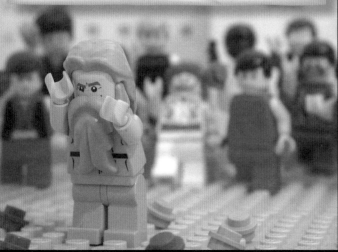

THEY DRAGGED HIM OUTSIDE THE CITY, THINKING HE WAS DEAD.

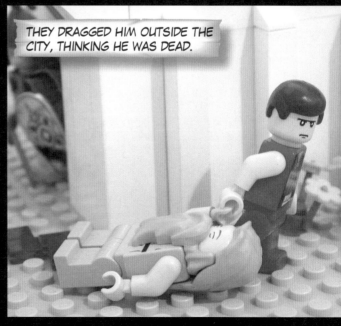

Acts 13:9-10 | Acts 13:11 | Acts 13:11 | Acts 13:12 | Acts 14:8, 14:19 | Acts 14:19

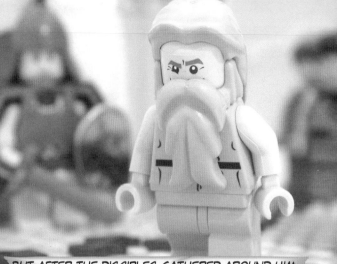

BUT AFTER THE DISCIPLES GATHERED AROUND HIM, PAUL GOT UP AND WENT BACK INTO THE CITY.

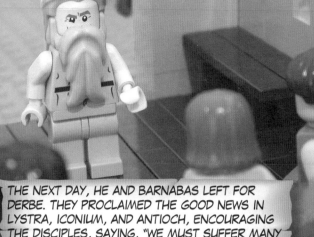

THE NEXT DAY, HE AND BARNABAS LEFT FOR DERBE. THEY PROCLAIMED THE GOOD NEWS IN LYSTRA, ICONIUM, AND ANTIOCH, ENCOURAGING THE DISCIPLES, SAYING, "WE MUST SUFFER MANY HARDSHIPS TO ENTER THE KINGDOM OF GOD."

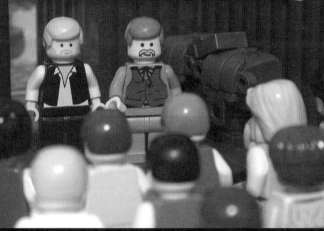

THEN SOME MEN CAME FROM JUDEA AND WERE TEACHING THE BROTHERS: "UNLESS YOU ARE CIRCUMCISED ACCORDING TO THE CUSTOM OF MOSES, YOU CANNOT BE SAVED."

THIS LEAD TO A MAJOR ARGUMENT AND DISPUTE WITH PAUL AND BARNABAS.

THEY DECIDED PAUL AND BARNABAS SHOULD GO TO JERUSALEM AND MEET WITH THE APOSTLES AND ELDERS ABOUT THIS CONTROVERSY.

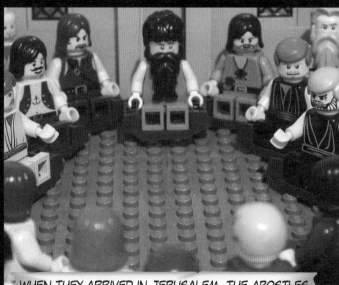

WHEN THEY ARRIVED IN JERUSALEM, THE APOSTLES AND ELDERS MET TO CONSIDER THIS QUESTION.

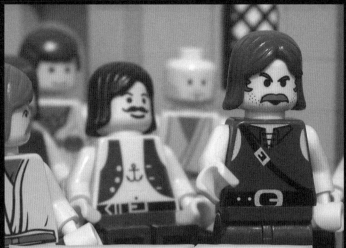

AFTER MUCH DISCUSSION, PETER STOOD AND SAID, "WHY ARE YOU TESTING GOD BY PLACING ON THE NECK OF DISCIPLES A YOKE THAT NEITHER WE NOR OUR ANCESTORS HAVE BEEN ABLE TO BEAR?"

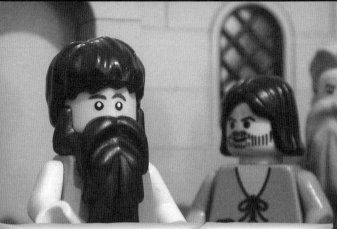

AFTER A SILENCE, JAMES SAID, "I DETERMINE THAT WE SHOULD NOT TROUBLE THE GENTILES WHO TURN TO GOD. WRITE AND TELL THEM TO ABSTAIN FROM MEAT SACRIFICED TO IDOLS, FROM BLOOD, FROM THE MEAT OF STRANGLED ANIMALS, AND FROM SEXUAL SIN."

SO THE APOSTLES, ELDERS, AND WHOLE CHURCH DECIDED TO SEND JUDAS CALLED BARSABBAS AND SILAS ALONG WITH PAUL AND BARNABAS TO ANTIOCH TO DELIVER THE LETTER.

WHEN THEY GATHERED THE CHURCH AND READ THE LETTER ALOUD, THE PEOPLE REJOICED AT ITS ENCOURAGING MESSAGE.

AFTER A FEW DAYS PAUL SAID TO BARNABAS, "LET'S GO BACK AND VISIT THE BROTHERS IN ALL THE TOWNS WHERE WE PREACHED AND SEE HOW THEY ARE."

BARNABAS WANTED TO BRING ALONG JOHN CALLED MARK, BUT PAUL INSISTED THEY NOT TAKE HIM BECAUSE HE HAD DESERTED THEM IN PAMPHYLIA.

THE ARGUMENT WAS SO SEVERE THAT THEY PARTED WAYS. BARNABAS TOOK MARK AND SAILED FOR CYPRUS WHILE PAUL CHOSE SILAS AND WENT THROUGH SYRIA AND CILICIA.

PAUL ALSO WENT TO DERBE AND TO LYSTRA. THERE WAS A DISCIPLE THERE NAMED TIMOTHY WHO WAS THE SON OF A JEWISH WOMAN WHO WAS A BELIEVER AND WHOSE FATHER WAS A GREEK.

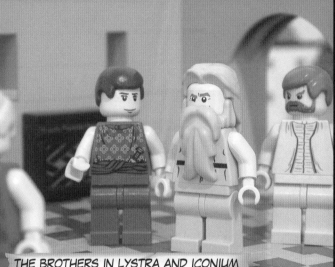

THE BROTHERS IN LYSTRA AND ICONIUM SPOKE WELL OF HIM, AND PAUL WANTED TIMOTHY TO COME WITH HIM.

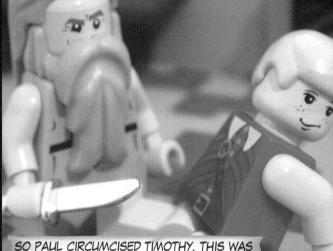

SO PAUL CIRCUMCISED TIMOTHY. THIS WAS BECAUSE OF THE JEWS IN THIS AREA WHO KNEW THAT HIS FATHER WAS A GREEK.

THEY TRAVELED THROUGH THE REGION OF PHRYGIA AND GALATIA, HAVING BEEN FORBIDDEN BY THE HOLY GHOST FROM PREACHING THE WORD IN THE PROVINCE OF ASIA.

THEY ATTEMPTED TO GO INTO BITHYNIA, BUT THE SPIRIT OF JESUS WOULD NOT ALLOW THEM.

PAUL'S TRAVELING COMPANIONS TOOK HIM AS FAR AS ATHENS AND THEN LEFT HIM. WHILE IN ATHENS, PAUL'S SOUL WAS ANGERED TO SEE A CITY FULL OF IDOLS.

SO HE DEBATED WITH THE JEWS IN THE SYNAGOGUE AND WITH ANYONE WHO HAPPENED TO BE IN THE MARKETPLACE EVERY DAY.

SOME EPICUREAN AND STOIC PHILOSOPHERS ARGUED WITH HIM, SOME SAYING, "WHAT IS THIS FOOLISH BABBLER TRYING TO SAY?" AND OTHERS SAYING, "HE SEEMS TO BE ADVOCATING SOME SORT OF STRANGE DEITIES."

THEY BROUGHT PAUL TO THE AREOPAGUS, SAYING, "TELL US THIS NEW DOCTRINE YOU ARE TEACHING. YOUR IDEAS ARE STRANGE, AND WE WANT TO KNOW THEIR MEANING."

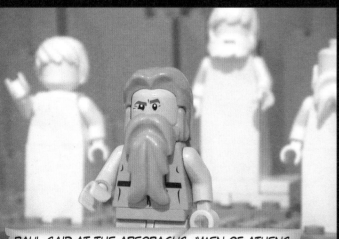

PAUL SAID AT THE AREOPAGUS, "MEN OF ATHENS, GOD HAS SET A DAY ON WHICH THE WORLD WILL BE JUDGED IN RIGHTEOUSNESS BY A MAN HE HAS APPOINTED. AND GOD HAS PROVED THIS TO ALL MEN BY RAISING HIM FROM THE DEAD."

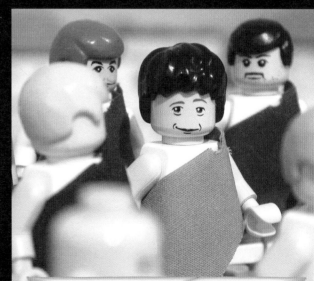

WHEN THEY HEARD ABOUT THE RESURRECTION FROM THE DEAD, SOME LAUGHED AT HIM.

BUT OTHERS SAID, "WE WOULD LIKE TO HEAR MORE ABOUT THIS ANOTHER TIME."

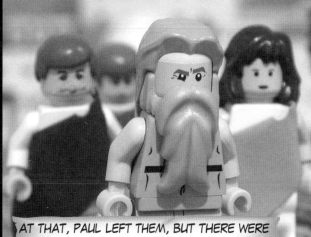

AT THAT, PAUL LEFT THEM, BUT THERE WERE A FEW WHO BECAME HIS FOLLOWERS AND BELIEVED, INCLUDING DIONYSIUS FROM THE AREOPAGUS AND A WOMAN NAMED DAMARIS.

PAUL LEFT ATHENS AND WENT TO CORINTH, AND ON EVERY SABBATH HE WOULD DEBATE IN THE SYNA-GOGUE, TRYING TO CONVERT JEWS AND GENTILES.

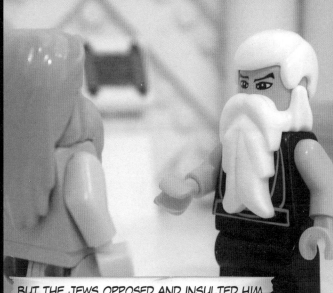

BUT THE JEWS OPPOSED AND INSULTED HIM.

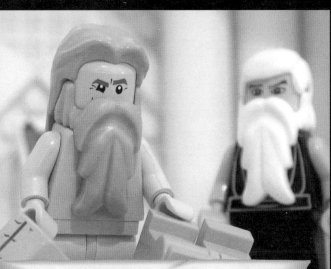

AND PAUL SHOOK OUT HIS CLOTHES IN FRONT OF THEM AND SAID, "YOUR BLOOD BE ON YOUR OWN HEADS! FROM NOW ON I WILL GO TO THE GENTILES!"

ONE NIGHT, THE LORD SAID TO PAUL IN A VISION, "SPEAK OUT AND DO NOT BE AFRAID. I AM WITH YOU AND NO ONE WILL ASSAULT OR HARM YOU BECAUSE I HAVE MANY PEOPLE IN THIS CITY."

SO PAUL STAYED THERE FOR EIGHTEEN MONTHS, BUT THEN THE JEWS MADE AN UNITED ASSAULT ON HIM.

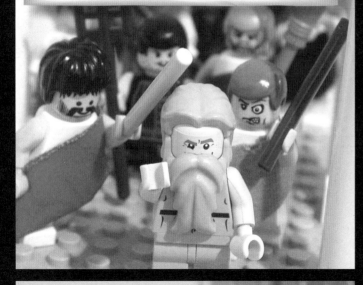

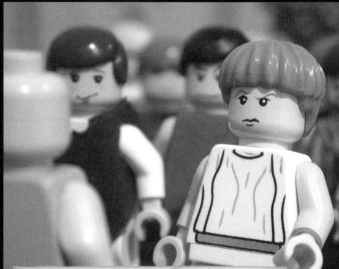

THEN PAUL LEFT THE BROTHERS TO SAIL FOR SYRIA. AT CENCHREA HE HAD HIS HAIR CUT OFF BECAUSE OF A VOW HE HAD MADE.

PAUL MADE HIS WAY BY LAND AS FAR AS EPHESUS WHERE HE CAME ACROSS SOME DISCIPLES AND ASKED THEM, "DID YOU RECEIVE THE HOLY GHOST WHEN YOU WERE BAPTIZED?"

AND THEY REPLIED, "NO, WE HAVE NOT EVEN HEARD THAT THERE IS A HOLY GHOST."

SO PAUL PLACED HIS HANDS ON THEM.

AND THE HOLY GHOST CAME UPON THEM, AND THEY BEGAN TO SPEAK IN TONGUES AND TO PROPHESY.

Acts 18:11 | Acts 18:18 | Acts 19:1-2 | Acts 19:2-3 | Acts 19:6 | Acts 19:6-7

THERE WERE ABOUT TWELVE MEN IN ALL.

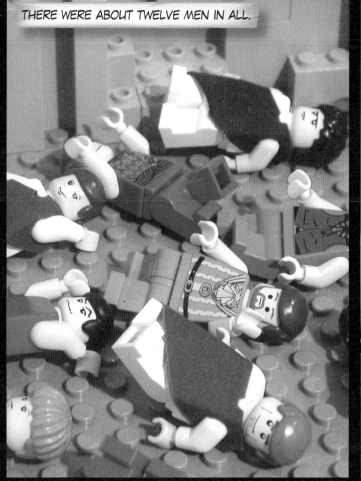

GOD PERFORMED SUCH EXTRAORDINARY MIRACLES THROUGH PAUL THAT EVEN HANDKERCHIEFS OR APRONS THAT HAD TOUCHED HIM WERE BROUGHT TO THE SICK, AND THE EVIL SPIRITS WENT OUT OF THEM.

NOW SEVEN SONS OF SCEVA, A JEWISH HIGH PRIEST, TRIED TO INVOKE THE NAME OF LORD JESUS OVER PEOPLE POSSESSED WITH DEMONS, SAYING, "I COMMAND YOU BY JESUS WHO IS PREACHED BY PAUL!"

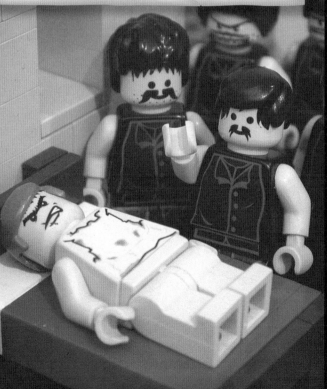

AND THE EVIL SPIRIT ANSWERED THEM, "I KNOW OF JESUS, AND I'VE HEARD OF PAUL, BUT WHO ARE YOU?"

THEN THE MAN WITH THE EVIL SPIRIT JUMPED AT THEM.

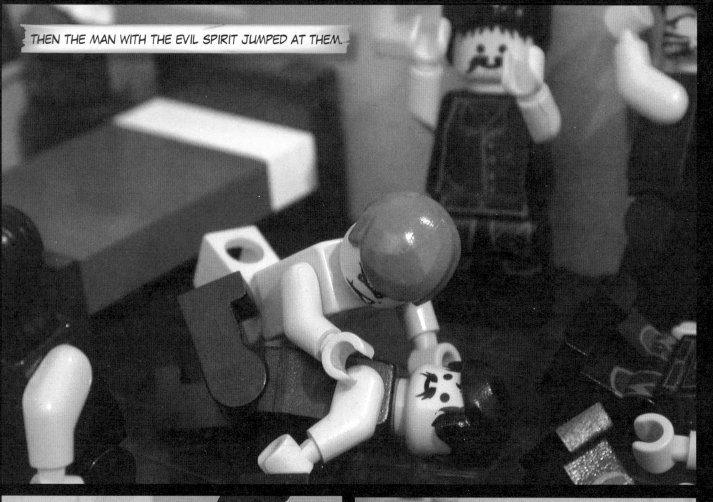

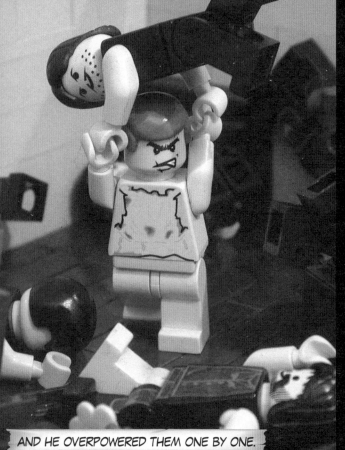

AND HE OVERPOWERED THEM ONE BY ONE.

HE BEAT THEM SO BADLY THEY CAME RUNNING OUT OF THE HOUSE NAKED AND BADLY WOUNDED.

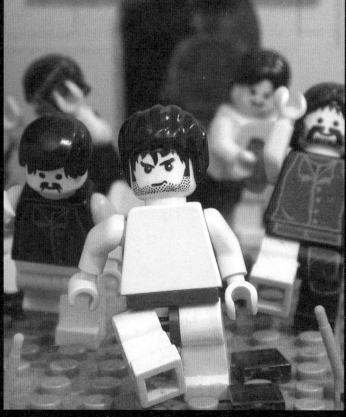

MANY BELIEVERS THEN CAME FORWARD AND A LARGE NUMBER WHO HAD PRACTICED MAGIC COLLECTED THEIR BOOKS AND BURNED THEM UP IN PUBLIC.

THE VALUE OF THE BOOKS WAS ABOUT 50,000 SILVER PIECES. IN THIS WAY THE WORD OF THE LORD SPREAD WIDELY AND GREW IN POWER.

WE SAILED FROM PHILIPPI TO TROAS AND ON SUNDAY WHEN WE ASSEMBLED TO BREAK BREAD, PAUL BEGAN TO SPEAK TO THE PEOPLE.

BECAUSE HE WAS INTENDING TO LEAVE THE NEXT DAY, PAUL EXTENDED HIS SPEECH TO THE MIDDLE OF THE NIGHT.

SITTING IN THE WINDOW, A YOUNG MAN NAMED EUTYCHUS WAS FALLING ASLEEP WHILE PAUL TALKED ON AND ON.

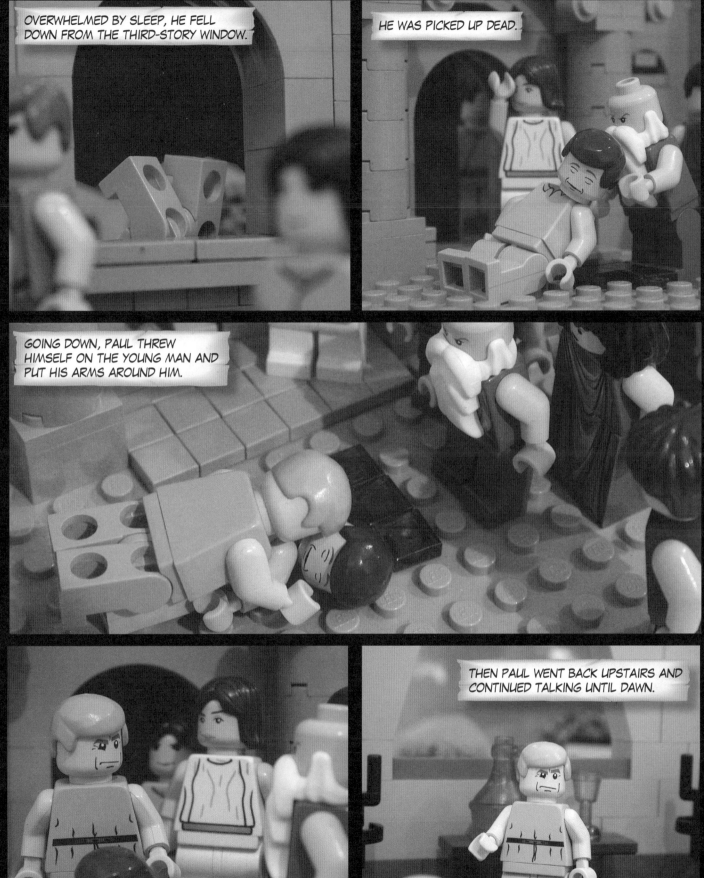

PART III.
REVELATION OF JOHN

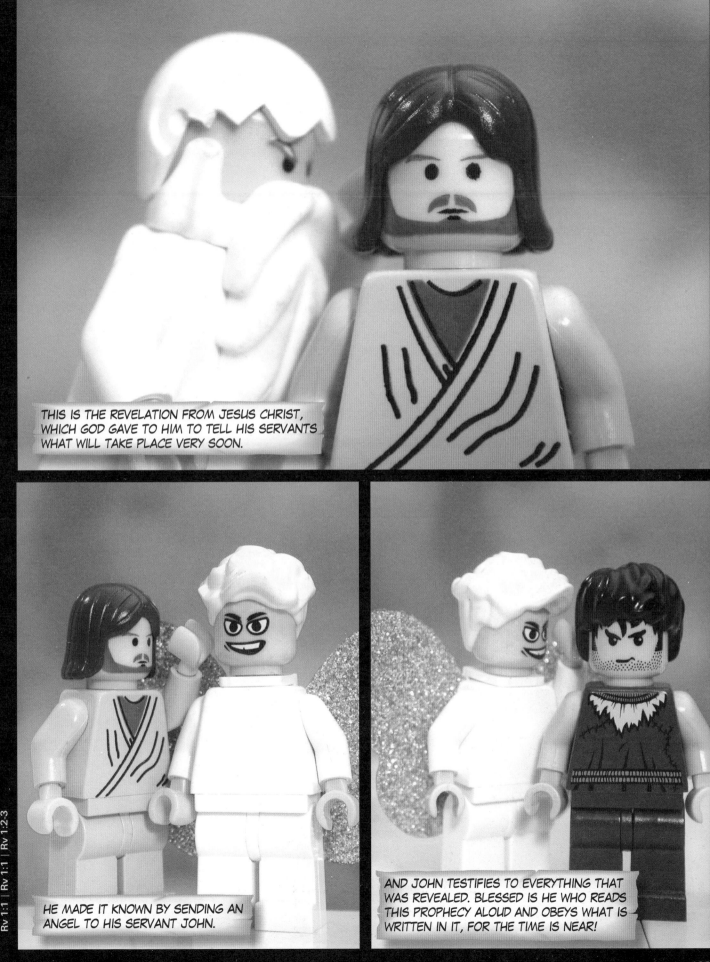

THIS IS THE REVELATION FROM JESUS CHRIST, WHICH GOD GAVE TO HIM TO TELL HIS SERVANTS WHAT WILL TAKE PLACE VERY SOON.

HE MADE IT KNOWN BY SENDING AN ANGEL TO HIS SERVANT JOHN.

AND JOHN TESTIFIES TO EVERYTHING THAT WAS REVEALED. BLESSED IS HE WHO READS THIS PROPHECY ALOUD AND OBEYS WHAT IS WRITTEN IN IT, FOR THE TIME IS NEAR!

I, JOHN, WAS ON THE ISLAND CALLED PATMOS BECAUSE OF THE WORD OF GOD AND THE TESTIMONY ABOUT JESUS.

IT WAS ON THE LORD'S DAY, AND I WAS IN THE SPIRIT WHEN BEHIND ME I HEARD A LOUD VOICE LIKE A TRUMPET SAYING, "WRITE IN A BOOK WHAT YOU SEE AND SEND IT TO THE SEVEN CHURCHES: EPHESUS, SMYRNA, PERGAMUM, THYATIRA, SARDIS, PHILADELPHIA, AND LAODICEA."

I TURNED TO SEE WHO WAS SPEAKING TO ME, AND I SAW SEVEN GOLDEN LAMPSTANDS, AND IN THEIR MIDST WAS ONE LIKE A SON OF MAN, AND HIS FACE SHONE LIKE THE SUN AT FULL FORCE.

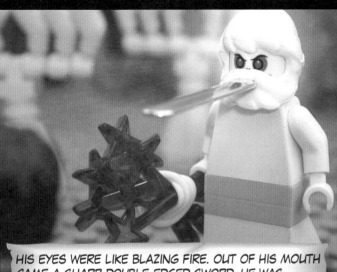

HIS EYES WERE LIKE BLAZING FIRE. OUT OF HIS MOUTH CAME A SHARP DOUBLE-EDGED SWORD. HE WAS DRESSED IN A LONG ROBE WITH A GOLDEN BELT, AND IN HIS RIGHT HAND WERE HELD SEVEN STARS.

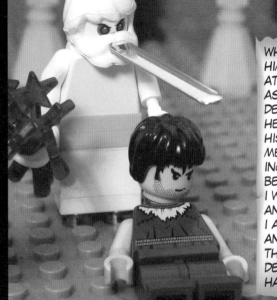

WHEN I SAW HIM, I FELL AT HIS FEET AS THOUGH DEAD. BUT HE PLACED HIS HAND ON ME, SAYING, "DO NOT BE AFRAID. I WAS DEAD AND LOOK, I AM ALIVE. AND I HAVE THE KEYS OF DEATH AND HADES."

Rv 1:9 | Rv 1:10-11 | Rv 1:12-13, 1:16 | Rv 1:14-16 | Rv 1:17-18

"NOW WRITE DOWN ALL THAT YOU HAVE SEEN, THE THINGS HAPPENING NOW, AND WHAT WILL HAPPEN AFTER THESE THINGS."

"WRITE THE FOLLOWING TO THE ENVOY OF THE CHURCH IN SMYRNA."

"I KNOW THE DISTRESS YOU ARE SUFFERING AND THE SLANDER OF THOSE WHO CALL THEMSELVES JEWS BUT ARE REALLY OF THE SYNAGOGUE OF SATAN."

"WRITE THE FOLLOWING TO THE ENVOY OF THE CHURCH IN PERGAMUM: I KNOW YOU LIVE WHERE SATAN HAS HIS THRONE, YET YOU HOLD FAST AND HAVE NOT RENOUNCED YOUR FAITH IN ME."

Rv 2:9 | Rv 2:12-13

"BUT THERE ARE SOME AMONG YOU WHO HOLD TO THE TEACHINGS OF BALAAM WHO INSTRUCTED BALAK TO CAUSE THE PEOPLE OF ISRAEL TO SIN BY EATING FOOD SACRIFICED TO IDOLS."

"AND PRACTICE SEXUAL IMMORALITY."

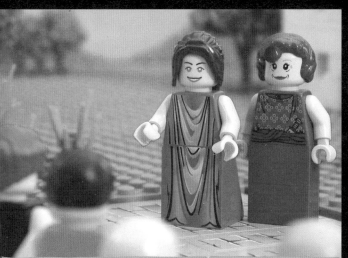

"WRITE THE FOLLOWING TO THE ENVOY OF THE CHURCH IN THYATIRA: YOU TOLERATE THAT WOMAN JEZEBEL WHO MISLEADS MY SERVANTS INTO SEXUAL IMMORALITY."

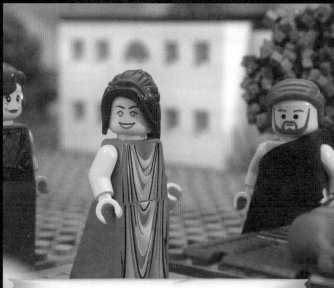

"AND THE EATING OF FOOD SACRIFICED TO IDOLS."

"I HAVE GIVEN HER TIME TO REPENT OF HER SEXUAL IMMORALITY, BUT SHE IS UNWILLING. LOOK! I WILL CAST HER ON A BED OF ANGUISH, AND THOSE WHO COMMIT ADULTERY WITH HER WILL HAVE INTENSE TORMENTS."

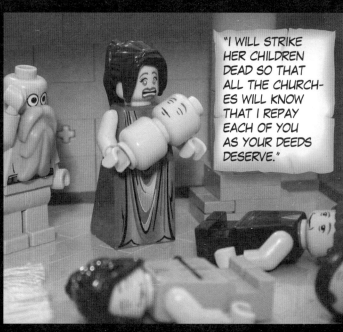

"I WILL STRIKE HER CHILDREN DEAD SO THAT ALL THE CHURCHES WILL KNOW THAT I REPAY EACH OF YOU AS YOUR DEEDS DESERVE."

"TO EVERYONE WHO CONTINUES TO DO MY WORKS TO THE END, I WILL GIVE AUTHORITY OVER THE NATIONS TO RULE THEM WITH AN IRON ROD AND SMASH THEM LIKE POTS OF CLAY."

AFTER THIS I LOOKED AND SAW A DOOR OPEN IN THE SKY AND HEARD THE SAME VOICE LIKE A TRUMPET, SAYING, "COME UP HERE, AND I WILL SHOW YOU WHAT MUST TAKE PLACE AFTER THIS."

AND THERE IN HEAVEN STOOD A THRONE, WITH SOMEONE SEATED WHO LOOKED LIKE JASPER AND CARNELIAN STONE. A RAINBOW SURROUNDED THE THRONE THAT LOOKED LIKE EMERALD.

AROUND THE THRONE WERE FOUR LIVING CREATURES, COVERED WITH EYES, EACH WITH SIX WINGS. THE FIRST LIVING CREATURE WAS LIKE A LION.

THE SECOND WAS LIKE A BULL.

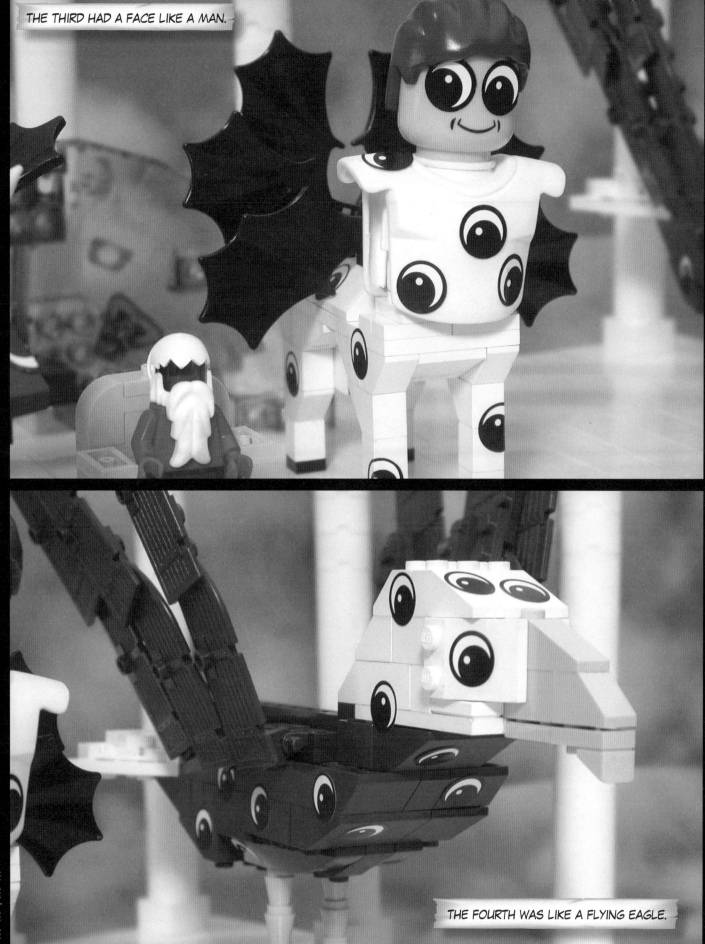

THE THIRD HAD A FACE LIKE A MAN.

THE FOURTH WAS LIKE A FLYING EAGLE.

DAY AND NIGHT THEY SING, "HOLY, HOLY, HOLY IS THE LORD GOD THE ALMIGHTY, WHO WAS, WHO IS, AND IS TO COME." IN FRONT OF THE THRONE WAS A SEA OF GLASS LIKE CRYSTAL, AND SEVEN LAMPS WERE BLAZING IN FRONT OF THE THRONE.

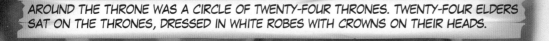

AROUND THE THRONE WAS A CIRCLE OF TWENTY-FOUR THRONES. TWENTY-FOUR ELDERS SAT ON THE THRONES, DRESSED IN WHITE ROBES WITH CROWNS ON THEIR HEADS.

Rv 4:5-6, 4:8 | Rv 4:4

THE TWENTY-FOUR ELDERS CAST THEIR CROWNS BEFORE THE THRONE, PROSTRATE THEMSELVES, AND SING, "YOU ARE WORTHY, OUR LORD AND GOD, TO RECEIVE GLORY AND HONOR AND POWER, BECAUSE YOU CREATED ALL THINGS."

THEN IN THE RIGHT HAND OF THE ONE SEATED ON THE THRONE, I SAW A SCROLL SEALED WITH SEVEN SEALS. AND A POWERFUL ANGEL PRO-CLAIMED WITH A LOUD VOICE, "WHO IS WORTHY TO OPEN THE SCROLL AND BREAK ITS SEALS?"

BUT NO ONE IN HEAVEN, ON EARTH, OR UNDER THE EARTH COULD OPEN THE SCROLL. AND I WEPT AND WEPT BE-CAUSE NO ONE WAS FOUND WHO WAS WORTHY TO OPEN THE SCROLL.

THEN ONE OF THE ELDERS SAID TO ME, "DO NOT WEEP! LOOK, THE LION OF THE TRIBE OF JUDAH, THE ROOT OF DAVID, HAS CONQUERED. HE IS ABLE TO OPEN THE SCROLL AND ITS SEVEN SEALS."

THEN BETWEEN THE THRONE AND THE FOUR LIVING CREATURES, I SAW A LAMB STANDING AND LOOKING AS IF IT HAD BEEN KILLED. IT HAD SEVEN HORNS AND SEVEN EYES.

THE LAMB TOOK THE SCROLL FROM THE RIGHT HAND OF THE ONE SITTING ON THE THRONE.

THEN THE LIVING CREATURES AND THE ELDERS SANG, "YOU ARE WORTHY TO OPEN THE SEALS OF THE SCROLL, BECAUSE WITH YOUR BLOOD YOU PURCHASED MEN FOR GOD FROM EVERY NATION TO BE PRIESTS TO SERVE OUR GOD, AND THEY WILL REIGN ON THE EARTH."

THEN I HEARD THE VOICE OF ANGELS, NUMBERING TEN MILLION. THEY SURROUNDED THE THRONE AND SANG, "WORTHY IS THE LAMB THAT WAS SLAUGHTERED TO RECEIVE POWER, WEALTH, WISDOM, MIGHT, HONOR, GLORY, AND BLESSING!"

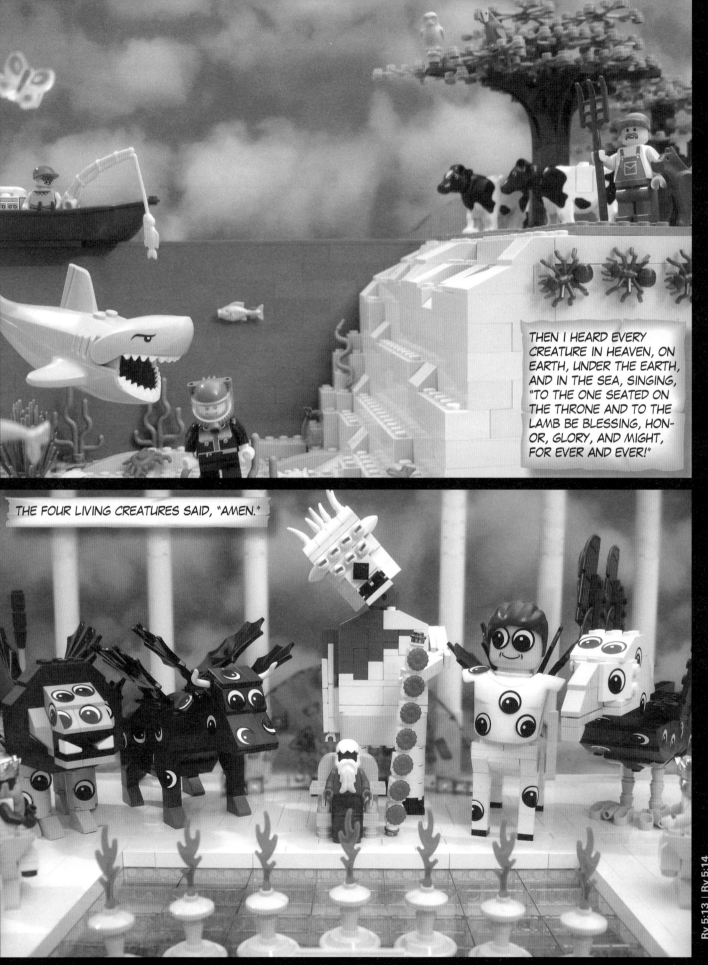

THEN I HEARD EVERY CREATURE IN HEAVEN, ON EARTH, UNDER THE EARTH, AND IN THE SEA, SINGING, "TO THE ONE SEATED ON THE THRONE AND TO THE LAMB BE BLESSING, HONOR, GLORY, AND MIGHT, FOR EVER AND EVER!"

THE FOUR LIVING CREATURES SAID, "AMEN."

Rv 5:13 | Rv 5:14

THEN I SAW THE LAMB OPEN ONE OF THE SEVEN SEALS, AND I HEARD ONE OF THE FOUR LIVING CREATURES SAY WITH A THUNDEROUS VOICE, "COME!"

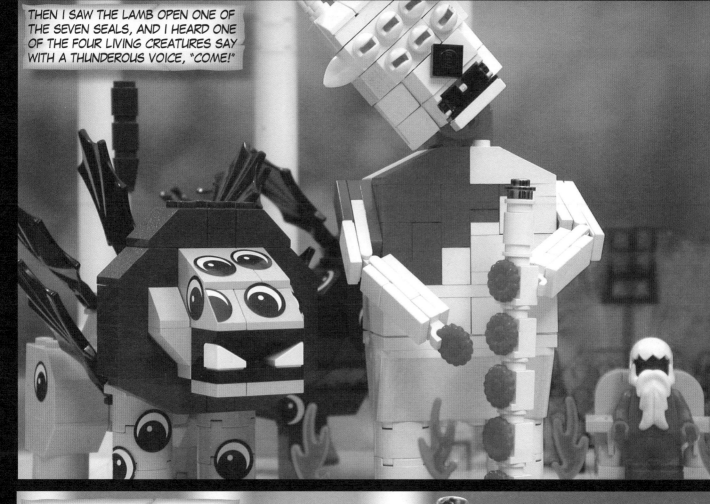

AND LOOK! THERE WAS A WHITE HORSE AND ITS RIDER HAD A BOW AND A CROWN LIKE A CONQUEROR, AND HE RODE OUT TO CONQUER.

WHEN THE LAMB OPENED THE SECOND SEAL, I HEARD THE SECOND LIVING CREATURE SAY, "COME!"

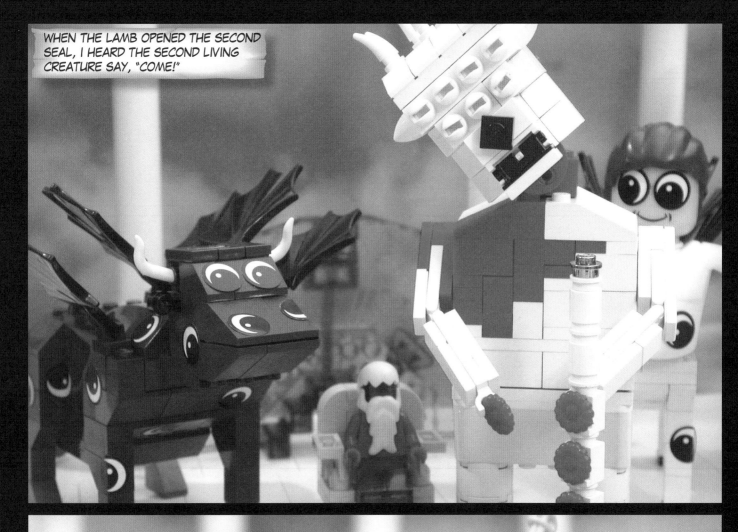

AND ANOTHER HORSE CAME OUT, FIERY RED. ITS RIDER WAS COMMISSIONED TO TAKE PEACE FROM THE EARTH AND MAKE MEN SLAUGHTER EACH OTHER. HE WAS GIVEN A BIG SWORD.

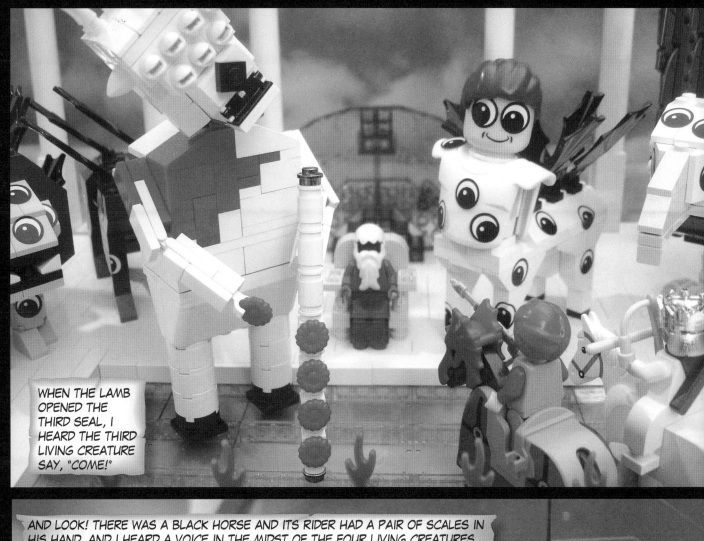

WHEN THE LAMB OPENED THE THIRD SEAL, I HEARD THE THIRD LIVING CREATURE SAY, "COME!"

AND LOOK! THERE WAS A BLACK HORSE AND ITS RIDER HAD A PAIR OF SCALES IN HIS HAND. AND I HEARD A VOICE IN THE MIDST OF THE FOUR LIVING CREATURES SAYING, "A QUART OF WHEAT FOR A DAY'S PAY, AND THREE QUARTS OF BARLEY FOR A DAY'S PAY, BUT DO NOT DAMAGE THE OLIVE OIL AND THE WINE!"

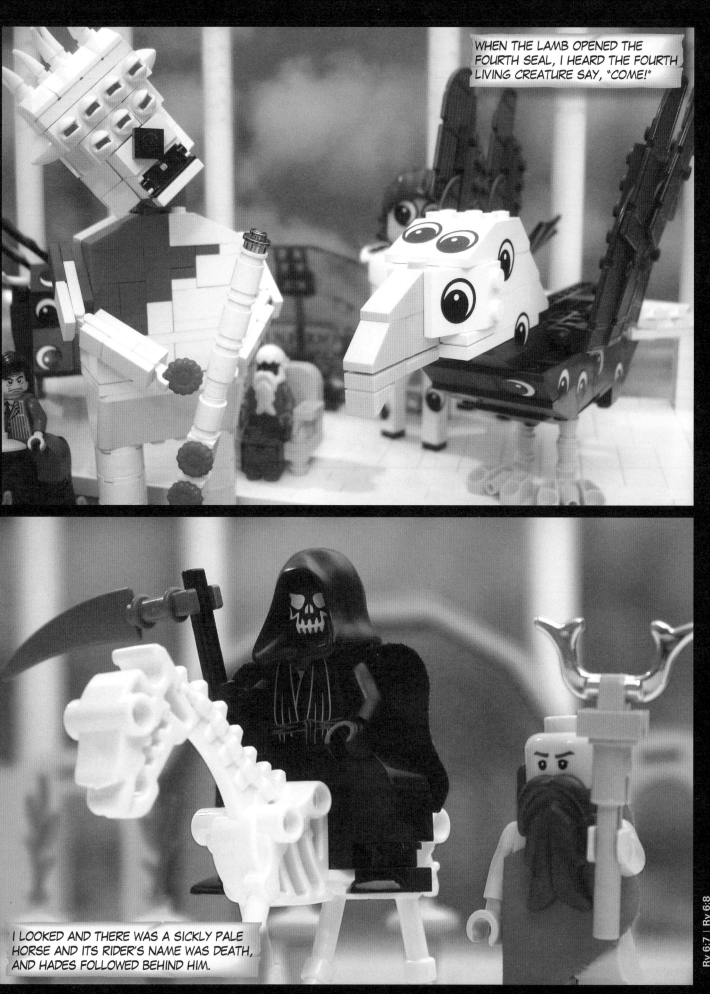

WHEN THE LAMB OPENED THE FOURTH SEAL, I HEARD THE FOURTH LIVING CREATURE SAY, "COME!"

I LOOKED AND THERE WAS A SICKLY PALE HORSE AND ITS RIDER'S NAME WAS DEATH, AND HADES FOLLOWED BEHIND HIM.

Rv 6:7 | Rv 6:8

THEY WERE GIVEN AUTHORITY TO KILL ONE QUARTER OF THE EARTH'S POPULATION...

...BY SWORD...

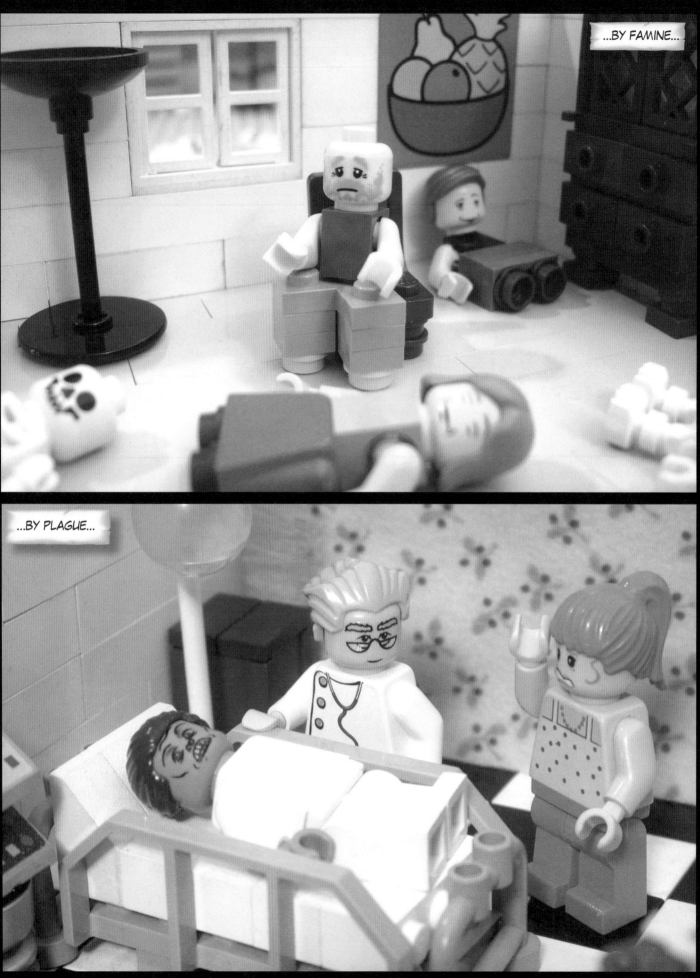

...AND BY THE WILD ANIMALS OF THE EARTH.

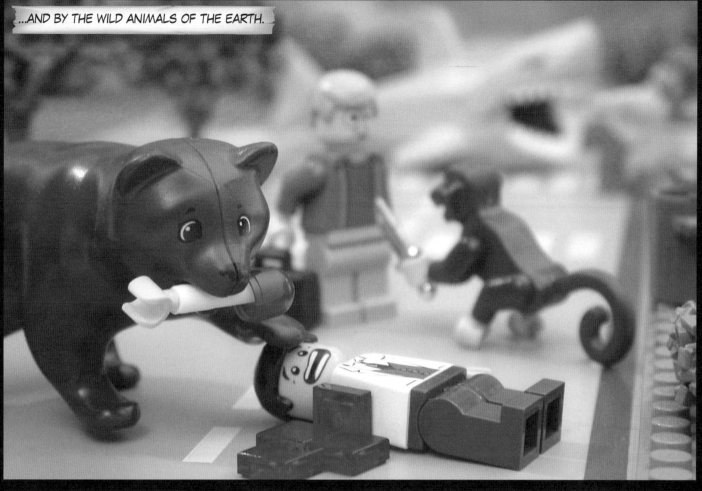

WHEN THE LAMB OPENED THE FIFTH SEAL...

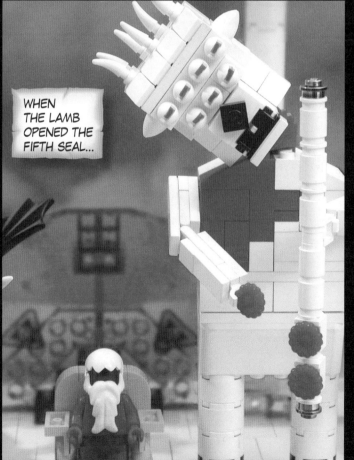

...UNDER THE ALTAR I SAW THE SOULS OF THOSE WHO HAD BEEN SLAUGHTERED BECAUSE OF THE WORD OF GOD AND THE TESTIMONY THEY HAD GIVEN. THEY SHOUTED, "LORD, HOW LONG UNTIL YOU JUDGE THE INHABITANTS OF THE EARTH AND AVENGE OUR BLOOD?"

THEY WERE TOLD TO BE PATIENT A LITTLE LONGER, UNTIL THE FULL NUMBER OF THEIR FELLOW SERVANTS AND BROTHERS WHO ARE TO BE KILLED AS THEY HAD BEEN KILLED IS REACHED.

THEN I SAW THE LAMB OPEN THE SIXTH SEAL.

AND THERE WAS A GIANT EARTHQUAKE.

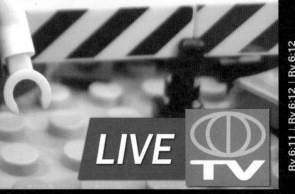

LIVE
TV

THE SUN TURNED BLACK LIKE A HAIRY SACKCLOTH.

THE SKY WAS ROLLED UP LIKE A SCROLL.

THE MOON TURNED RED LIKE BLOOD.

THE STARS OF THE SKY FELL TO EARTH LIKE FIGS DROPPING FROM A FIG TREE THAT HAS BEEN SHAKEN BY A STRONG WIND.

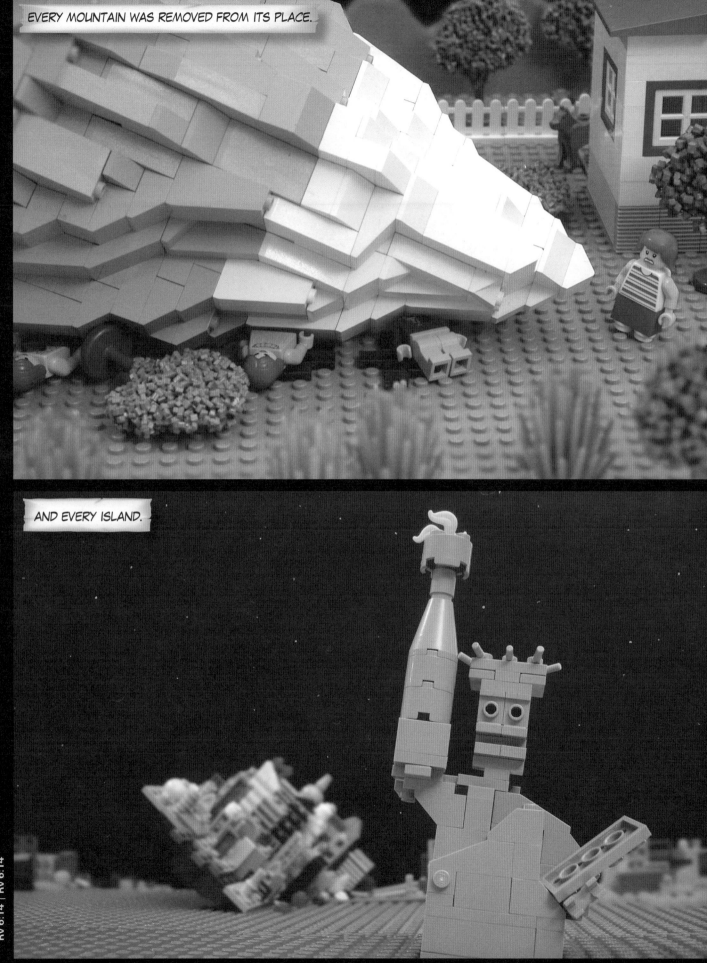

THEN THE KINGS OF THE EARTH, THE GENERALS, THE RICH PEOPLE, AND EVERYONE BOTH SLAVE AND FREE, HID IN CAVES AND AMONG THE MOUNTAIN ROCKS.

THEY SHOUTED TO THE MOUNTAINS AND THE ROCKS, "FALL ON US! HIDE US FROM THE ONE SEATED ON THE THRONE AND FROM THE WRATH OF THE LAMB!"

AFTER THIS I SAW FOUR ANGELS STANDING AT THE FOUR CORNERS OF THE EARTH WHO HAD BEEN GIVEN AUTHORITY TO DAMAGE THE LAND AND THE SEA.

THEN I SAW ANOTHER ANGEL COMING UP FROM THE EAST, AND HE SHOUTED, "DO NOT DAMAGE THE LAND OR THE SEA OR THE TREES..."

"...UNTIL WE PUT A MARK ON THE FORE-HEADS OF THE SERVANTS OF OUR GOD."

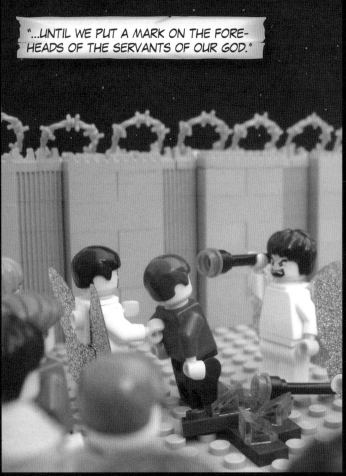

AND I HEARD THAT THE NUMBER OF PEOPLE SEALED WAS 144,000 OUT OF ALL THE TRIBES OF THE PEOPLE OF ISRAEL: JUDAH, REUBEN, GAD, ASHER, NAPHTALI, MANASSEH, SIMEON, LEVI, ISSACHAR, ZEBULUN, JOSEPH, AND BENJAMIN.

WHEN THE LAMB OPENED THE SEVENTH SEAL, I SAW THE SEVEN ANGELS WHO STAND BEFORE GOD, AND SEVEN TRUMPETS WERE GIVEN TO THEM.

ANOTHER ANGEL WHO HAD A GOLDEN CENSER CAME AND FILLED IT WITH THE FIRE OF THE ALTAR.

Rv 7:4 | Rv 7:4 | Rv 8:1-2 | Rv 8:3, 8:5

AND THEN HE THREW IT ONTO THE EARTH.

AND THERE WERE CRASHES OF THUNDER, FLASHES OF LIGHTNING, AND AN EARTHQUAKE.

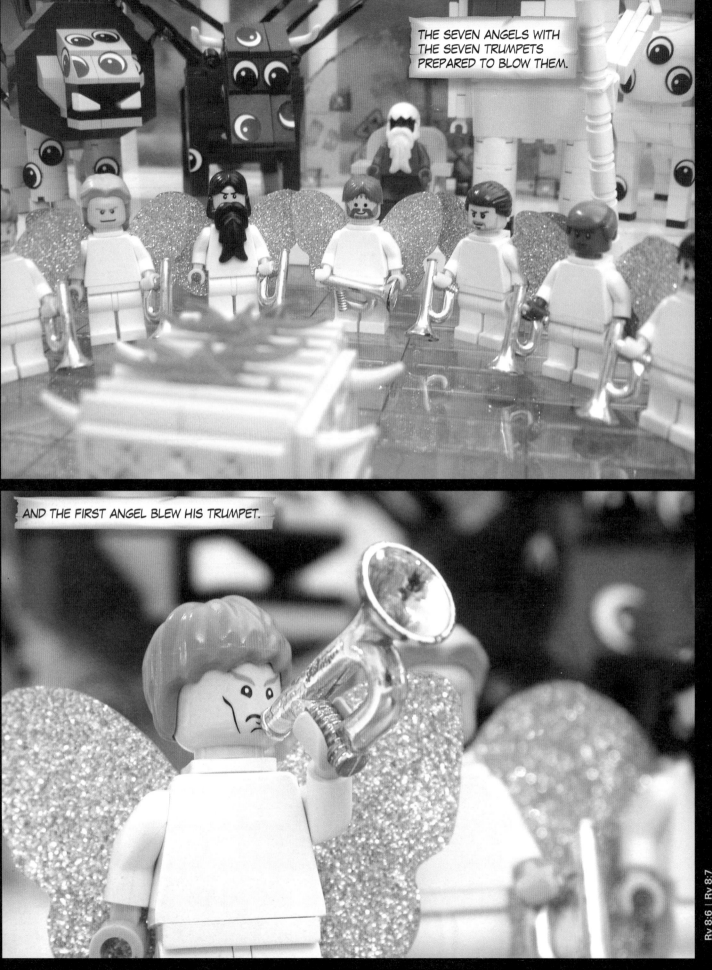

AND THERE WAS HAIL AND FIRE MIXED WITH BLOOD THROWN AT THE EARTH.

A THIRD OF THE EARTH WAS BURNED UP.

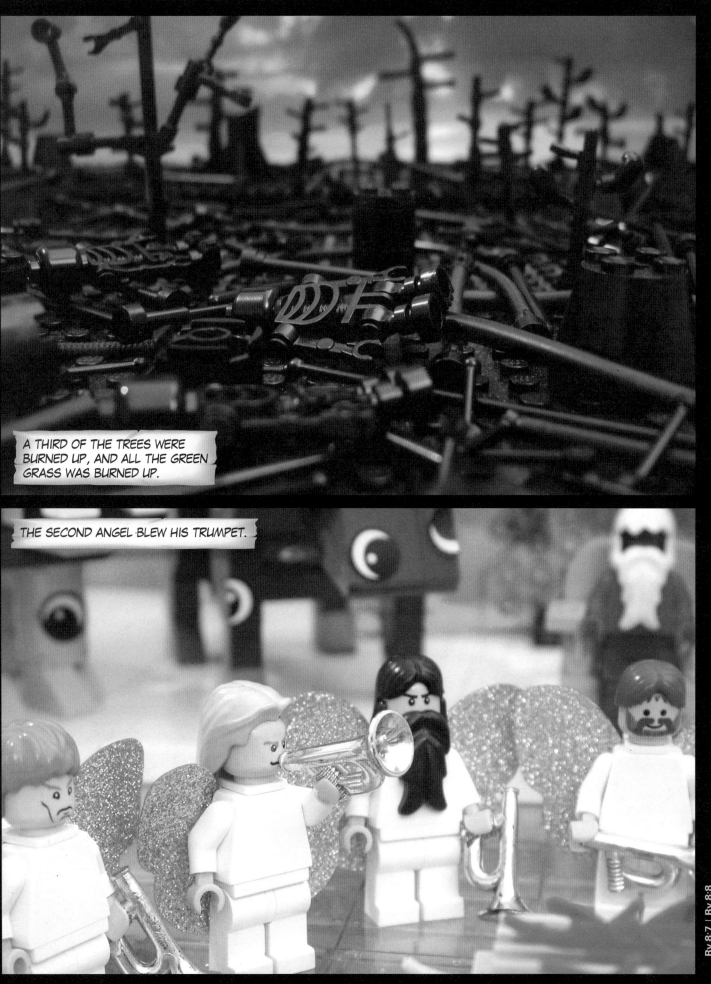

A THIRD OF THE TREES WERE BURNED UP, AND ALL THE GREEN GRASS WAS BURNED UP.

THE SECOND ANGEL BLEW HIS TRUMPET.

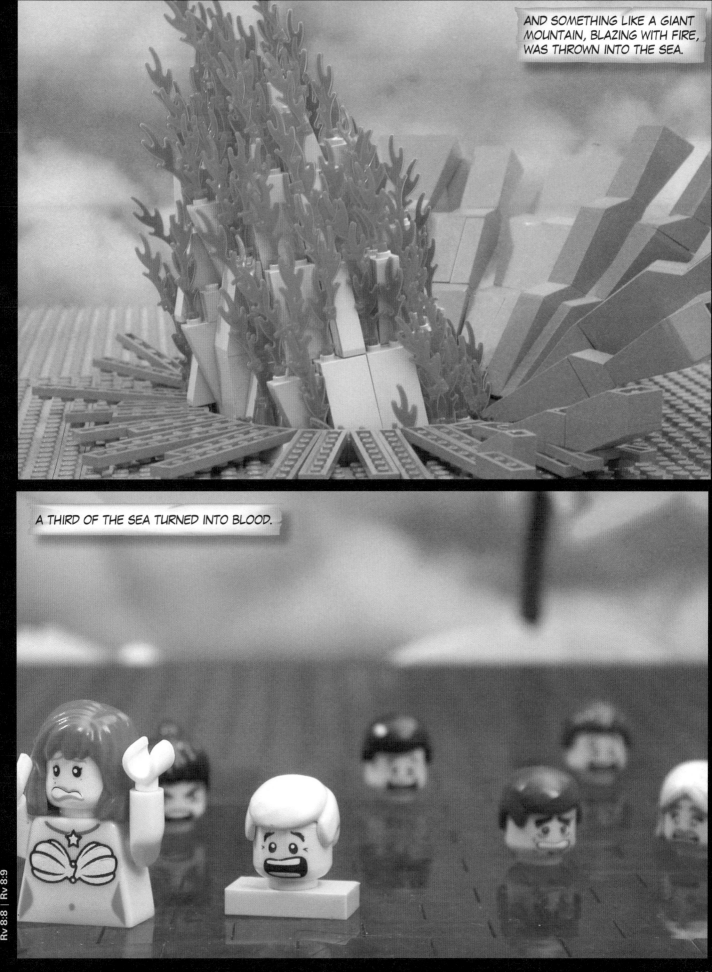

AND SOMETHING LIKE A GIANT MOUNTAIN, BLAZING WITH FIRE, WAS THROWN INTO THE SEA.

A THIRD OF THE SEA TURNED INTO BLOOD.

A THIRD OF ALL THE LIVING
THINGS IN THE SEA DIED.

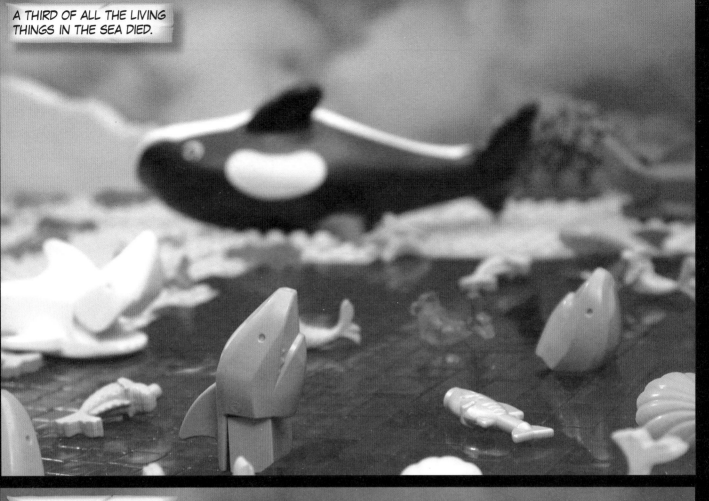

AND A THIRD OF THE SHIPS
WERE DESTROYED.

THEN THE THIRD ANGEL BLEW HIS TRUMPET.

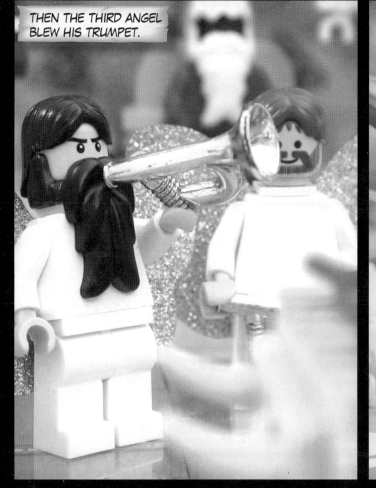

AND A GIANT STAR NAMED WORMWOOD FELL FROM HEAVEN, BLAZING LIKE A TORCH, AND IT FELL ON A THIRD OF THE RIVERS AND SOURCES OF THE RIVERS.

A THIRD OF THE WATERS TURNED BITTER, AND MANY PEOPLE DIED FROM THE WATERS THAT HAD BECOME BITTER.

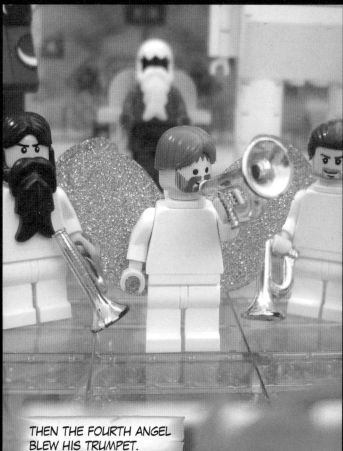

THEN THE FOURTH ANGEL BLEW HIS TRUMPET.

AND A THIRD OF THE SUN WAS STRUCK.

AND A THIRD OF THE MOON AND STARS.

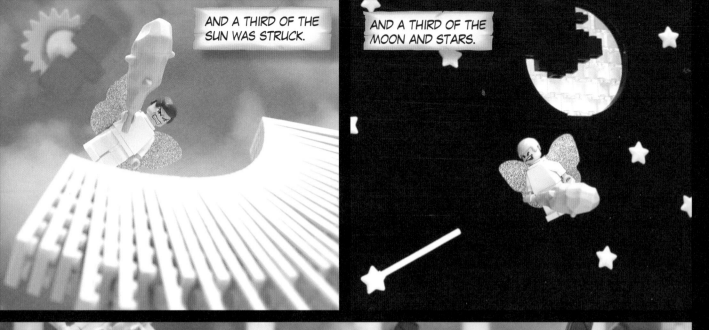

THEN I LOOKED AND SAW A FLYING EAGLE SHOUT, "WOE! WOE! WOE TO THE INHABITANTS OF THE EARTH, BECAUSE OF THE TRUMPETS ABOUT TO BE BLOWN BY THE OTHER THREE ANGELS!"

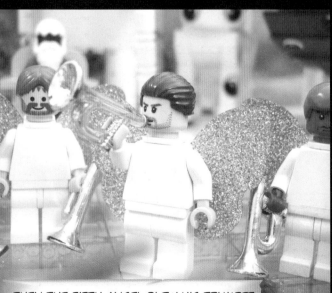

THEN THE FIFTH ANGEL BLEW HIS TRUMPET.

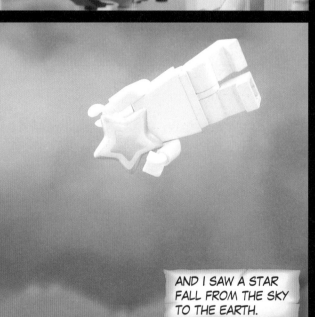

AND I SAW A STAR FALL FROM THE SKY TO THE EARTH.

Rv 8:12 | Rv 8:12 | Rv 8:13 | Rv 9:1 | Rv 9:1

AND THE STAR WAS GIVEN THE KEY TO THE PIT OF THE ABYSS.

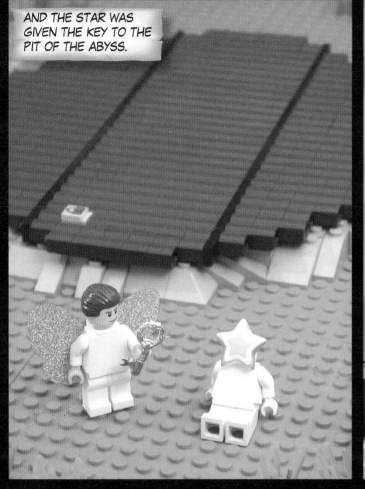

HE OPENED THE ABYSS.

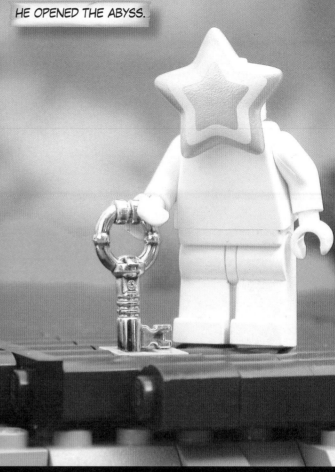

AND GREAT AMOUNTS OF SMOKE CAME OUT OF THE ABYSS, LIKE THE SMOKE FROM A GREAT FURNACE. THE SUN AND SKY WERE DARKENED BY THE SMOKE.

AND OUT OF THE SMOKE CAME LOCUSTS UPON THE EARTH. THEIR FACES WERE LIKE HUMAN FACES, THEIR HAIR WAS LIKE WOMEN'S HAIR, THEIR TEETH WERE LIKE LIONS' TEETH, AND THEY HAD BREASTPLATES LIKE IRON BREASTPLATES.

THEY HAVE TAILS LIKE SCORPIONS WITH STINGERS, AND IN THEIR TAILS IS THEIR POWER TO TORTURE PEOPLE FOR FIVE MONTHS.

AS KING OVER THEM THEY HAVE THE ANGEL OF THE ABYSS WHOSE NAME IN HEBREW IS ABADDON AND IN GREEK HE IS CALLED APOLLYON.

Rv 9:3 9:7-9 | Rv 9:10 | Rv 9:11

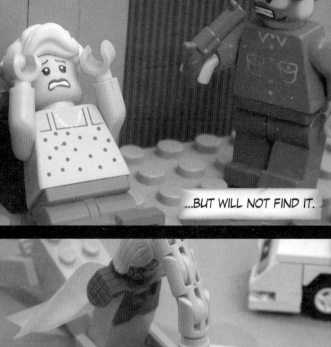
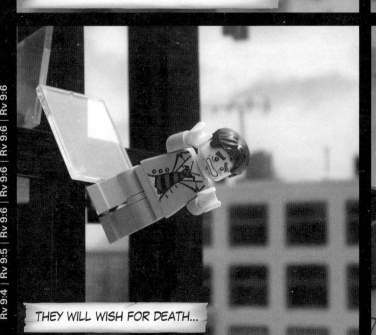

THEN THE SIXTH ANGEL BLEW HIS TRUMPET, AND I HEARD THE GOLDEN ALTAR SAYING TO THE SIXTH ANGEL, "RELEASE THE FOUR ANGELS WHO ARE BOUND AT THE GREAT RIVER EUPHRATES."

AND THE FOUR ANGELS WHO HAD BEEN KEPT READY FOR THIS VERY HOUR WERE RELEASED TO KILL A THIRD OF MANKIND.

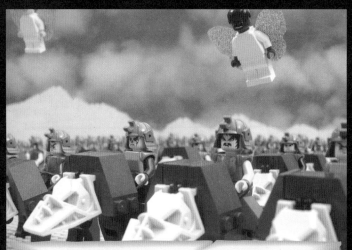

THE NUMBER OF THE ARMY OF THE HORSEMEN WAS TWO HUNDRED MILLION. THE RIDERS HAD BREASTPLATES OF FIRE, OF SAPPHIRE, AND OF SULFUR. THE HEADS OF THE HORSES WERE LIKE THE HEADS OF LIONS.

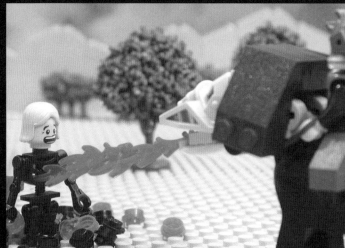

AND OUT OF THEIR MOUTHS CAME FIRE, SMOKE, AND SULFUR. A THIRD OF HUMANKIND WAS KILLED BY THESE THREE PLAGUES. BY THE FIRE...

...BY THE SMOKE...

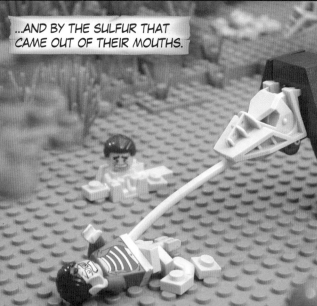

...AND BY THE SULFUR THAT CAME OUT OF THEIR MOUTHS.

THE POWER OF THE HORSES WAS IS IN THEIR MOUTHS AND IN THEIR TAILS. FOR THEIR TAILS ARE LIKE SNAKES, HAVING HEADS WITH WHICH THEY INFLICT INJURY.

THE REST OF HUMANKIND, WHO WERE NOT KILLED BY THESE PLAGUES, DID NOT GIVE UP WORSHIPING DE- MONS AND IDOLS OF GOLD, SILVER, BRONZE, STONE, AND WOOD, WHICH CANNOT SEE OR HEAR OR WALK.

AND THEY DID NOT REPENT OF THEIR MURDERS, THEIR USE OF MAGIC, THEIR SEXUAL IMMORALITY, OR THEIR STEALING.

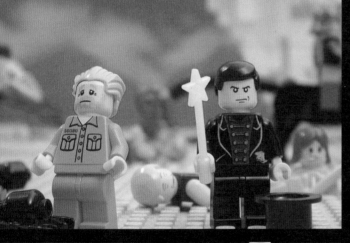

THEN THE SEVENTH ANGEL BLEW HIS TRUMPET, AND THE TWENTY-FOUR ELDERS WORSHIPPED GOD, SAYING, "YOUR WRATH HAS COME. THE TIME HAS COME TO REWARD YOUR SERVANTS, PROPHETS, AND SAINTS, AND TO RUIN THOSE WHO RUIN THE EARTH."

THEN A GREAT SIGN APPEARED IN THE SKY: A WOMAN CLOTHED WITH THE SUN, WITH THE MOON UNDER HER FEET, AND A CROWN OF TWELVE STARS ON HER HEAD.

SHE WAS PREGNANT AND CRIED OUT IN PAIN AS SHE WAS ABOUT TO GIVE BIRTH.

223

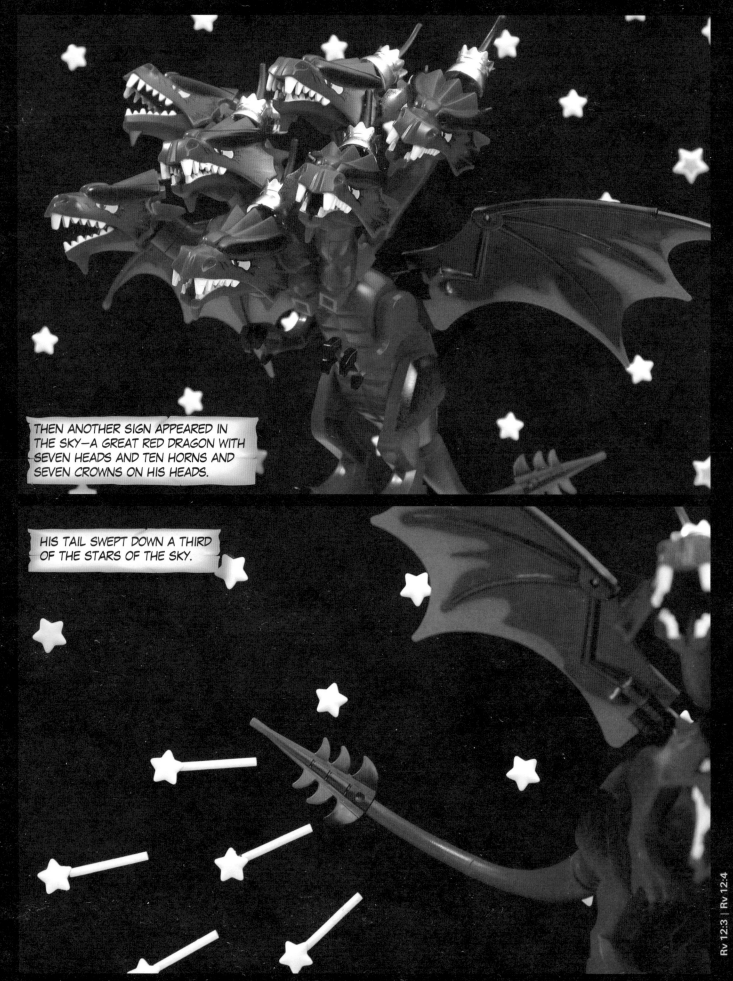

THEN ANOTHER SIGN APPEARED IN THE SKY—A GREAT RED DRAGON WITH SEVEN HEADS AND TEN HORNS AND SEVEN CROWNS ON HIS HEADS.

HIS TAIL SWEPT DOWN A THIRD OF THE STARS OF THE SKY.

AND THREW THEM TO THE EARTH.

THEN THE DRAGON STOOD IN FRONT OF THE WOMAN WHO WAS ABOUT TO GIVE BIRTH, SO THAT THE MOMENT SHE GAVE BIRTH HE MIGHT DEVOUR THE CHILD.

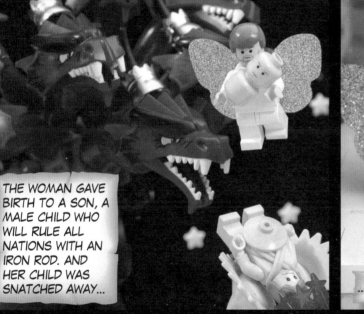

THE WOMAN GAVE BIRTH TO A SON, A MALE CHILD WHO WILL RULE ALL NATIONS WITH AN IRON ROD. AND HER CHILD WAS SNATCHED AWAY...

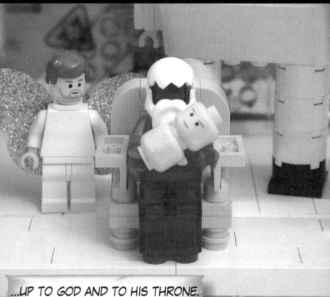

...UP TO GOD AND TO HIS THRONE.

AND THE WOMAN FLED INTO THE DESERT TO A PLACE PREPARED FOR HER BY GOD, WHERE THEY CAN FEED HER FOR 1,260 DAYS.

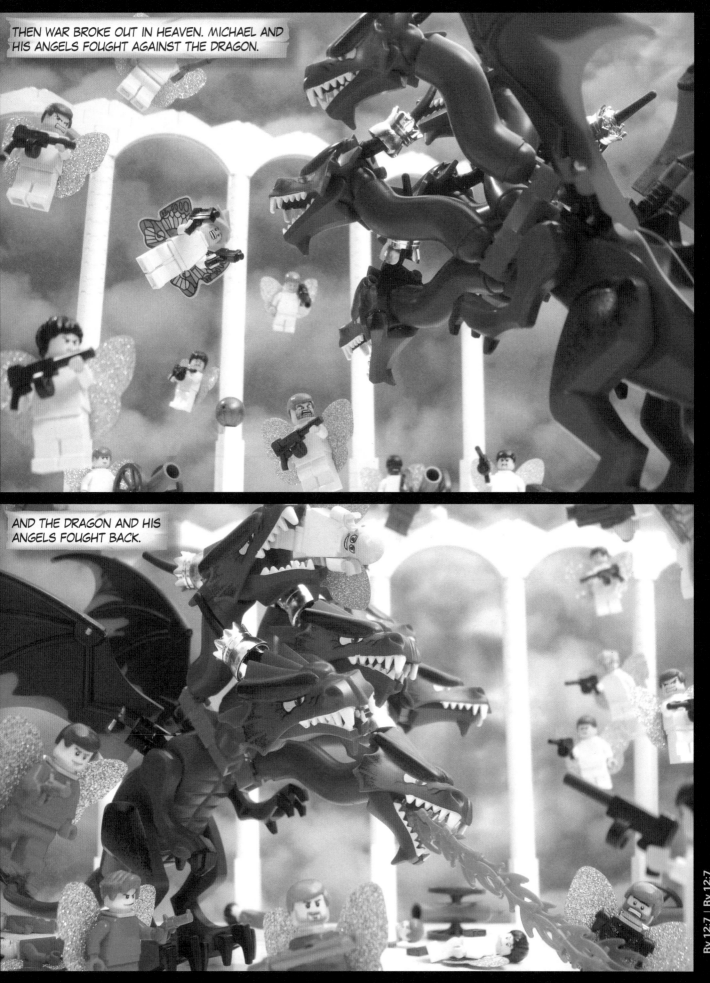

THEN WAR BROKE OUT IN HEAVEN. MICHAEL AND HIS ANGELS FOUGHT AGAINST THE DRAGON.

AND THE DRAGON AND HIS ANGELS FOUGHT BACK.

Rv 12:7 | Rv 12:7

BUT HE DID NOT PREVAIL, SO THE GREAT DRAGON, THE ANCIENT SERPENT, THE ONE CALLED THE DEVIL AND SATAN, WHO DECEIVES THE WHOLE WORLD, WAS THROWN DOWN TO THE EARTH.

AND HIS ANGELS ALONG WITH HIM.

WHEN THE DRAGON SAW THAT HE HAD BEEN THROWN DOWN TO THE EARTH, HE PURSUED THE WOMAN WHO HAD GIVEN BIRTH TO THE MALE CHILD.

BUT THE WOMAN WAS GIVEN THE TWO WINGS OF THE GREAT EAGLE, SO THAT SHE COULD FLY FROM THE SERPENT INTO THE DESERT...

...TO HER PLACE WHERE SHE IS FED FOR A TIME, AND TIMES, AND HALF A TIME.

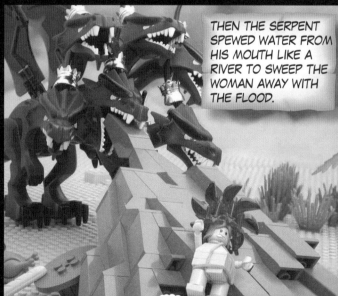

THEN THE SERPENT SPEWED WATER FROM HIS MOUTH LIKE A RIVER TO SWEEP THE WOMAN AWAY WITH THE FLOOD.

BUT THE EARTH CAME TO THE AID OF THE WOMAN. IT OPENED ITS MOUTH AND SWALLOWED THE RIVER THAT THE DRAGON HAD SPEWED FROM HIS MOUTH.

THEN I SAW A BEAST RISING OUT OF THE SEA. IT HAD TEN HORNS AND SEVEN HEADS, AND ON ITS HORNS WERE TEN CROWNS.

Rv 12:16 | Rv 13:1

ONE OF THE HEADS OF THE BEAST SEEMED TO HAVE BEEN KILLED UNTO DEATH, BUT THE MORTAL WOUND HAD BEEN HEALED. AND ON ITS HEADS WAS A BLASPHEMOUS NAME.

THE BEAST I SAW WAS LIKE A LEOPARD, BUT ITS FEET WERE LIKE A BEAR'S, AND ITS MOUTH WAS LIKE A LION'S MOUTH.

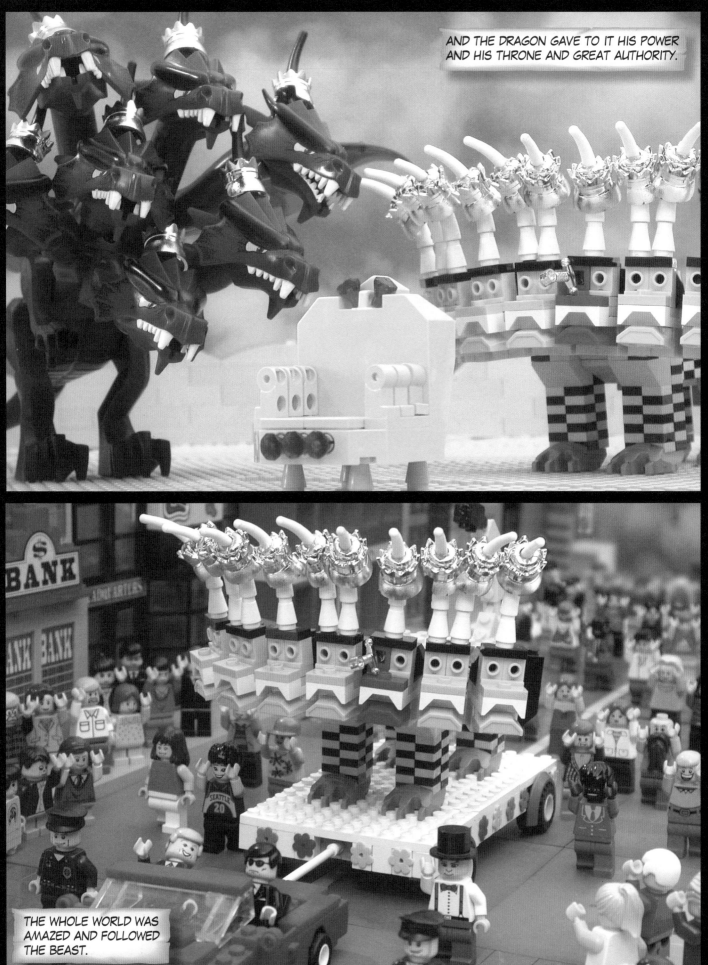

AND THE DRAGON GAVE TO IT HIS POWER AND HIS THRONE AND GREAT AUTHORITY.

THE WHOLE WORLD WAS AMAZED AND FOLLOWED THE BEAST.

THEY WORSHIPPED THE DRAGON AND THE BEAST, SAYING, "WHO IS LIKE THE BEAST? WHO CAN MAKE WAR AGAINST HIM?"

THE BEAST WAS GIVEN A MOUTH TO UTTER PROUD WORDS AND BLASPHEMIES AND TO EXERCISE HIS AUTHORITY FOR FORTY-TWO MONTHS.

IT OPENED HIS MOUTH TO BLASPHEME AGAINST GOD AND TO SLANDER HIS NAME AND HIS DWELLING PLACE AND THOSE WHO LIVE IN HEAVEN.

THE BEAST WAS PERMITTED TO MAKE WAR AGAINST THE SAINTS AND DEFEAT THEM.

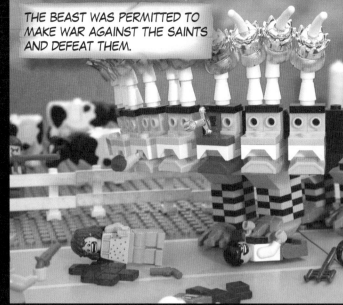

AND ALL WHO LIVE ON THE EARTH WILL WORSHIP THE BEAST.

THEN I SAW ANOTHER BEAST THAT ROSE OUT OF THE EARTH. HE HAD TWO HORNS LIKE A LAMB AND HE SPOKE LIKE A DRAGON.

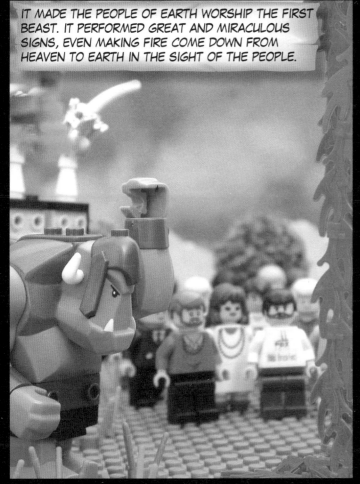

IT MADE THE PEOPLE OF EARTH WORSHIP THE FIRST BEAST. IT PERFORMED GREAT AND MIRACULOUS SIGNS, EVEN MAKING FIRE COME DOWN FROM HEAVEN TO EARTH IN THE SIGHT OF THE PEOPLE.

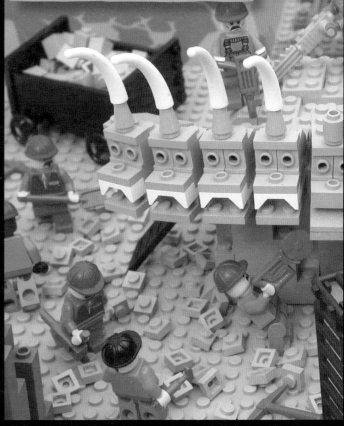

IT TOLD THE PEOPLE OF EARTH TO MAKE AN IMAGE OF THE BEAST WHO HAD BEEN WOUNDED BY THE SWORD AND YET LIVED.

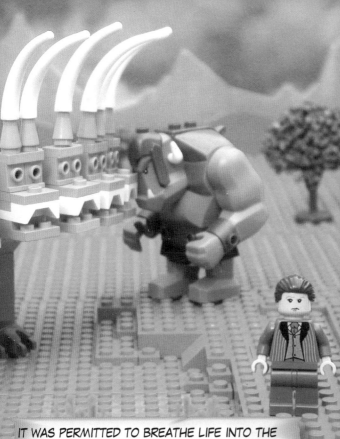

IT WAS PERMITTED TO BREATHE LIFE INTO THE IMAGE OF THE BEAST SO THAT IT COULD SPEAK...

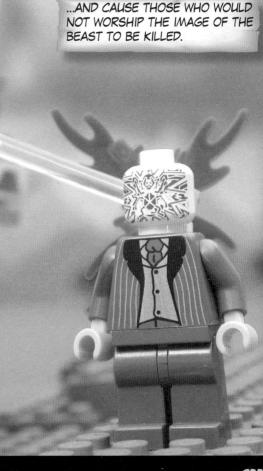

...AND CAUSE THOSE WHO WOULD NOT WORSHIP THE IMAGE OF THE BEAST TO BE KILLED.

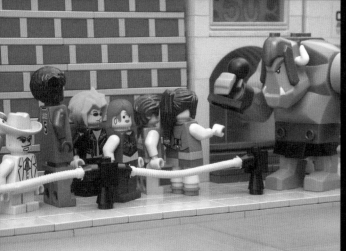

NO ONE COULD BUY OR SELL UNLESS HE HAD THE MARK, WHICH IS THE NAME OF THE BEAST OR THE NUMBER OF HIS NAME: 666.

AND HE MADE EVERYONE, SMALL AND LARGE, RICH AND POOR, FREE AND SLAVE, RECEIVE A MARK ON THEIR RIGHT HAND OR ON THEIR FOREHEAD.

THEN I LOOKED, AND THERE WAS THE LAMB, STANDING ON MOUNT ZION. AND WITH HIM WERE 144,000 WHO HAD HIS NAME AND HIS FATHER'S NAME WRITTEN ON THEIR FOREHEADS.

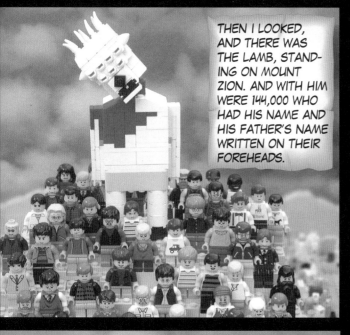

THESE ARE THE ONES WHO HAVE NOT DEFILED THEMSELVES WITH WOMEN, FOR THEY ARE VIRGINS. AND THEY FOLLOW THE LAMB WHEREVER HE GOES.

AND I SAW AN ANGEL IN THE MIDDLE OF THE SKY, SAYING WITH A LOUD VOICE, "ANYONE WHO WORSHIPS THE BEAST AND HIS IMAGE, AND TAKES THE MARK ON HIS FOREHEAD OR HIS HAND, WILL BE TORTURED WITH FIRE AND SULFUR IN FRONT OF THE HOLY ANGELS AND IN FRONT OF THE LAMB."

THEN I LOOKED AND SAW A WHITE CLOUD, AND SEATED ON THE CLOUD WAS ONE LIKE A SON OF MAN, WITH A GOLDEN CROWN ON HIS HEAD AND A SHARP SICKLE IN HIS HAND.

Rv 13:16 | Rv 13:17 | Rv 14:1 | Rv 14:4 | Rv 14:6, 14:9 | Rv 14:14

THE ONE SEATED ON THE CLOUD SWUNG HIS SICKLE OVER THE EARTH, AND THE EARTH WAS HARVESTED.

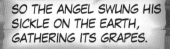

THEN ANOTHER ANGEL CAME OUT OF THE TEMPLE AND SHOUTED TO THE ONE WHO SAT ON THE CLOUD, "USE YOUR SICKLE AND REAP, FOR THE HOUR TO REAP HAS COME, BECAUSE THE HARVEST OF THE EARTH IS RIPE!"

ANOTHER ANGEL CAME OUT OF THE TEMPLE IN HEAVEN, AND HE TOO HAD A SHARP SICKLE. AND ANOTHER ANGEL SHOUTED TO THE ANGEL WITH THE SHARP SICKLE, "USE YOUR SHARP SICKLE AND GATHER THE CLUSTERS OF GRAPES FROM THE VINES OF THE EARTH, BECAUSE ITS GRAPES ARE RIPE!"

SO THE ANGEL SWUNG HIS SICKLE ON THE EARTH, GATHERING ITS GRAPES.

AND HE THREW THEM INTO THE GREAT WINE PRESS OF GOD'S WRATH.

THEY STOMPED ON THE WINE PRESS OUTSIDE THE CITY.

235

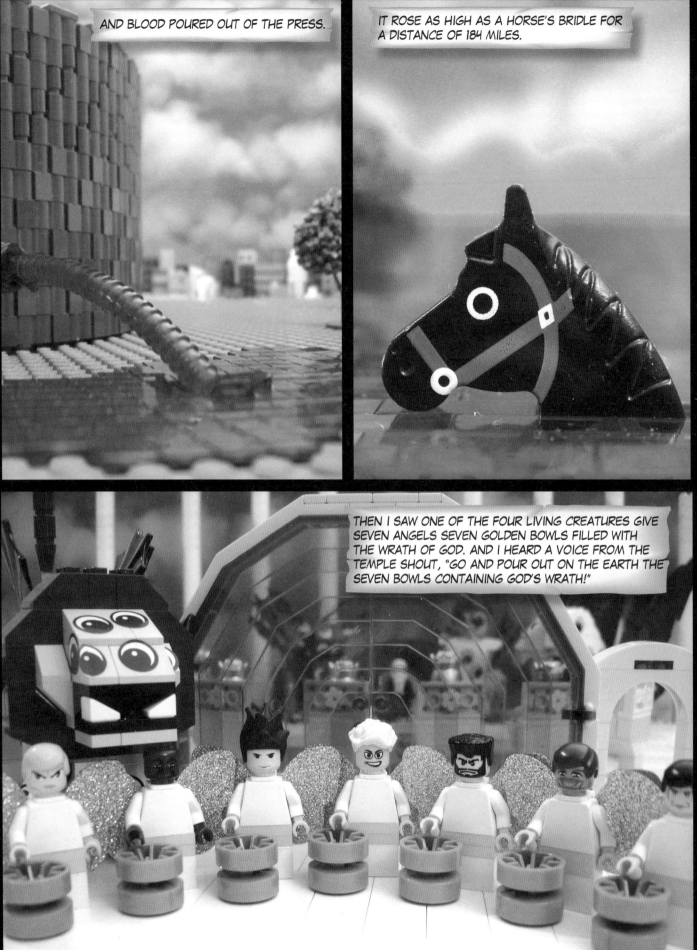

Rv 14:20 | Rv 14:20 | Rv 15:1, 16:1, 16:6-7

SO THE FIRST ANGEL WENT AND POURED HIS BOWL ON THE EARTH.

AND HORRIBLE, PAINFUL SORES BROKE OUT ON THE PEOPLE WHO HAD THE MARK OF THE BEAST AND WORSHIPPED HIS IMAGE.

THE SECOND ANGEL POURED HIS BOWL INTO THE SEA, AND IT BECAME LIKE THE BLOOD OF A CORPSE.

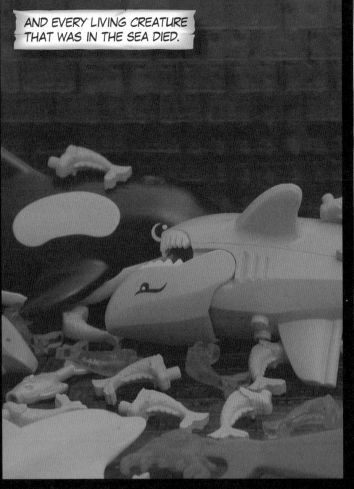

AND EVERY LIVING CREATURE THAT WAS IN THE SEA DIED.

THE THIRD ANGEL POURED HIS BOWL INTO THE RIVERS AND SPRINGS, AND THEY TURNED INTO BLOOD.

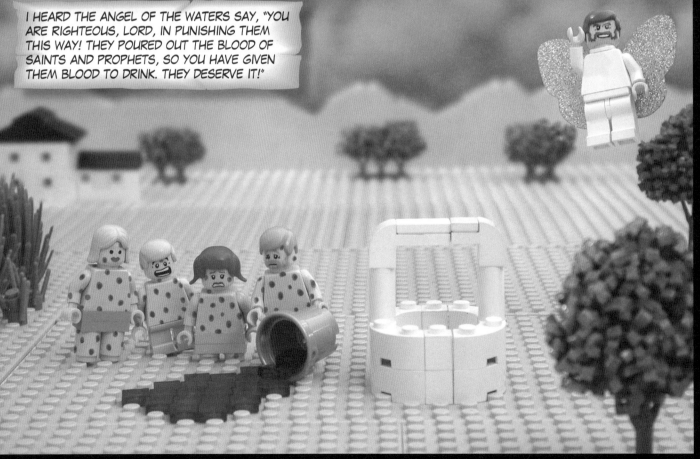

I HEARD THE ANGEL OF THE WATERS SAY, "YOU ARE RIGHTEOUS, LORD, IN PUNISHING THEM THIS WAY! THEY POURED OUT THE BLOOD OF SAINTS AND PROPHETS, SO YOU HAVE GIVEN THEM BLOOD TO DRINK. THEY DESERVE IT!"

AND I HEARD THE ALTAR SAY, "YES, LORD GOD ALMIGHTY, YOUR PUNISHMENTS ARE TRUE AND JUST!"

THE FOURTH ANGEL POURED OUT HIS BOWL ON THE SUN.

AND THE SUN WAS GIVEN POWER TO SCORCH PEOPLE WITH FIRE. PEOPLE WERE SCORCHED BY THE FIERCE HEAT, AND THEY CURSED THE NAME OF GOD WHO HAD CONTROL OVER THESE PLAGUES.

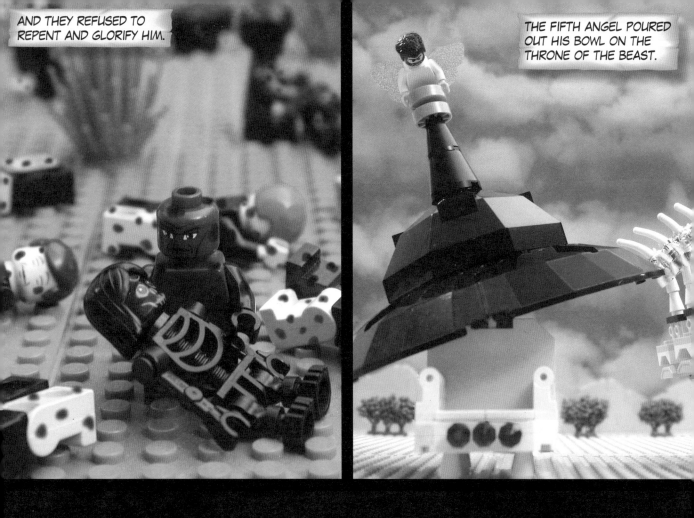

THE SIXTH ANGEL POURED HIS BOWL ON THE GREAT RIVER EUPHRATES, AND ITS WATER WAS DRIED UP IN ORDER TO PREPARE THE WAY FOR THE KINGS FROM THE EAST.

AND COMING OUT OF THE MOUTH OF THE DRAGON, OUT OF THE MOUTH OF THE BEAST, AND OUT OF THE MOUTH OF THE FALSE PROPHET, I SAW THREE EVIL SPIRITS LIKE FROGS.

THEY ARE DEMONIC SPIRITS WHO GO AROUND TO THE KINGS OF THE WHOLE WORLD AND ASSEMBLE THEM FOR BATTLE ON THE GREAT DAY OF GOD THE ALMIGHTY AT THE PLACE THAT IN HEBREW IS CALLED ARMAGEDDON.

THEN THE SEVENTH ANGEL POURED HIS BOWL INTO THE AIR, AND A VOICE SHOUTED FROM THE THRONE IN THE TEMPLE: "IT IS DONE!"

AND THERE WAS AN EARTHQUAKE SO TREMENDOUS THAT NONE LIKE IT HAD OCCURRED SINCE HUMANKIND HAS BEEN ON THE EARTH. THE CITIES OF THE NATIONS COLLAPSED.

EVERY ISLAND VANISHED.

AND NO MOUNTAINS WERE TO BE FOUND.

AND HUGE HAILSTONES, EACH WEIGHING A HUNDRED POUNDS, DROPPED FROM HEAVEN ON PEOPLE UNTIL THEY CURSED GOD.

THEN ONE OF THE SEVEN ANGELS WHO HAD THE SEVEN BOWLS CAME AND SAID TO ME, "COME, I WILL SHOW YOU THE PUNISHMENT OF THE GREAT WHORE WITH WHOM THE KINGS OF THE EARTH HAVE COMMITTED ADULTERY."

THE ANGEL CARRIED ME AWAY TO THE DESERT.

AND I SAW A WOMAN SITTING ON A RED BEAST THAT HAD SEVEN HEADS AND TEN HORNS.

THE WOMAN WAS CLOTHED IN PURPLE AND RED, AND ADORNED WITH GOLD AND JEWELS AND PEARLS, HOLDING IN HER HAND A CUP FULL OF ABOMINATIONS AND THE FILTH OF HER ADULTERY.

ON HER FOREHEAD WAS WRITTEN A NAME, A MYSTERY: "BABYLON THE GREAT, MOTHER OF WHORES AND OF THE ABOMINATIONS OF THE EARTH."

BABYLON THE GREAT MOTHER OF WHORES AND OF THE ABOMINATIONS OF THE EARTH

AND I SAW THAT THE WOMAN WAS DRUNK WITH THE BLOOD OF THE SAINTS AND THOSE WHO BORE WITNESS TO JESUS. THEN I HEARD ANOTHER VOICE FROM HEAVEN SAY, "HER SINS HAVE PILED UP TO HEAVEN! PAY HER BACK DOUBLE FOR WHAT SHE HAS DONE!"

"TO THE EXTENT SHE HONORED HERSELF WITH A LIFE OF LUXURY, NOW GIVE HER TORMENT AND DESPAIR!" AND SO IN A SINGLE DAY SHE WILL EXPERIENCE DISEASE, STARVATION, AND DESPAIR.

THEN THE ANGEL SAID TO ME, "THE BEAST AND THE TEN HORNS YOU SAW WILL HATE THE WHORE. THEY WILL BRING HER TO RUIN AND LEAVE HER NAKED."

Rv 18:7-8 | Rv 17:15-16

"THEY WILL EAT HER FLESH."

"AND BURN HER WITH FIRE—FOR GOD HAS PUT IT INTO THEIR MINDS TO CARRY OUT HIS INTENT. SHE WILL BE BURNED UP."

"AND THE KINGS OF THE EARTH WHO COMMITTED ADULTERY WITH HER WILL SEE THE SMOKE FROM THE FIRE THAT BURNS HER, AND THEY WILL WEEP AND MOURN OVER HER."

AFTER THIS I HEARD THE SHOUTING OF A GREAT MULTITUDE IN HEAVEN, SAYING, "SALVATION, GLORY, AND POWER TO OUR GOD! FOR HE HAS PUNISHED THE GREAT WHORE WHO CORRUPTED THE EARTH WITH HER ADULTERIES! HE HAS AVENGED THE BLOOD OF HIS SERVANTS!"

Rv 18:9 | Rv 19:1

THEN I SAW HEAVEN OPEN, AND THERE WAS A WHITE HORSE, AND ITS RIDER HAD EYES LIKE BLAZING FIRE, AND ON HIS HEAD ARE MANY CROWNS. HIS NAME IS THE WORD OF GOD. OUT OF HIS MOUTH COMES A SHARP SWORD TO STRIKE DOWN THE NATIONS. HE WILL RULE THEM WITH AN IRON ROD.

ON HIS THIGH HE HAS THIS NAME WRITTEN: "KING OF KINGS AND LORD OF LORDS."

THE ARMIES OF HEAVEN WERE FOLLOWING HIM, RIDING ON WHITE HORSES AND DRESSED IN FINE LINEN, WHITE AND CLEAN.

AND I SAW AN ANGEL STANDING IN THE SUN, WHO SHOUTED TO ALL THE BIRDS FLYING IN THE SKY, "COME, GATHER TO EAT THE FLESH OF KINGS AND GENERALS, HORSES AND THEIR RIDERS, THE FLESH OF ALL, FREE AND SLAVE, SMALL AND LARGE!"

THEN I SAW THE BEAST AND THE KINGS OF THE EARTH WITH THEIR ARMIES GATHERED TO MAKE WAR AGAINST THE RIDER OF THE HORSE AND HIS ARMY.

BUT THE BEAST WAS CAPTURED AND WITH HIM THE FALSE PROPHET.

THE TWO OF THEM WERE THROWN ALIVE INTO THE LAKE OF FIRE BURNING WITH BRIMSTONE.

THE REST WERE KILLED WITH THE SWORD THAT CAME OUT OF THE MOUTH OF THE RIDER ON THE HORSE.

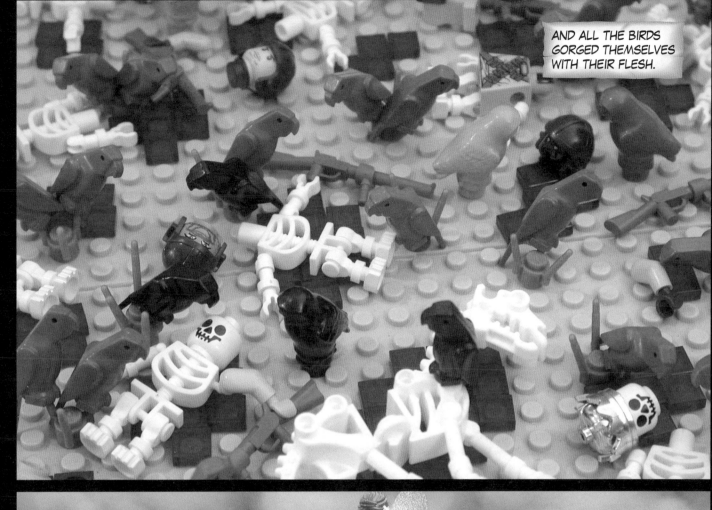

AND ALL THE BIRDS GORGED THEMSELVES WITH THEIR FLESH.

THEN I SAW AN ANGEL WITH A GREAT CHAIN SEIZE THE DRAGON. HE TIED HIM UP AND THREW HIM INTO THE ABYSS.

HE LOCKED IT FOR A THOUSAND YEARS. AFTER THAT HE HAS TO BE LET FREE FOR A LITTLE WHILE.

THEN I SAW THE SOULS OF THOSE WHO HAD BEEN DECAPITATED FOR THEIR TESTIMONY ABOUT JESUS AND FOR THE WORD OF GOD. THEY HAD NOT WORSHIPPED THE BEAST OR ITS IMAGE AND HAD NOT RECEIVED ITS MARK ON THEIR FOREHEADS OR THEIR HANDS.

THEY CAME BACK TO LIFE AND REIGNED WITH CHRIST FOR A THOUSAND YEARS. THEY WILL BE PRIESTS OF GOD AND CHRIST AND REIGN WITH HIM FOR A THOUSAND YEARS.

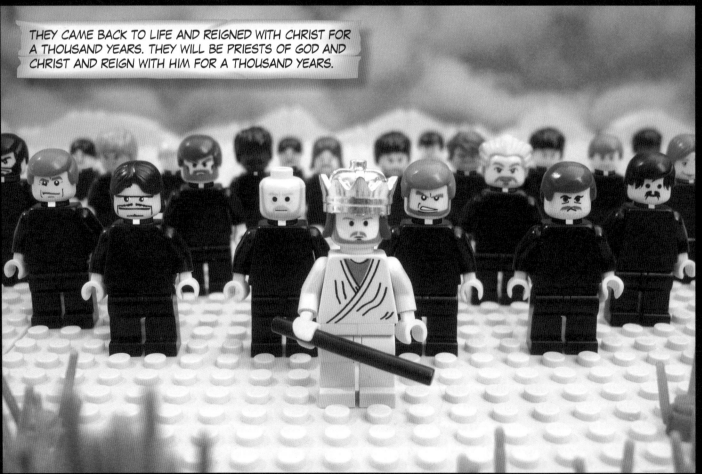

Rv 20:3 | Rv 20:4 | Rv 20:5-6

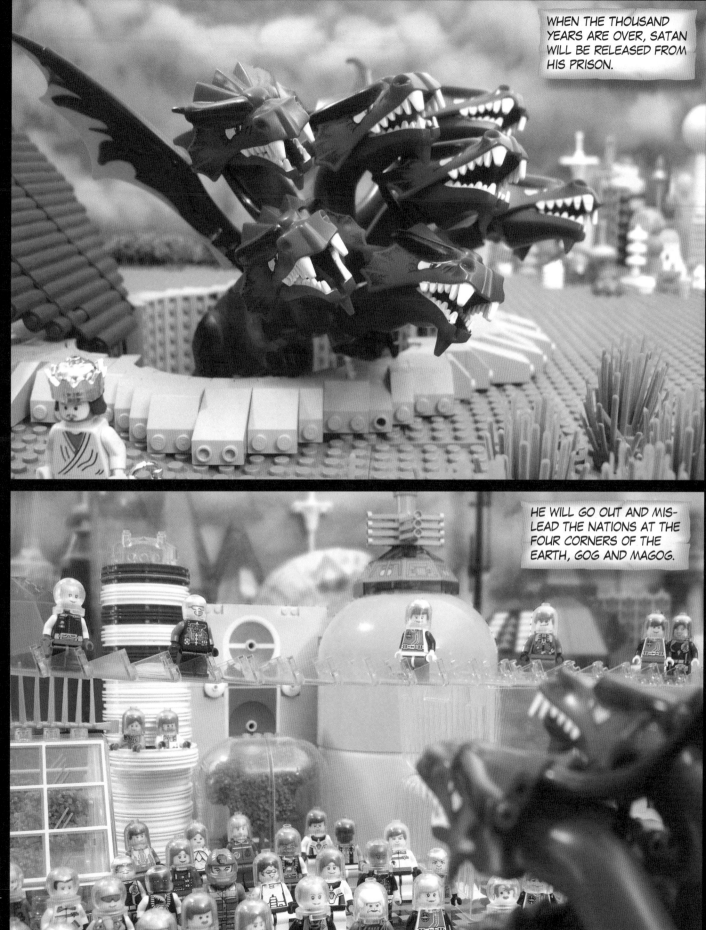

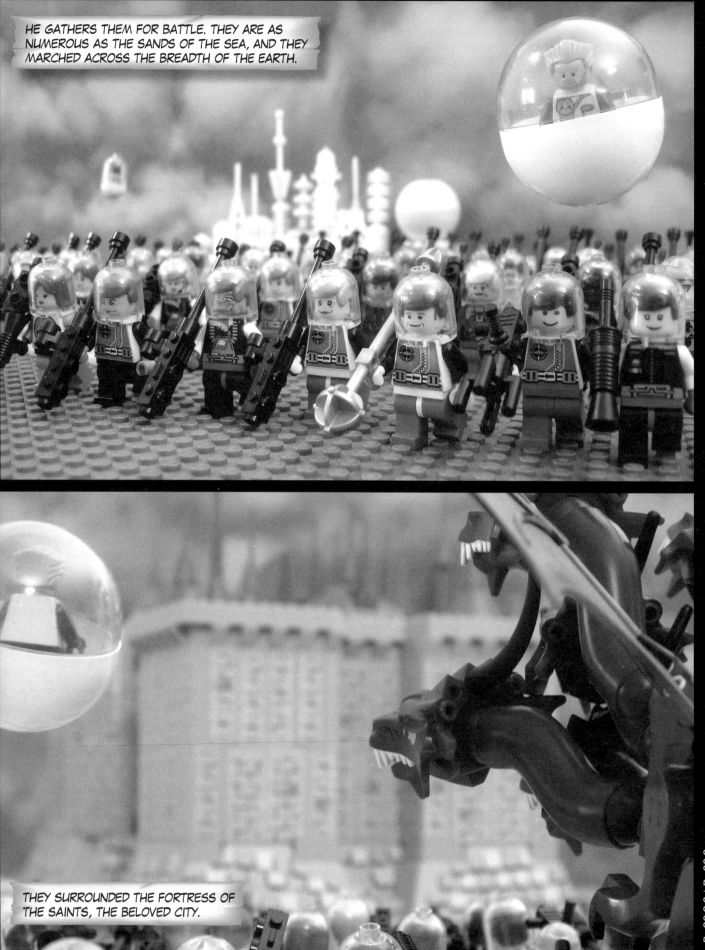

HE GATHERS THEM FOR BATTLE. THEY ARE AS NUMEROUS AS THE SANDS OF THE SEA, AND THEY MARCHED ACROSS THE BREADTH OF THE EARTH.

THEY SURROUNDED THE FORTRESS OF THE SAINTS, THE BELOVED CITY.

Rv 20:8-9 | Rv 20:9

BUT FIRE CAME DOWN FROM HEAVEN AND CONSUMED THEM.

AND THE DEVIL WHO MISLED THEM WAS THROWN INTO THE LAKE OF FIRE AND BRIMSTONE WHERE THE BEAST AND THE FALSE PROPHET WERE.

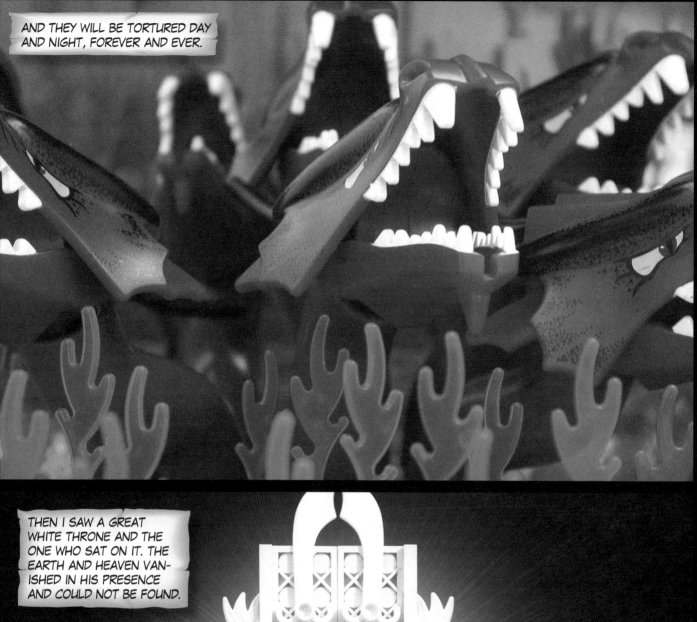

AND THEY WILL BE TORTURED DAY AND NIGHT, FOREVER AND EVER.

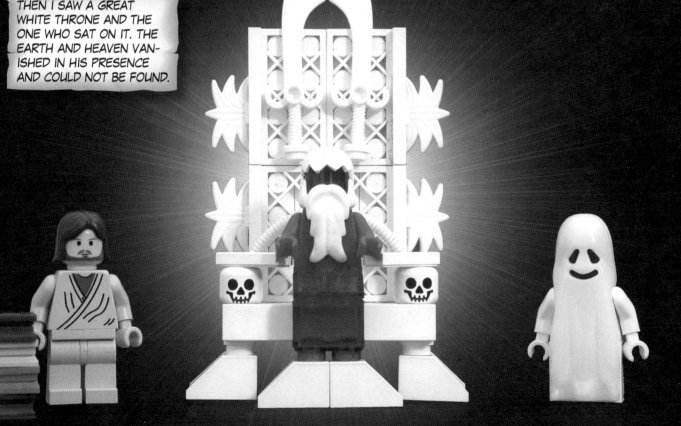

THEN I SAW A GREAT WHITE THRONE AND THE ONE WHO SAT ON IT. THE EARTH AND HEAVEN VANISHED IN HIS PRESENCE AND COULD NOT BE FOUND.

AND I SAW THE DEAD, LARGE AND SMALL, STANDING BEFORE THE THRONE, WHERE BOOKS WERE OPENED. THE SEA GAVE UP THE DEAD WHICH WERE IN IT, AND DEATH AND HADES GAVE UP THE DEAD WHICH WERE IN THEM.

AND DEATH AND HADES WERE THROWN INTO THE LAKE OF FIRE.

THE BOOKS WERE OPENED ALONG WITH ANOTHER BOOK, THE BOOK OF LIFE. THE DEAD WERE JUDGED BY WHAT WAS WRITTEN IN THE BOOKS, ACCORDING TO THEIR DEEDS.

AND ANYONE WHOSE NAME WAS NOT FOUND WRITTEN IN THE BOOK OF LIFE WAS THROWN INTO THE LAKE OF FIRE.

THIS IS THE SECOND DEATH, THE LAKE THAT BURNS WITH FIRE AND BRIMSTONE. IT WILL BE THE PLACE OF THE NONBELIEVERS...

Rv 20:12 | Rv 20:15 | Rv 20:14, 21:8

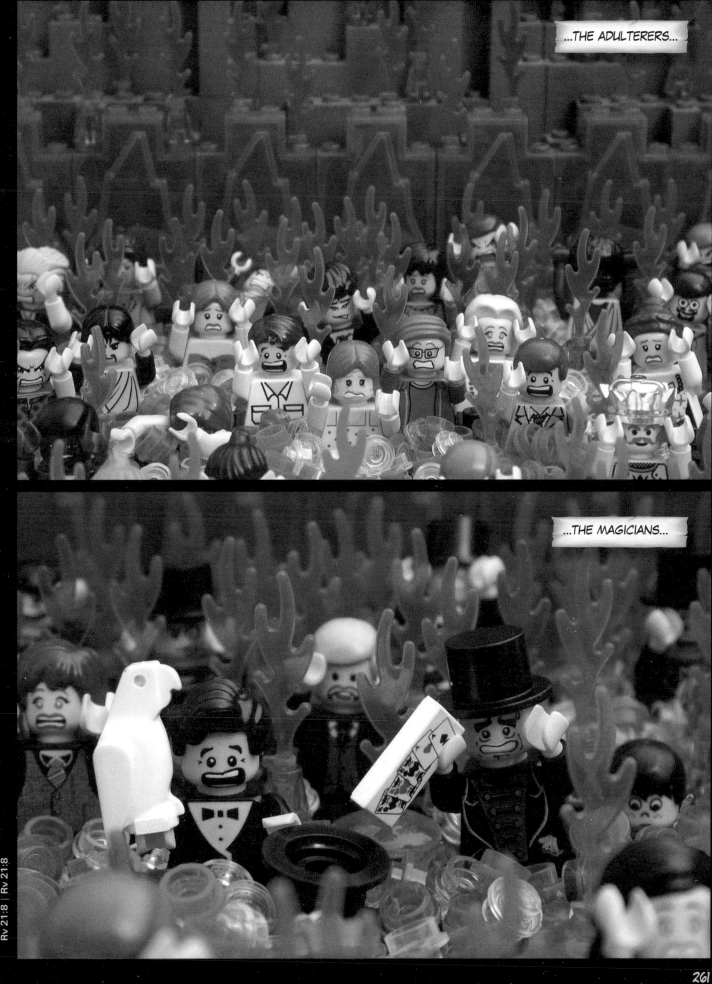

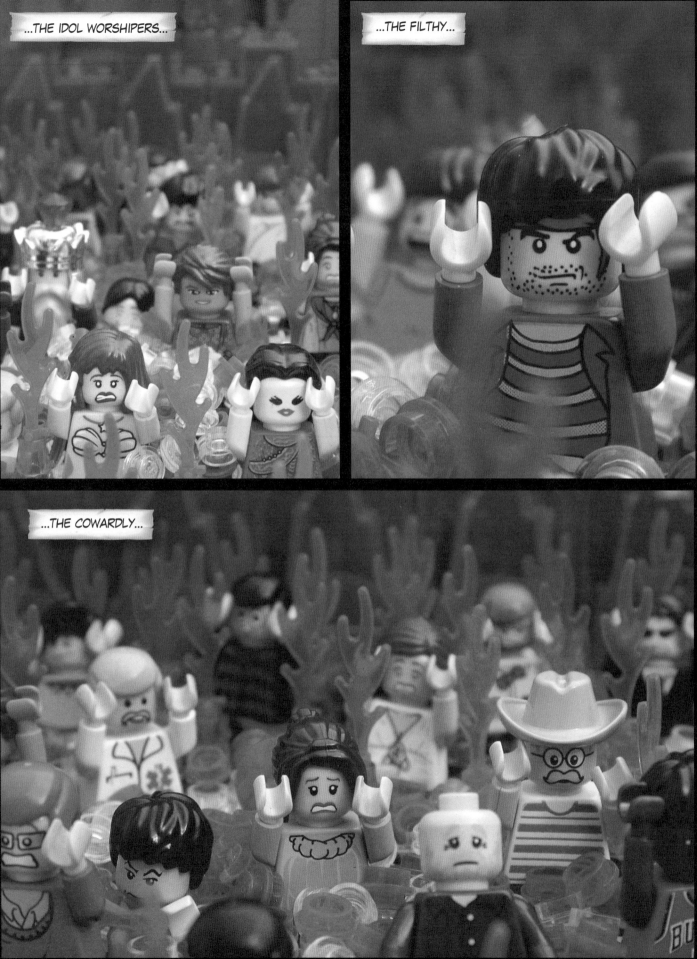

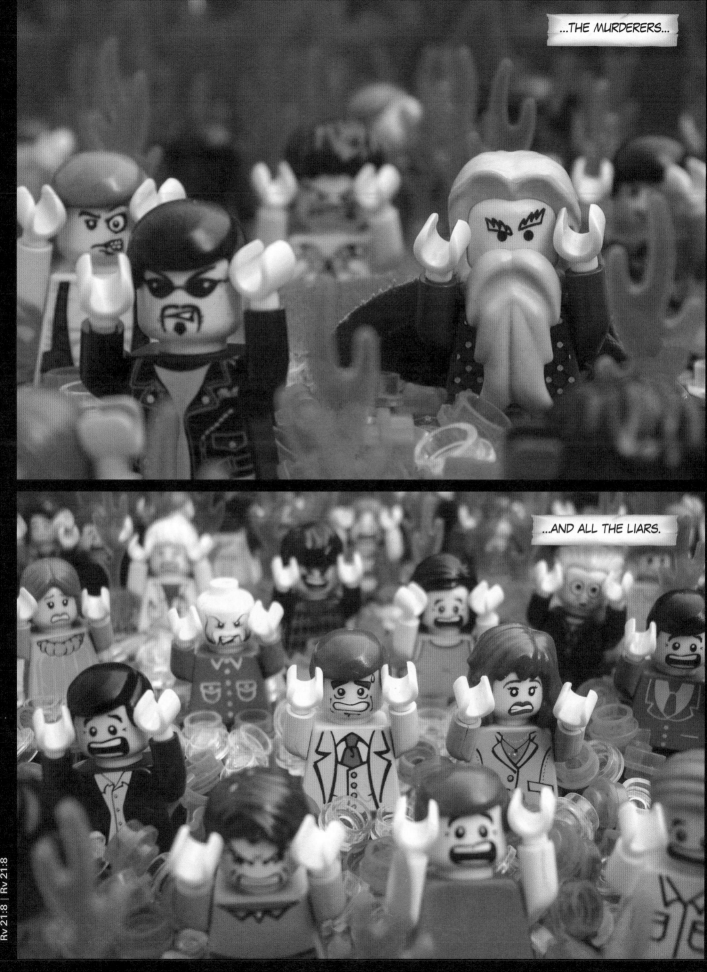

THE CITY HAD HIGH WALLS MADE OF DIAMOND WITH TWELVE PEARL GATES AND TWELVE FOUNDATION STONES OF JASPER, SAPPHIRE, AGATE, EMERALD, ONYX, CHRYSOLITE, CARNELIAN, BERYL, TOPAZ, CHRYSOPRASE, JACINTH, AND AMETHYST.

THEN I SAW A NEW EARTH. AND I SAW THE NEW JERUSALEM COMING DOWN OUT OF THE SKY FROM GOD. IT SHONE LIKE A PRECIOUS JEWEL, LIKE A CRYSTAL-CLEAR DIAMOND.

THE CITY ITSELF IS PURE GOLD, WITH THE RIVER OF THE WATER OF LIFE FLOWING THROUGH THE MIDDLE. ON EITHER SIDE OF THE RIVER IS THE TREE OF LIFE WITH ITS TWELVE KINDS OF FRUIT, PRODUCING ITS FRUIT YEAR-ROUND.

Rv 21:1-2, 21:11 | Rv 21:11-12, 21:14, 21:18-21 | Rv 21:18, 22:1-2

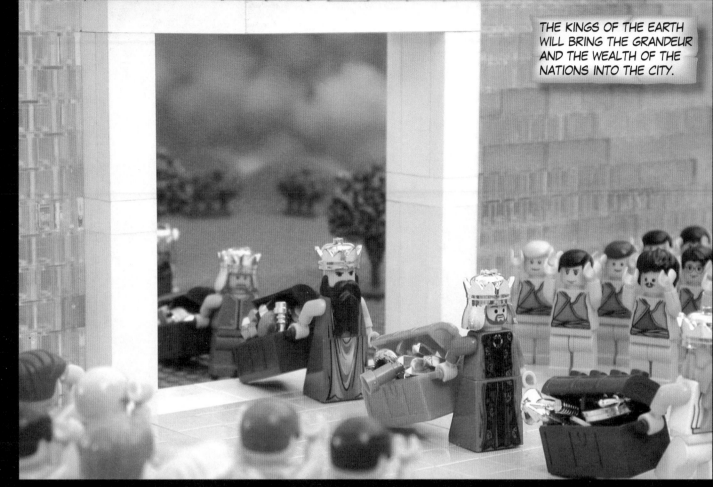

THE KINGS OF THE EARTH WILL BRING THE GRANDEUR AND THE WEALTH OF THE NATIONS INTO THE CITY.

THE THRONE OF GOD AND THE LAMB WILL BE IN THE CITY, AND HIS SERVANTS WILL SEE HIS FACE, AND HE WILL LIVE AMONG THEM.

HE WILL WIPE EVERY TEAR FROM THEIR EYES. THERE WILL BE NO MORE NIGHTTIME. AND DEATH, MOURNING, CRYING, AND PAIN WILL NOT EXIST ANY MORE. BLESSED ARE THOSE WHO CAN ENTER INTO THE CITY BY THE GATES!

HIS NAME WILL BE ON HIS SERVANTS' FOREHEADS, AND THEY WILL WORSHIP HIM.

Rv 21:4, 22: 5, 22:14 | Rv 22:4

WHILE OUTSIDE ARE THE DOGS, THE MAGICIANS, THE ADULTERERS, THE IDOL WORSHIPERS, AND EVERYONE WHO TELLS LIES. THEIR PLACE WILL BE IN THE LAKE THAT BURNS WITH FIRE AND BRIMSTONE.

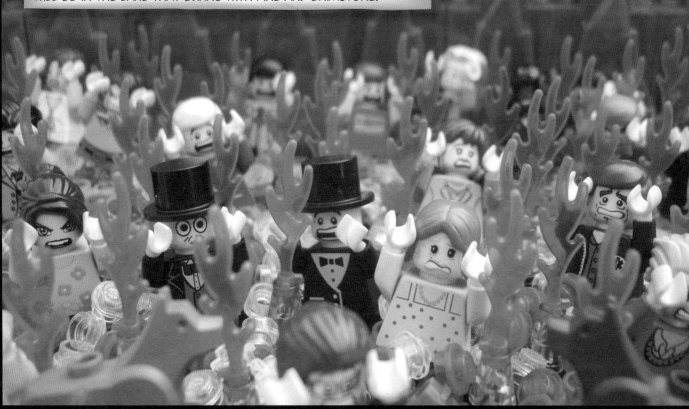

THE ANGEL SAID TO ME, "THE LORD HAS SENT ME TO SHOW HIS SERVANTS WHAT MUST SOON TAKE PLACE. DO NOT KEEP THE WORDS OF THIS BOOK SEALED UP!"

AND HE SAID TO ME, "LET THE EVILDOER CONTINUE TO DO EVIL AND THE FILTHY CONTINUE TO BE FILTHY. THE TIME IS NEAR."

I, JOHN, WARN EVERYONE WHO HEARS THE WORDS OF THIS BOOK: IF ANYONE TAKES AWAY FROM THE WORDS OF THIS BOOK OF PROPHECY, GOD WILL TAKE AWAY HIS SHARE IN THE TREE OF LIFE. IF ANYONE ADDS ANYTHING TO THEM, GOD WILL ADD TO HIM THE PLAGUES DESCRIBED IN THIS BOOK.

"I, JESUS, HAVE SENT MY ANGEL TO TESTIFY TO YOU ABOUT THESE THINGS. BEHOLD, I AM COMING SOON!"

"BEHOLD! I WILL COME LIKE A THIEF!"

THE END